Marilyn

by Milton Greene

earBOOKS

ISBN: 978-3-940004-02-4

Concept, photo editorial and text by Silja Schriever
Artwork and photo editorial by Petra Horn
Project Coordination and music selection by Beate Menck and Helge Trilck/edel
Translations by ar.pege translations sprl
Special thanks to Leah Huff (www.thearchivesstore.com)
and Janina Gehn (www.marilyn-online.de)

Produced by optimal media production GmbH, Röbel/Germany
Printed and manufactured in Germany

earBOOKS is a division of edel CLASSICS GmbH
For more information about earBOOKS please visit: **www.earbooks.net**

edel CLASSICS optimal
MEDIA PRODUCTION

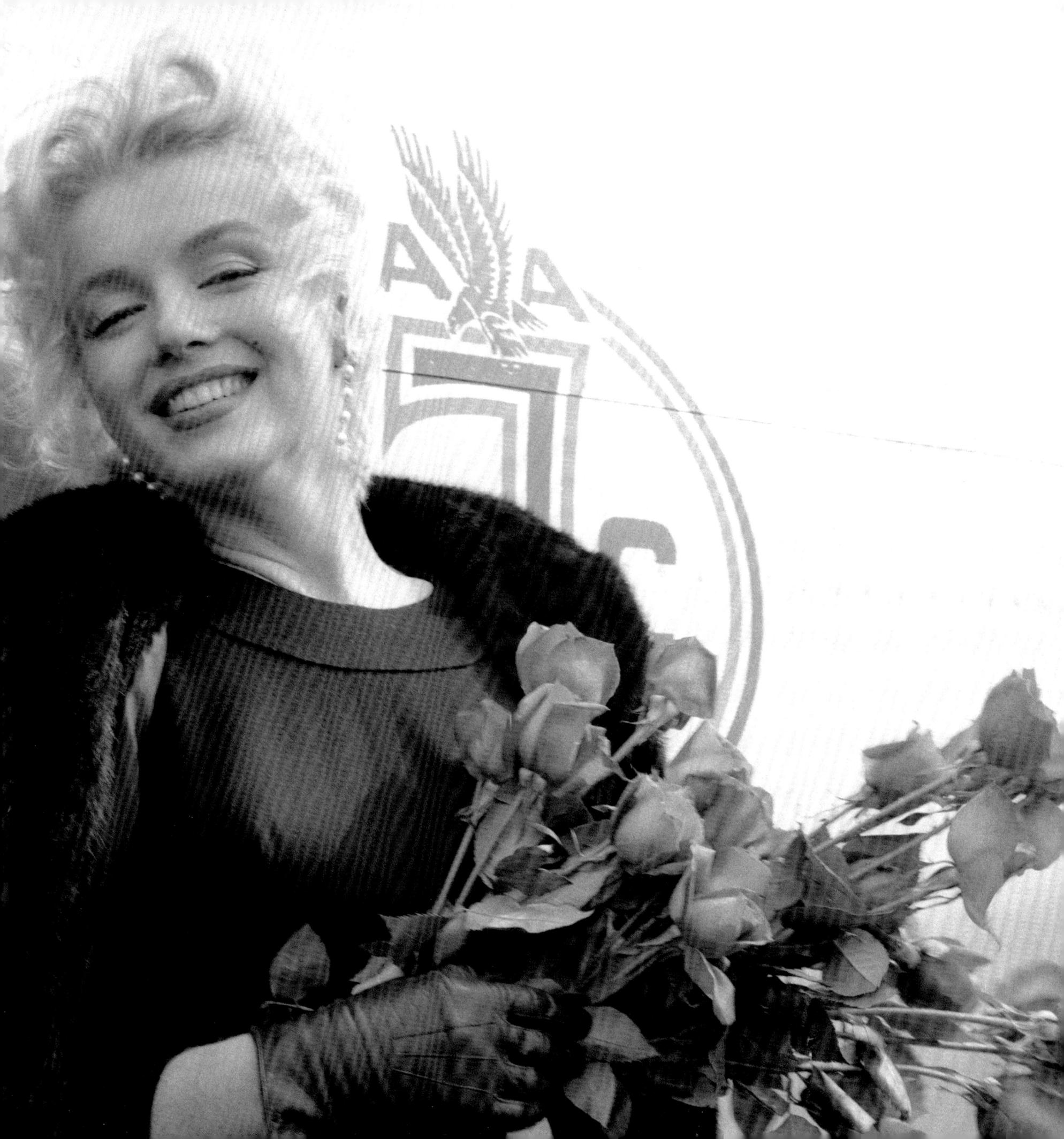

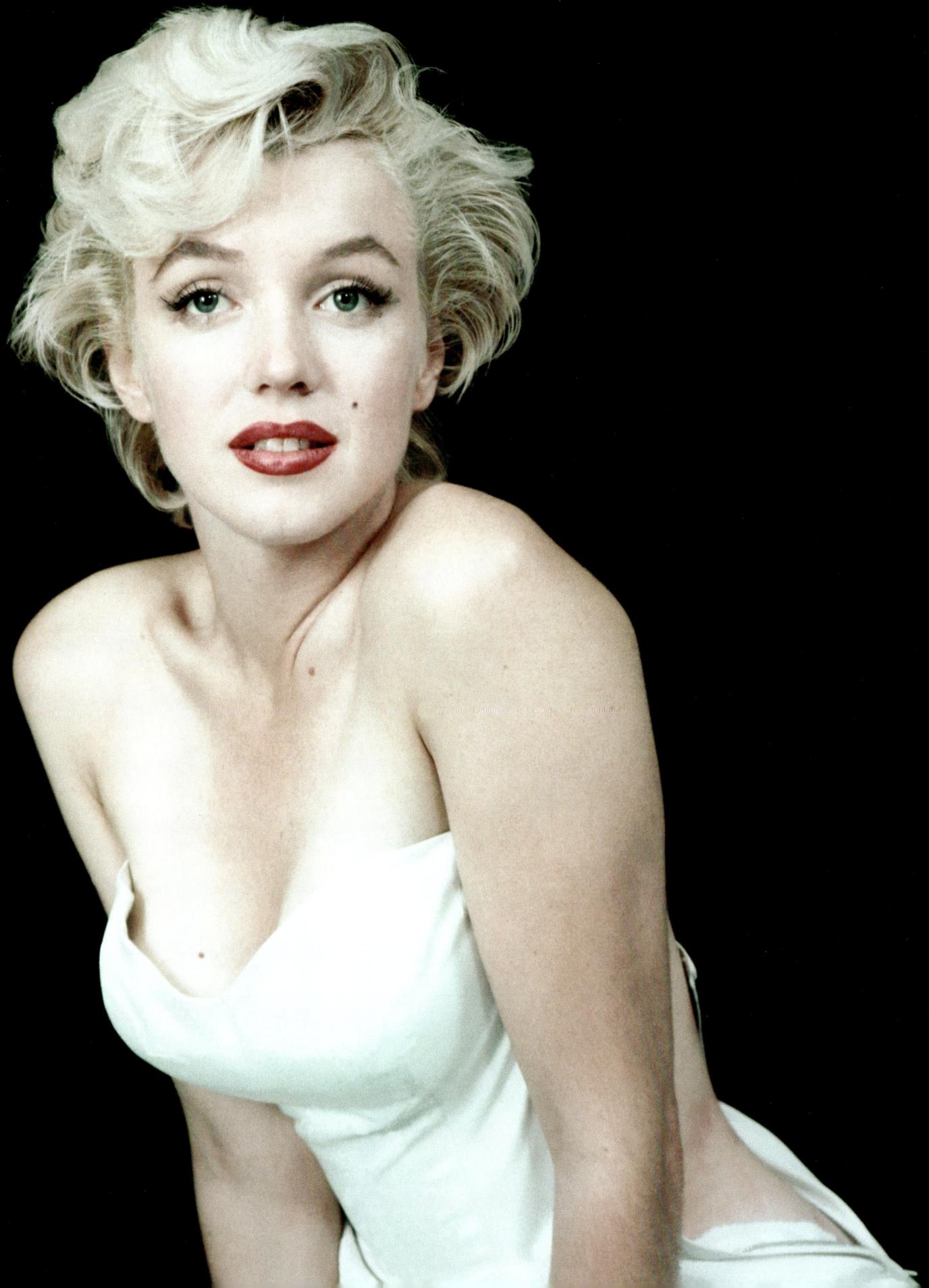

MARILYN MONROE

She is the most famous woman of the 20th century. Millions of photos of Marilyn Monroe have been printed in illustrated books, in magazines, as posters and postcards, and on placards. La Monroe is immortal. However, there is probably nobody who captured the many facets of the Hollywood goddess on such beautiful pictures as the star photographer Milton Hawthorne Greene. The earbook *Marilyn Monroe by Milton H. Greene* shows his famous works such as *White Fur* and the black series *Black Sitting* as well as outstanding unknown photos of the American Venus.

Milton H. Greene and Marilyn met in 1953 at a fashion shoot for the magazine Look – and got on extremely well right from the start. Milton was one of the few people who Marilyn trusted absolutely and by whom she felt herself to be understood. Marilyn lived with Greene and his family in Connecticut for about a year after turning her back on Hollywood for a while after disputes with her film studio. The joint company *Marilyn Monroe Productions* was founded during this time.

Greene's photos are among the best ever made of Marilyn. This is because they not only show the myth of Marilyn, but they also show her soul. With its unusual photographs, *Marilyn Monroe by Milton H. Greene* presents the star's beauty, fragility, inner conflict and also her wonderful humor.

Monroe's songs will also accompany you on your journey into a past era. Marilyn was also frequently able to display her musical talent in her films. Her highly individual, mellow, sensual, and yet extremely expressive voice enthralled the public. The famous songwriter team Sammy Cahn/James Van Heusen literally tailored songs such as *Let's Make Love* to suit her. The melodies resurrect the myth of Marilyn – and help us to understand her influence on the film culture of those times and on today's modern pop culture.

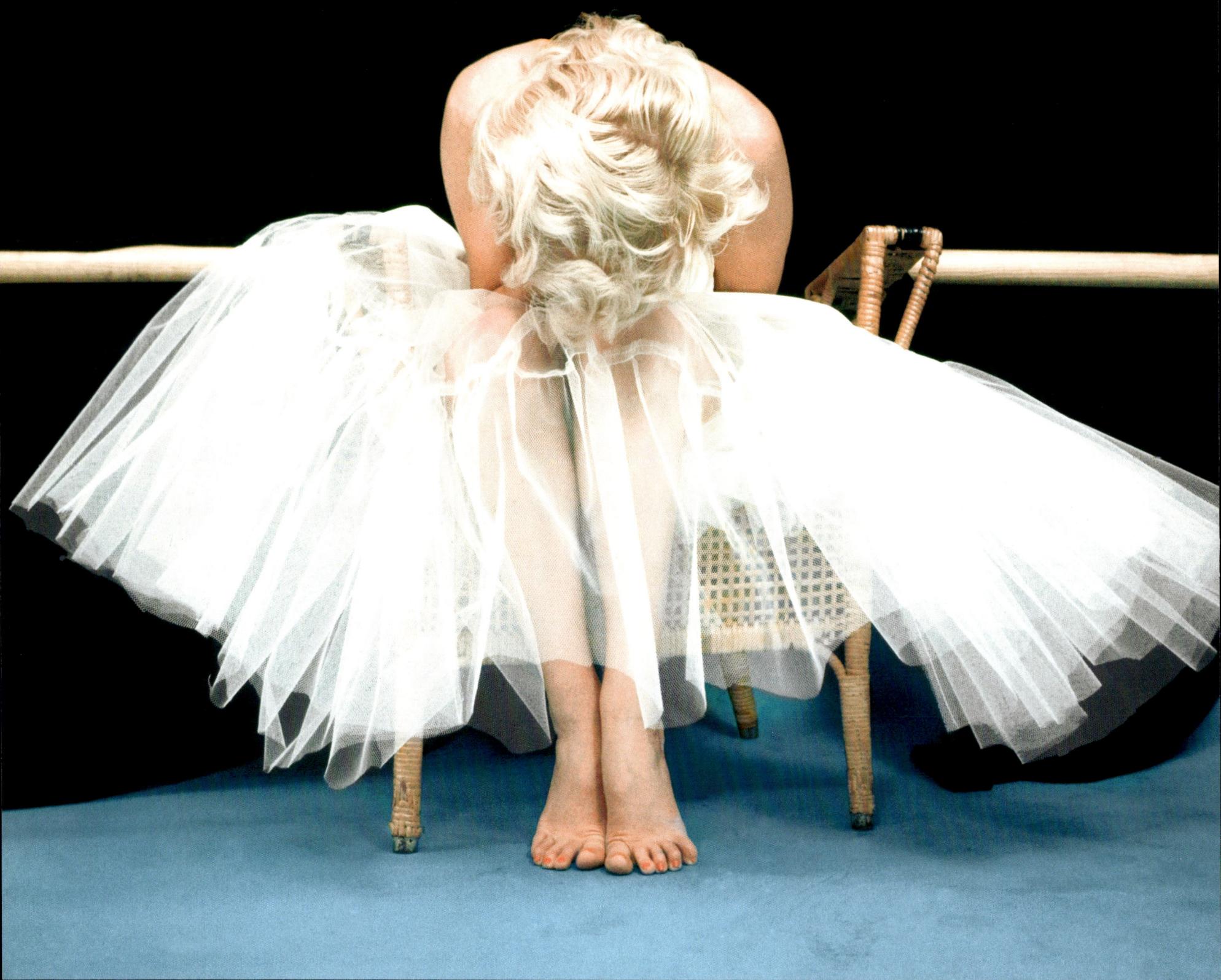

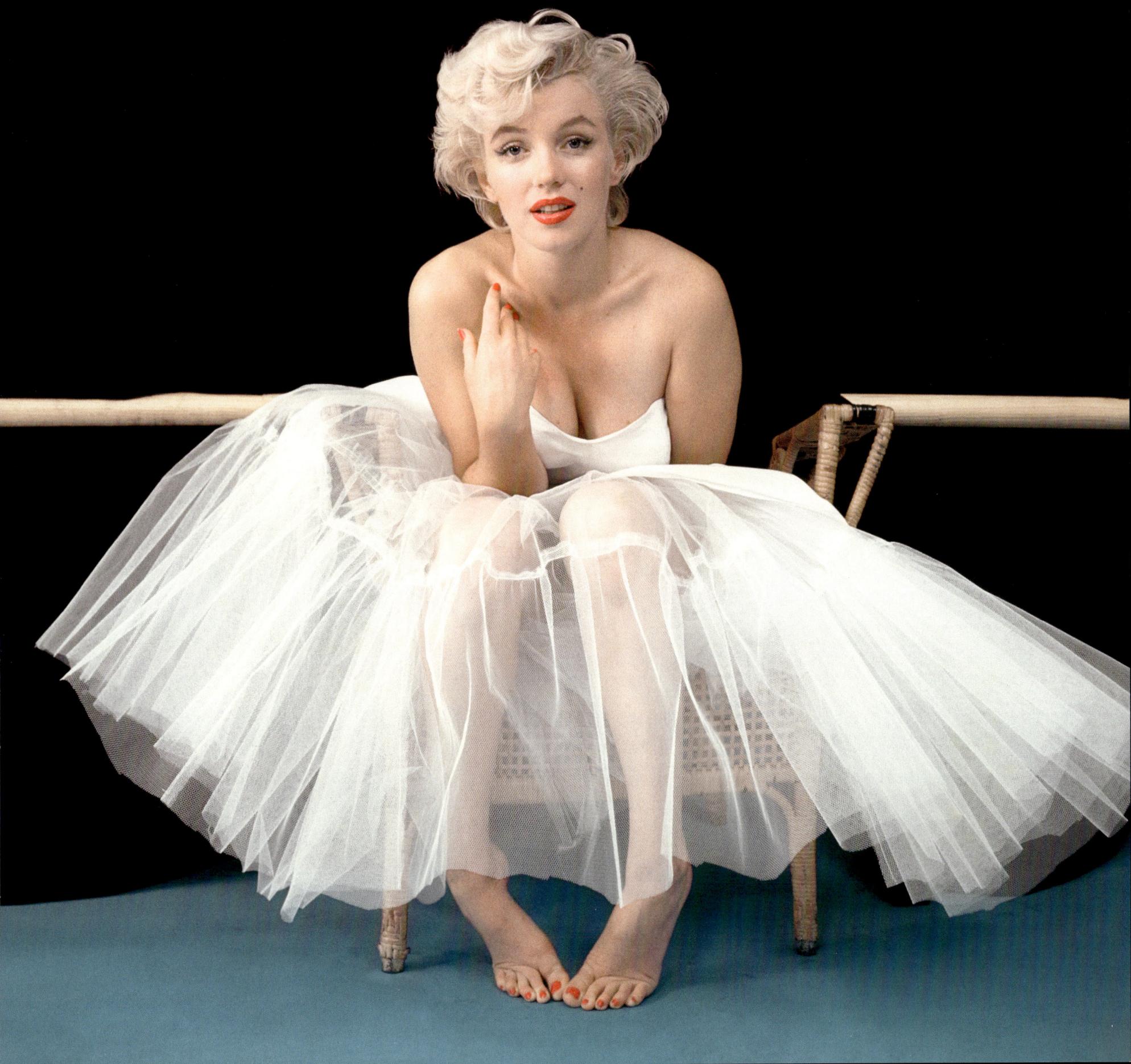

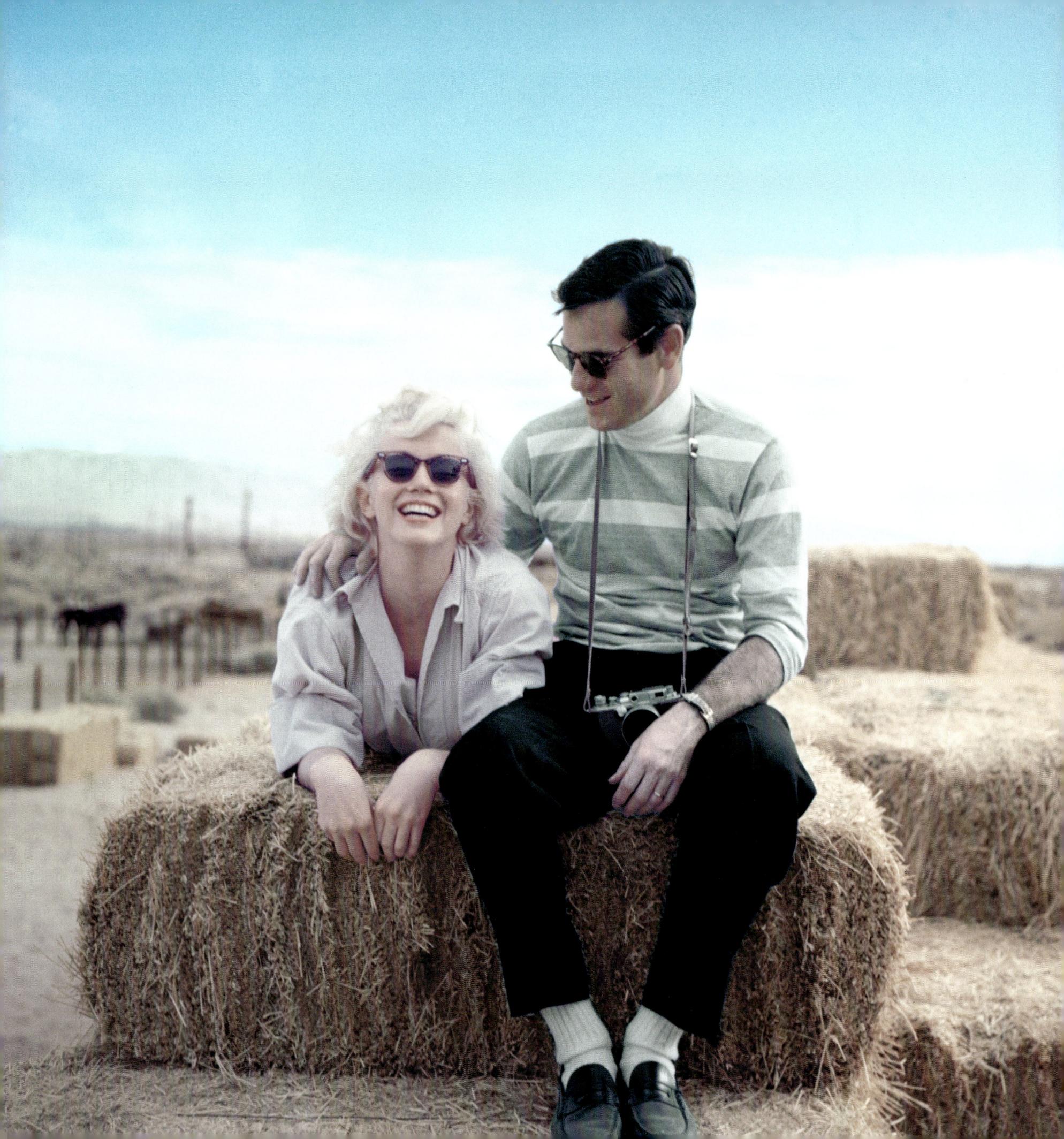

BIOGRAPHY MILTON H. GREENE
MARCH 14, 1922 - AUGUST 8, 1985

For over four decades, Milton H. Greene made his mark as one of the most celebrated photographers in the world.... Born in New York in 1922, Milton Greene began taking pictures at the early age of 14. Although he was the recipient of a scholarship to the renowned Pratt Institute, a heightened awareness of the photographic image diverted his attention to the camera and its versatility. He soon apprenticed himself to the famous photojournalist and wizard of composition, Elliot Elisofen. Before long, his keen regard for fashion and the camera found him assisting Louise Dahl-Wolfe, the distinguished fashion photographer known for her unique covers and fashion pages for Harper's Bazaar. At the age of twenty-three, Milton was referred to as "Color Photography's Wonder Boy".

The majority of Milton's work in the fifties and sixties appeared in major national publications including Life, Look, Harper's Bazaar, Town & Country and Vogue. In fact, Milton Greene, along with other eminent photographers such as Richard Avedon, Cecil Beaton, Irving Penn, and Norman Parkinson, is credited for bringing fashion photography into the realm of fine art.

Although Greene was initially renowned for his high-fashion photography, it is his remarkable portraits of our most beloved artists, musicians, film, and television and theatrical celebrities, which have become legendary. Milton believed that as an artist he wanted to capture people's beauty, which was in the heart and to show people in an elegant and natural way.

The range of Milton Greene's subjects include Marilyn Monroe, Grace Kelly, Frank Sinatra, Marlene Dietrich, Sammy Davis Jr., Ava Gardner, Paul Newman, Elizabeth Taylor, Audrey Hepburn oder Andy Warhol und Salvador Dalí. But it was his unique friendship, business relationship and ensuing photographs of Marilyn Monroe for which he is most fondly remembered.

Milton first encountered Marilyn Monroe on assignment for Look Magazine. They quickly became close friends and ultimately formed their own film production company which produced Bus Stop and The Prince and the Showgirl. Before marrying Arthur Miller, Monroe lived with Milton and his family in their Connecticut farmhouse. It was during this period that Greene was able to capture some of the most beautiful photographs ever taken of Marilyn Monroe, recording her moods, beauty, talent and spirits. During their ten years together, Greene photographed Monroe in countless photographic sessions including the famous "Black" sitting.

Greenes photography won him many national and international honors, medals and awards; among them the American Institute of Graphic Arts and the Art Director's Club of New York, Chicago, Los Angeles, Philadelphia, San Francisco, and Detroit. One of his last awards was from the Art Director's Club of New York for his work in Harper's Bazaar.

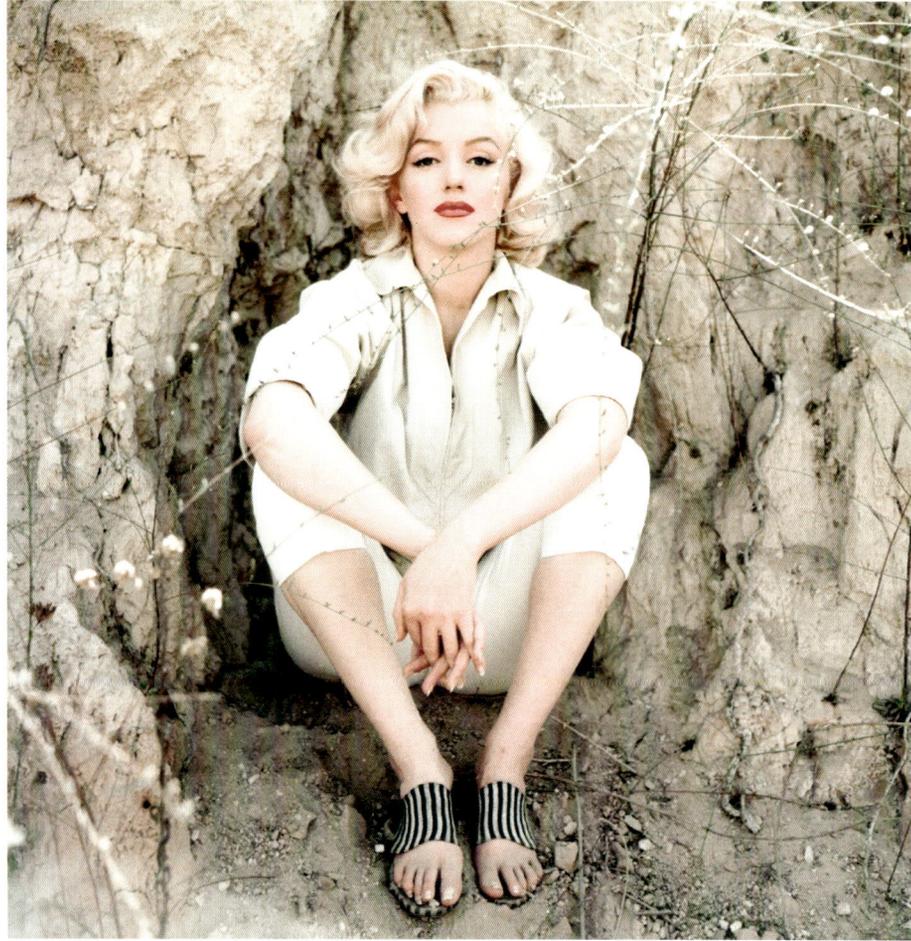

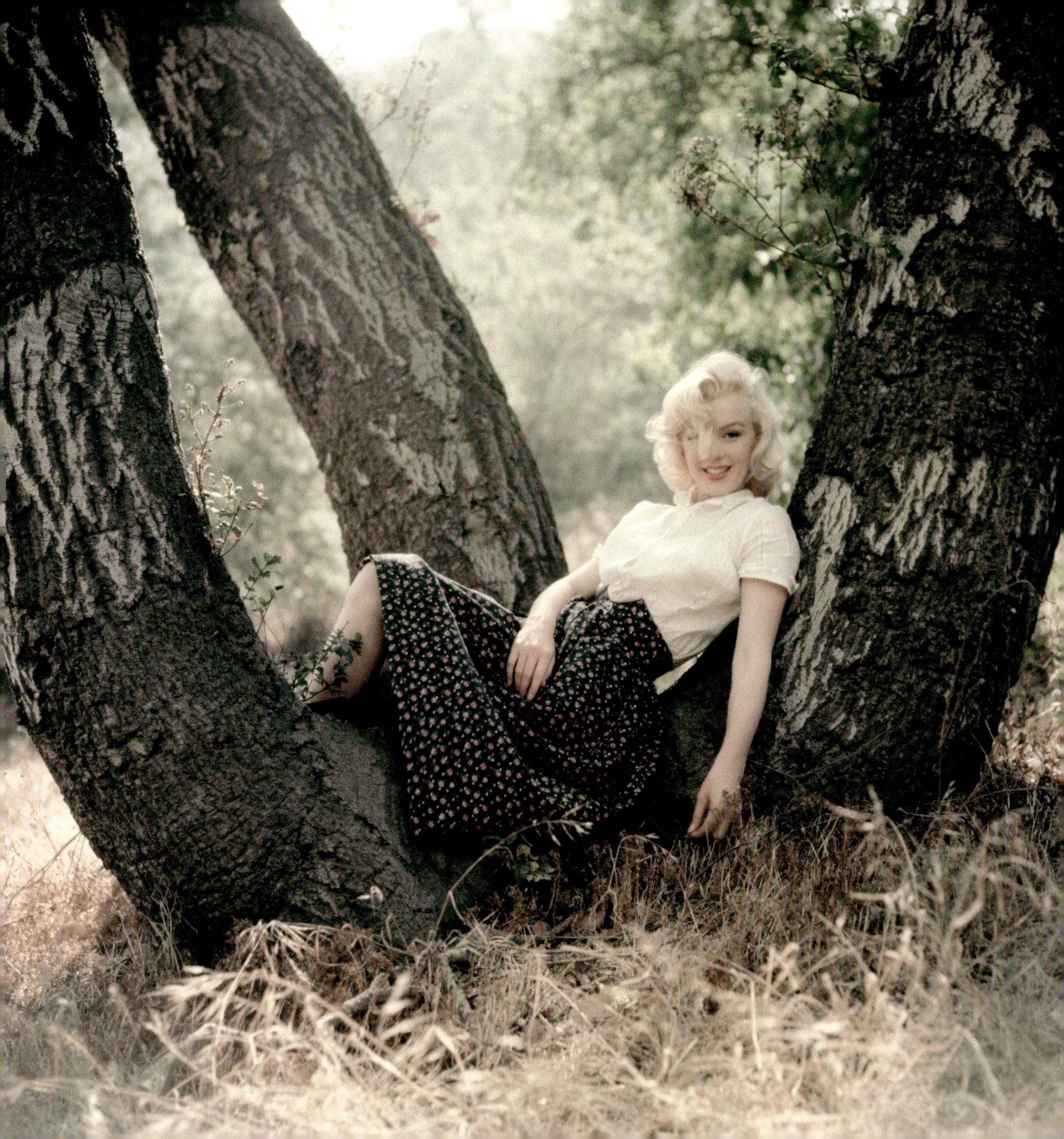

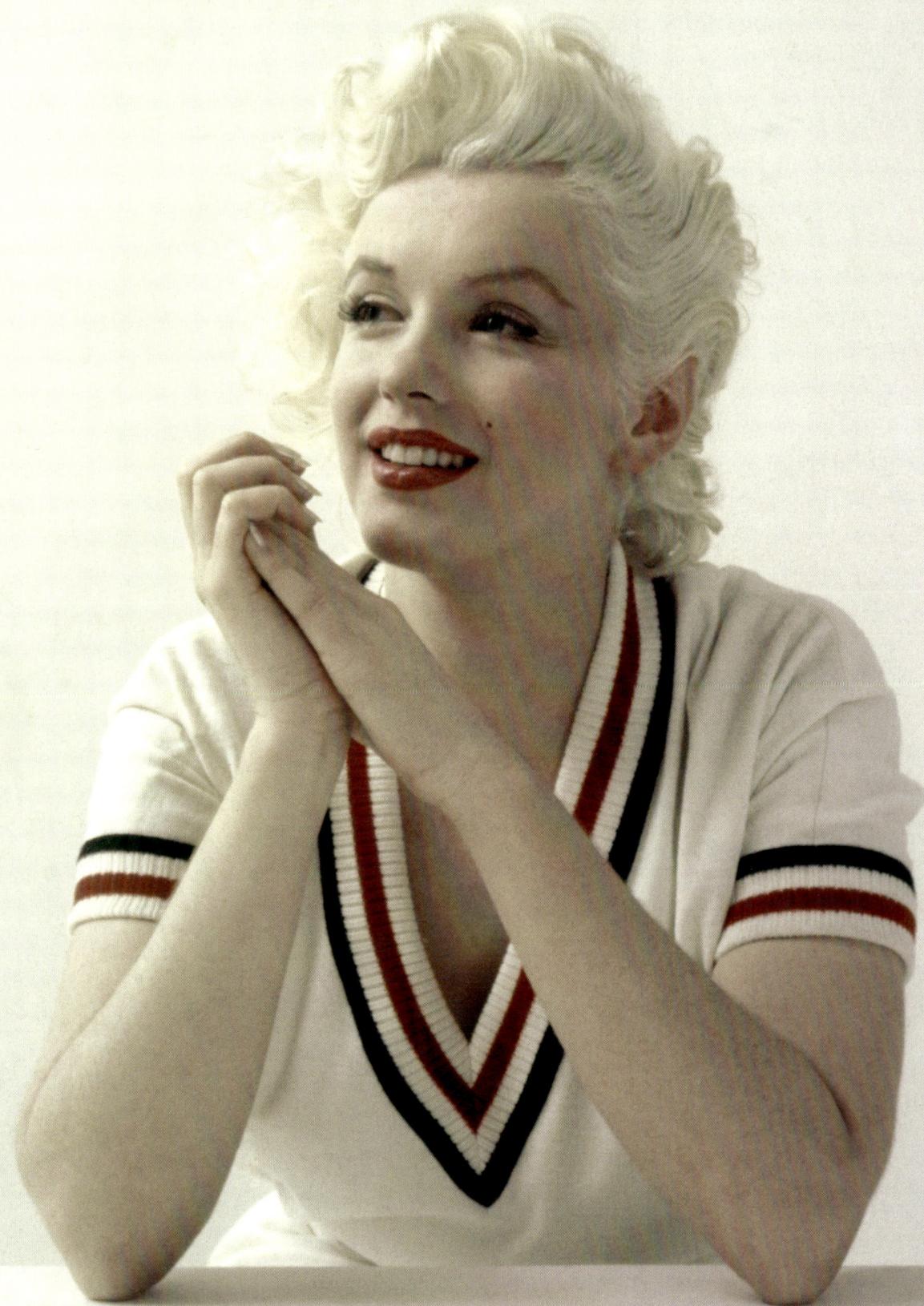

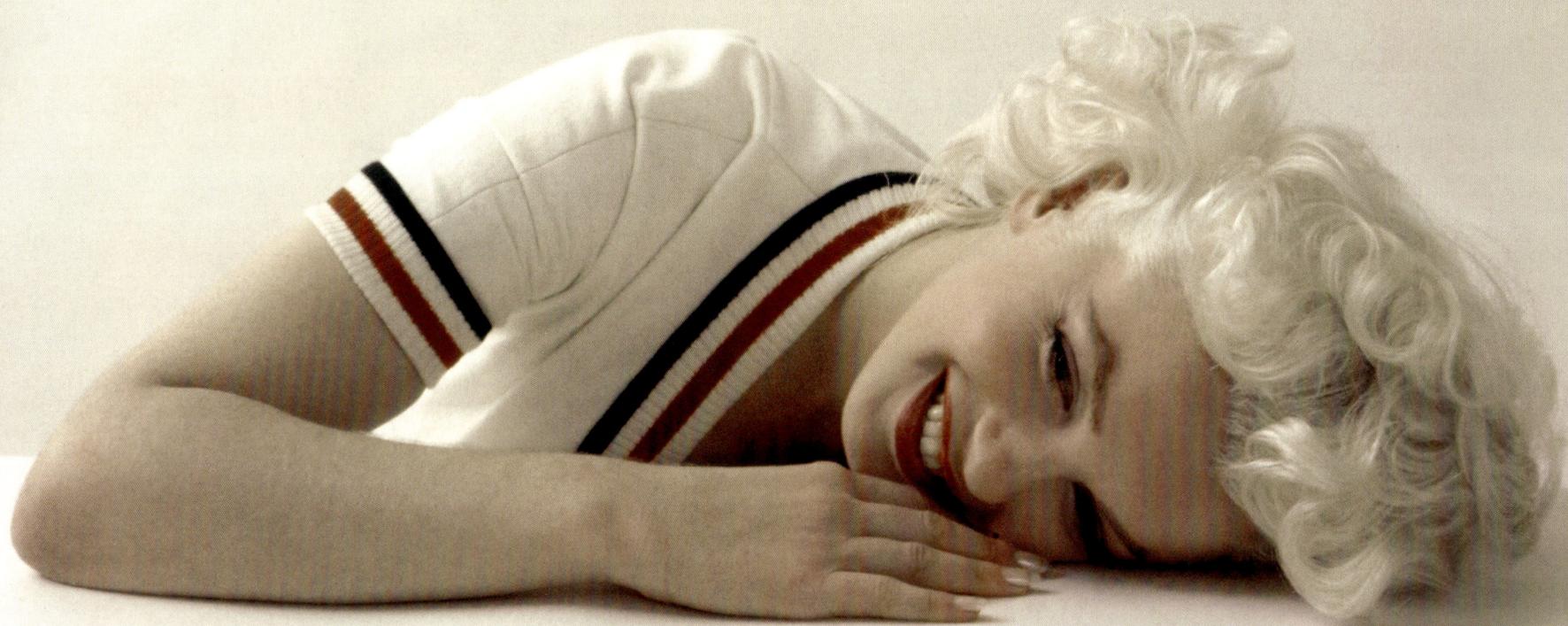

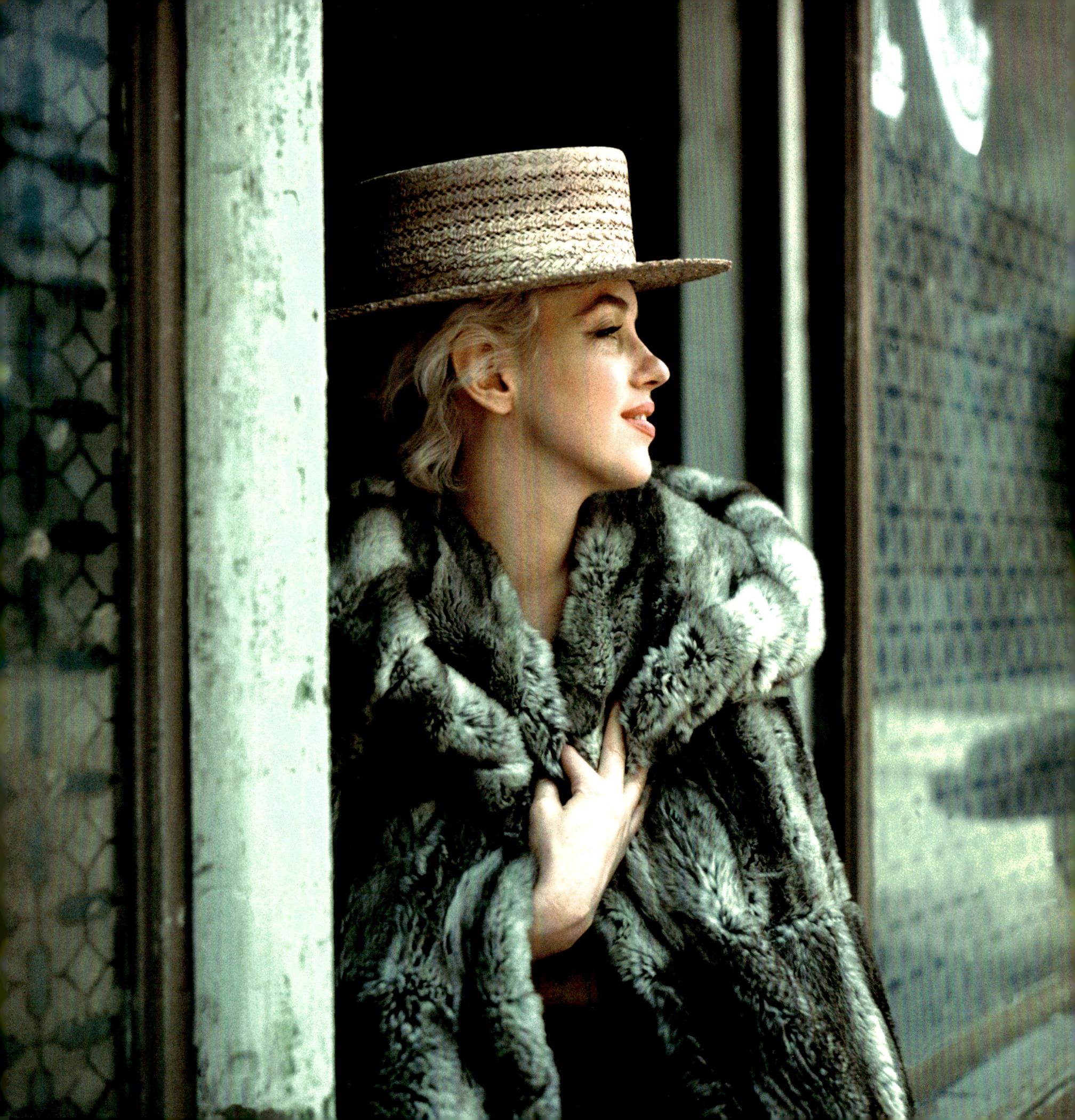

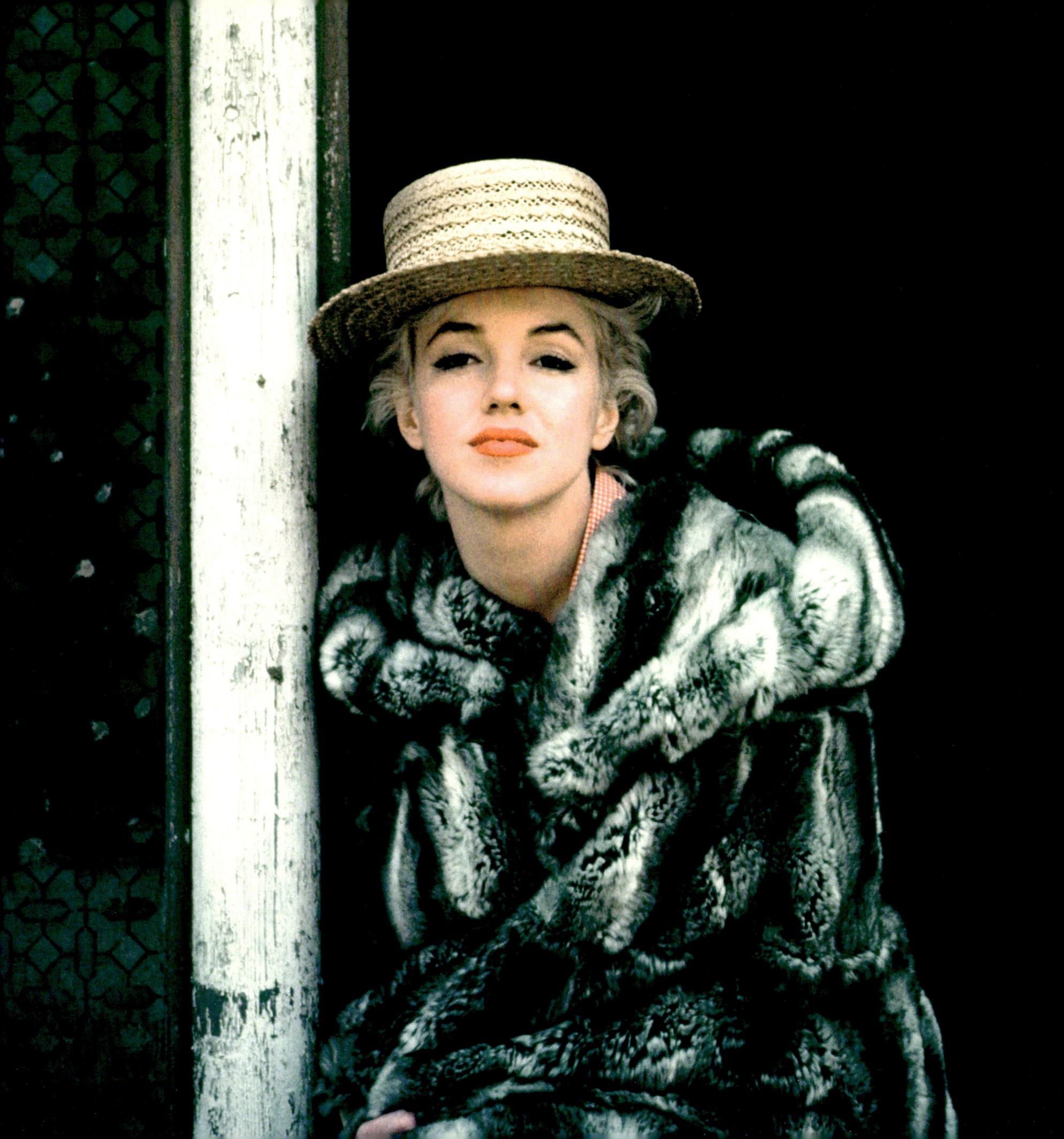

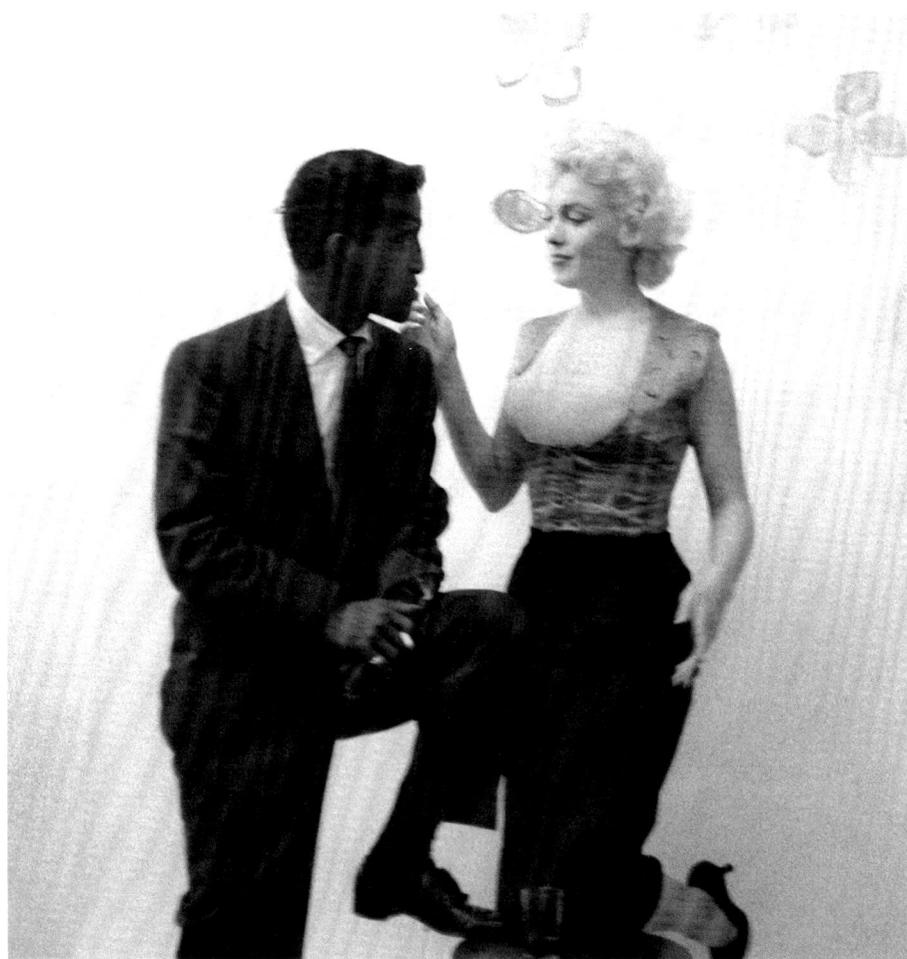

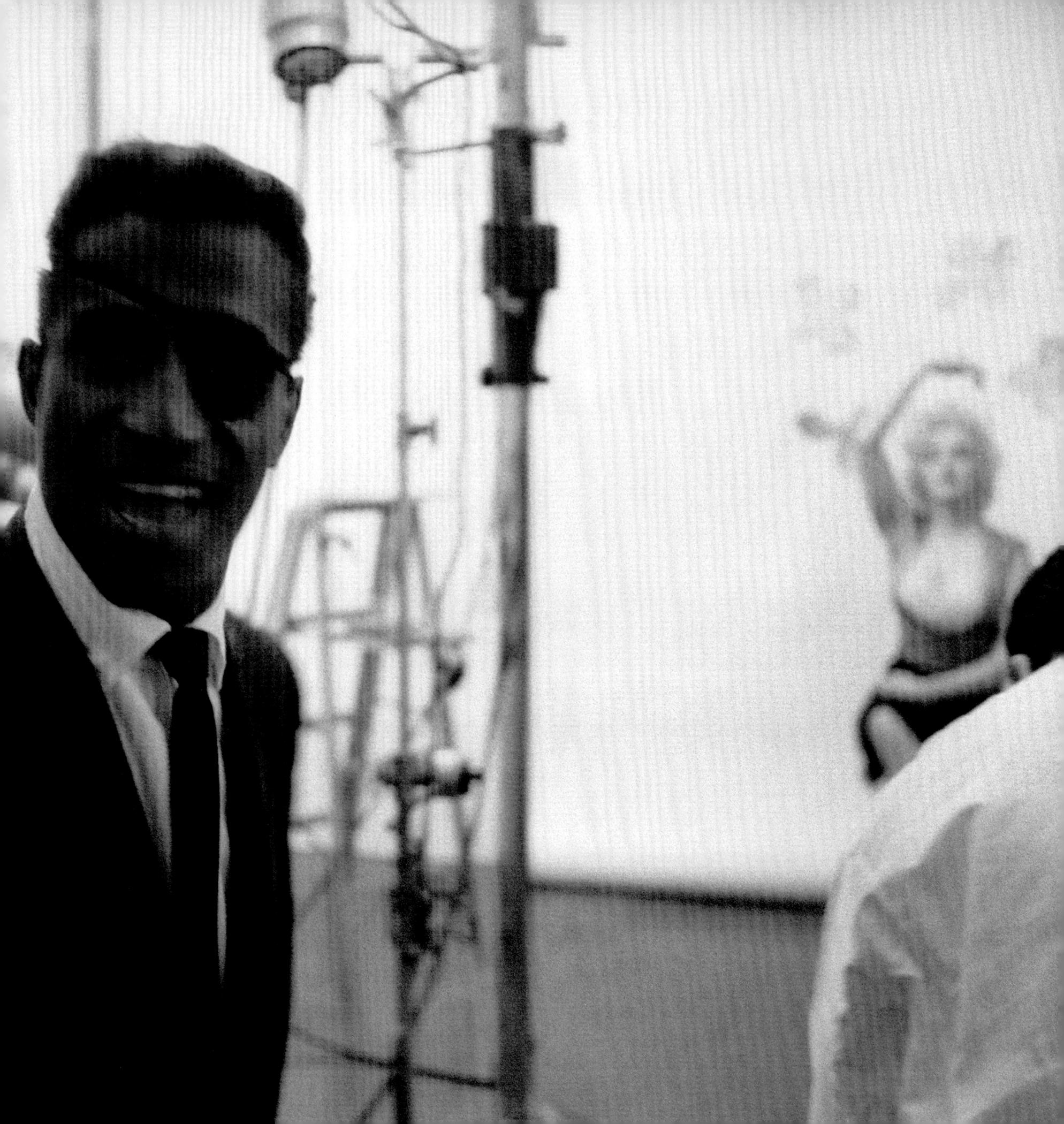

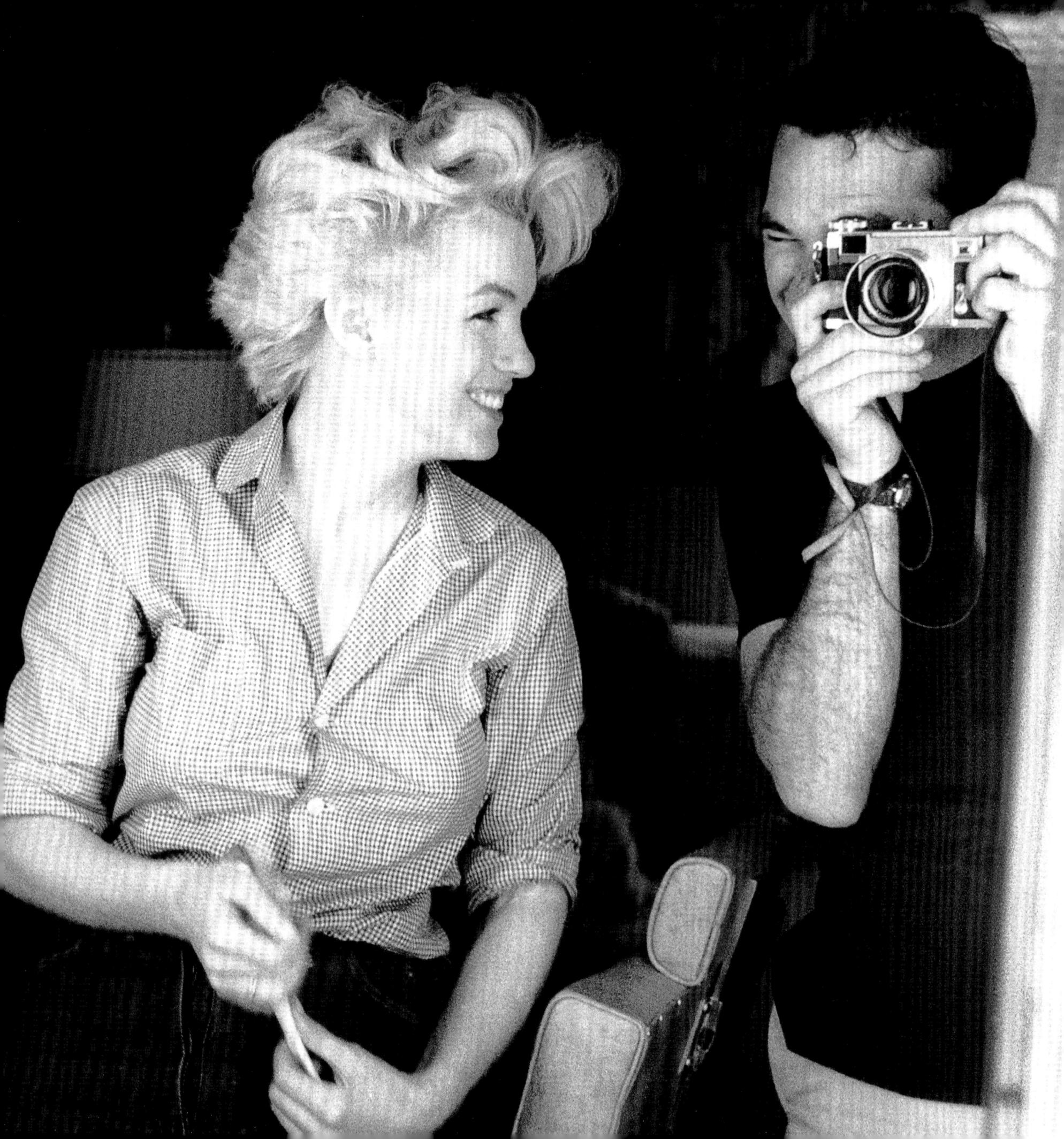

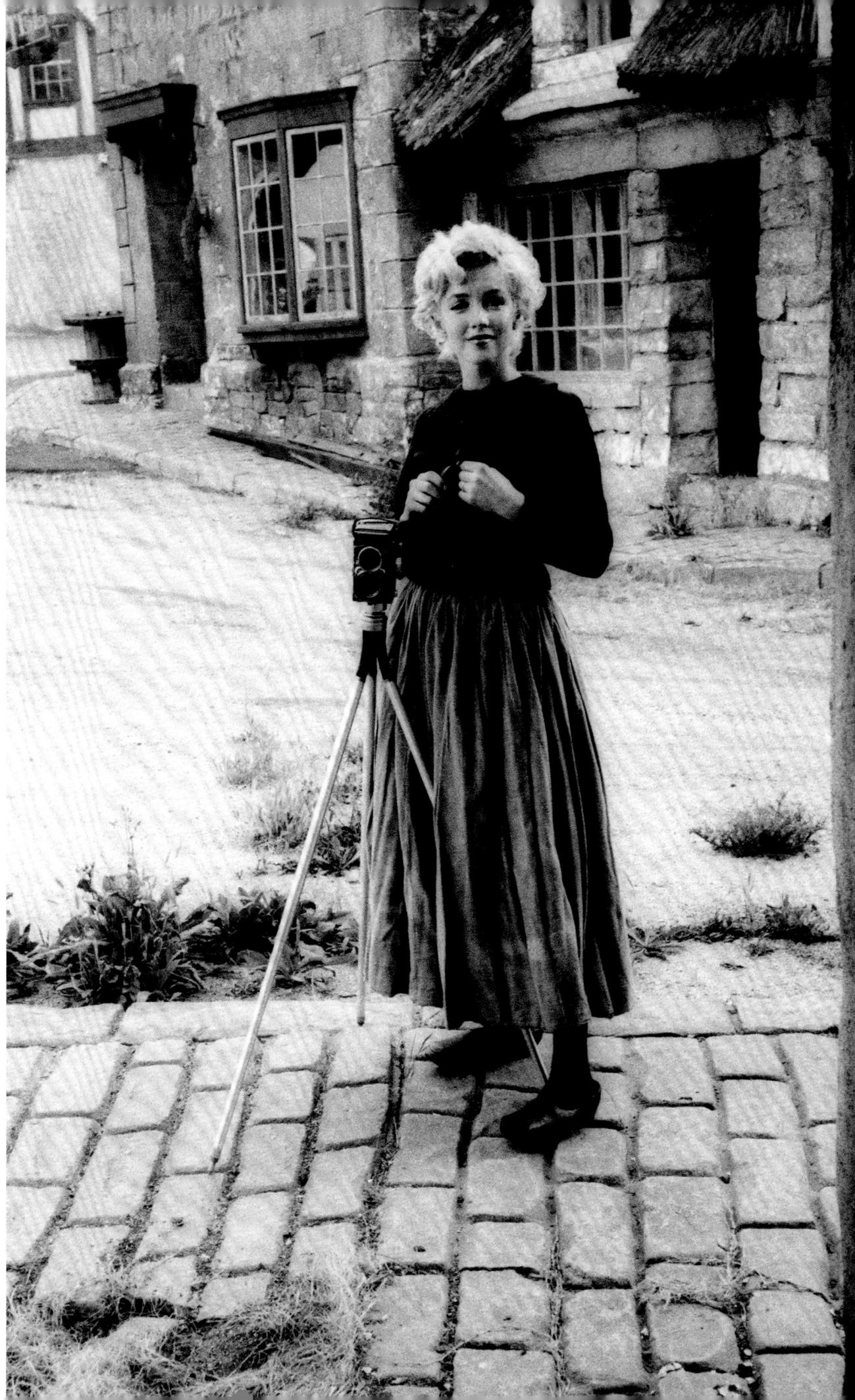

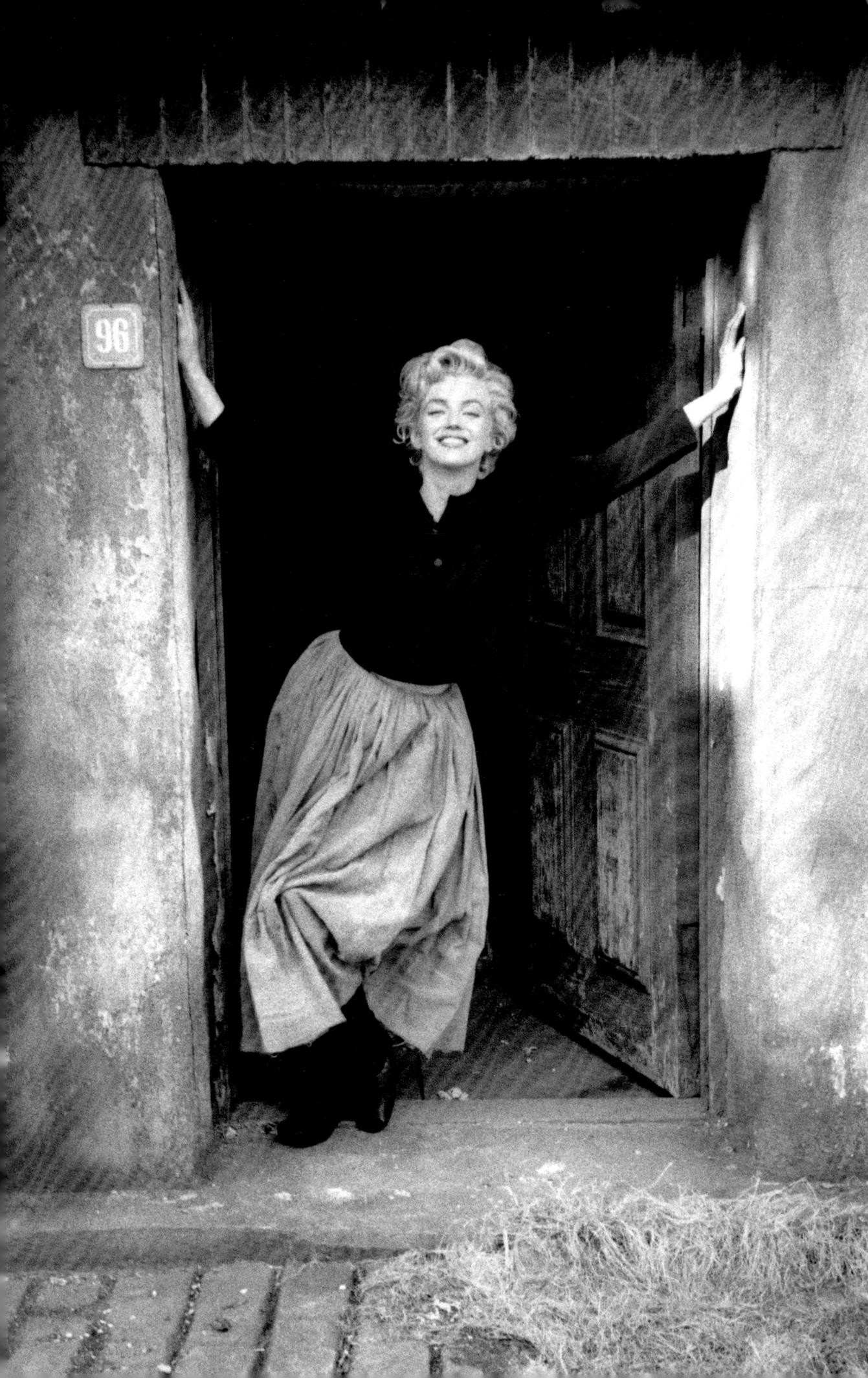

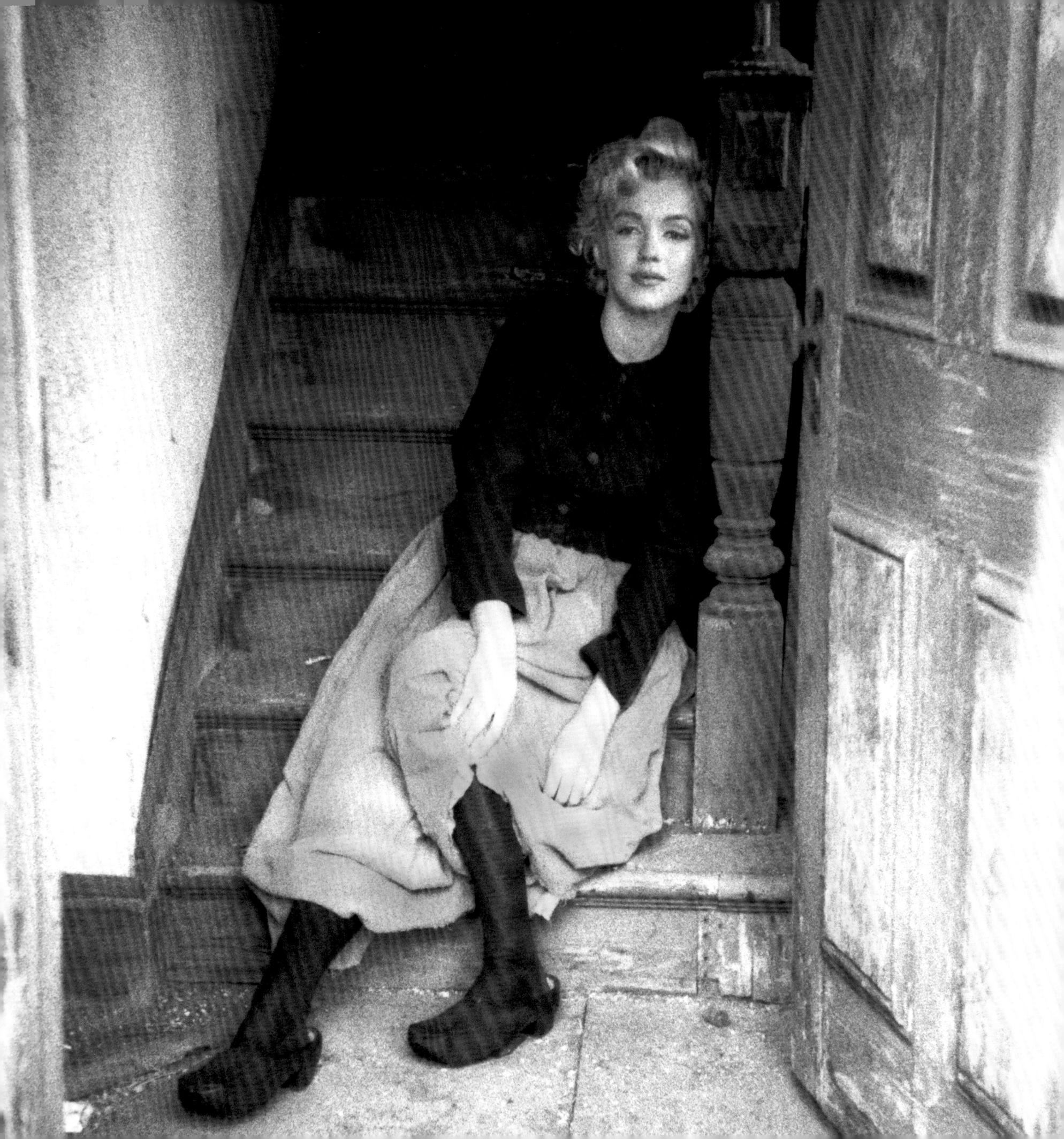

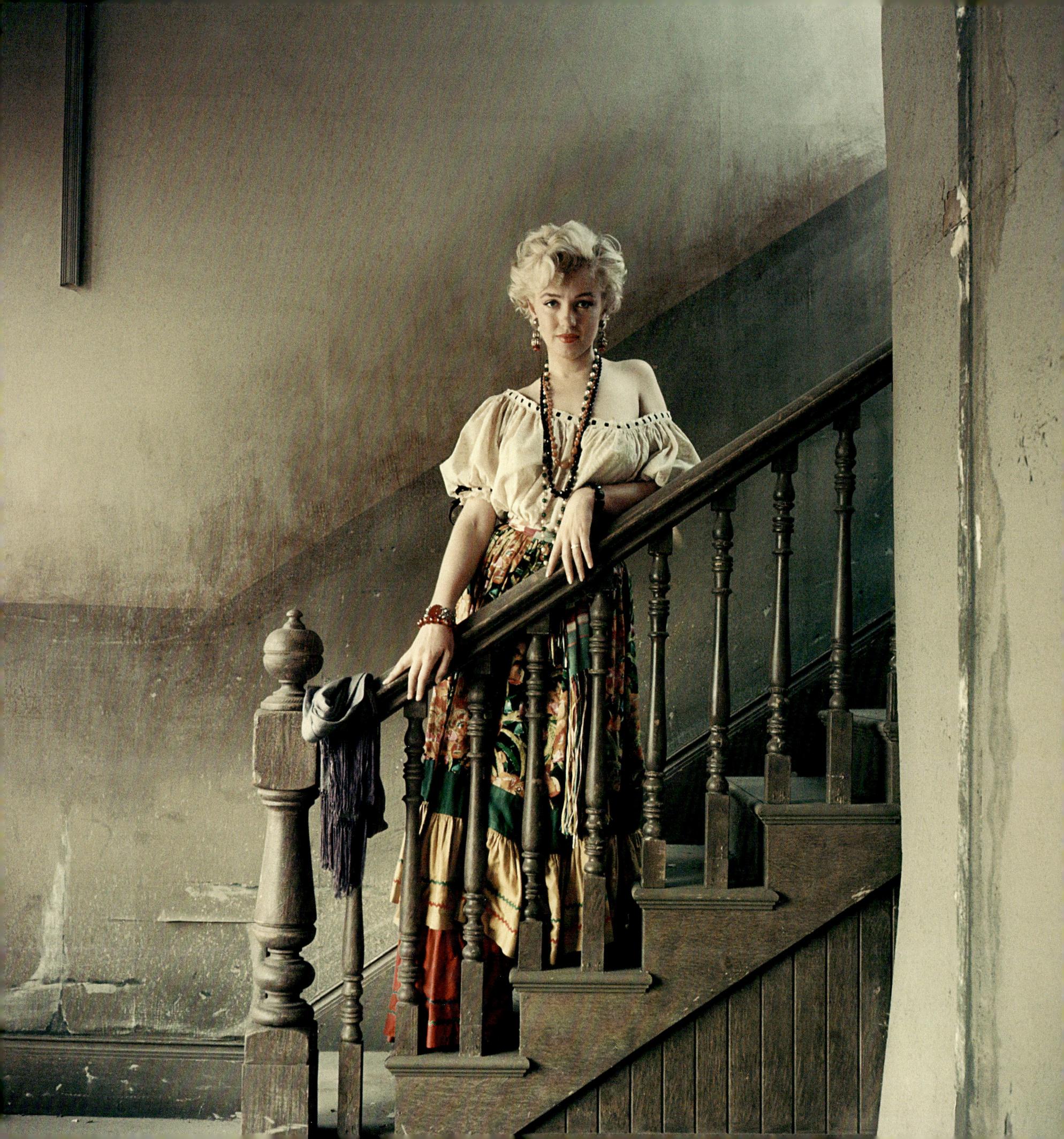

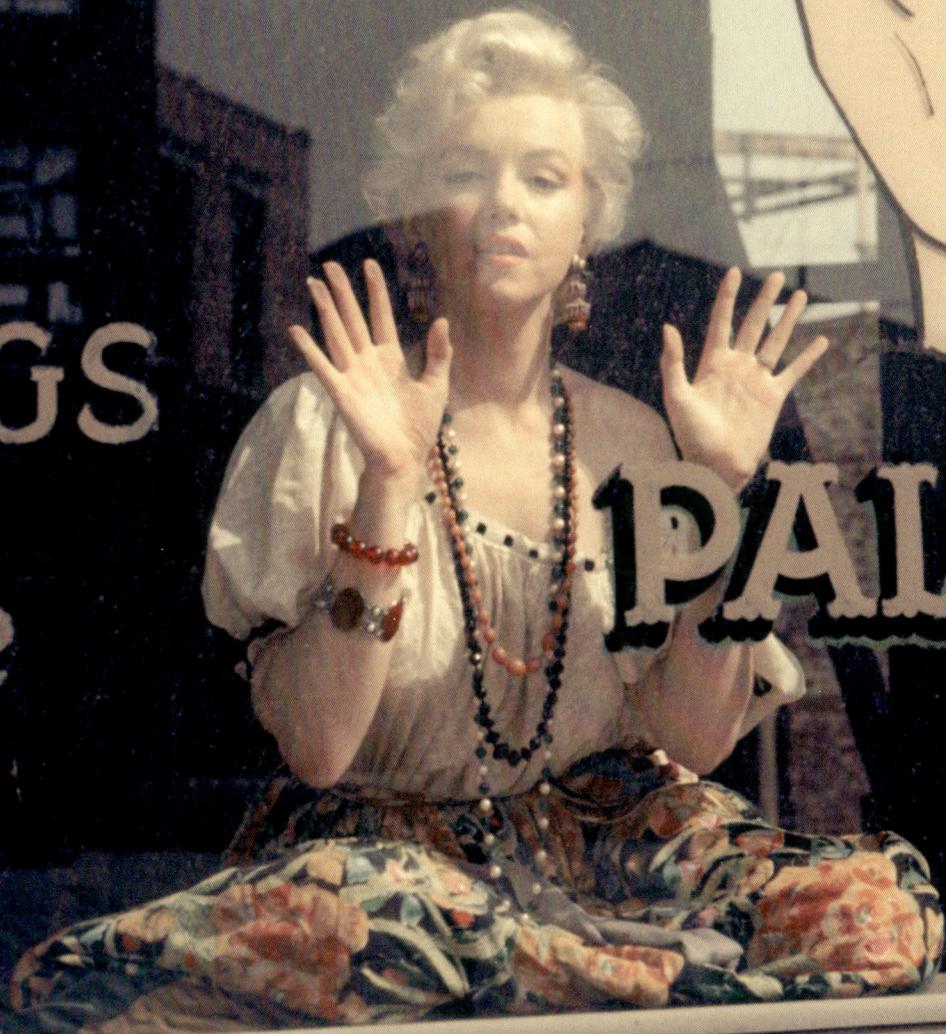

I AM NOT
INTERESTED
IN MONEY.
I JUST WANT
TO BE
WONDERFUL.

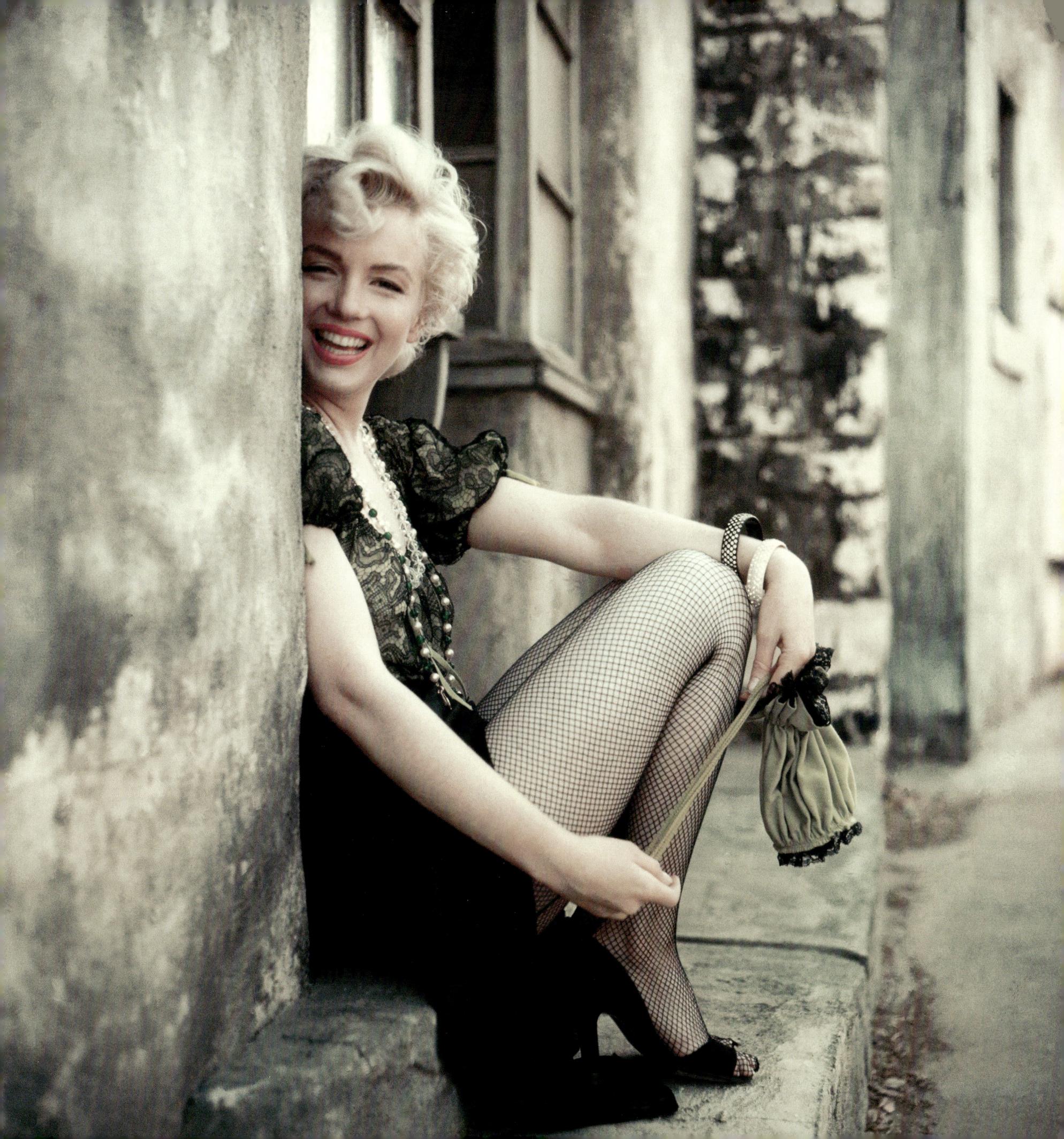

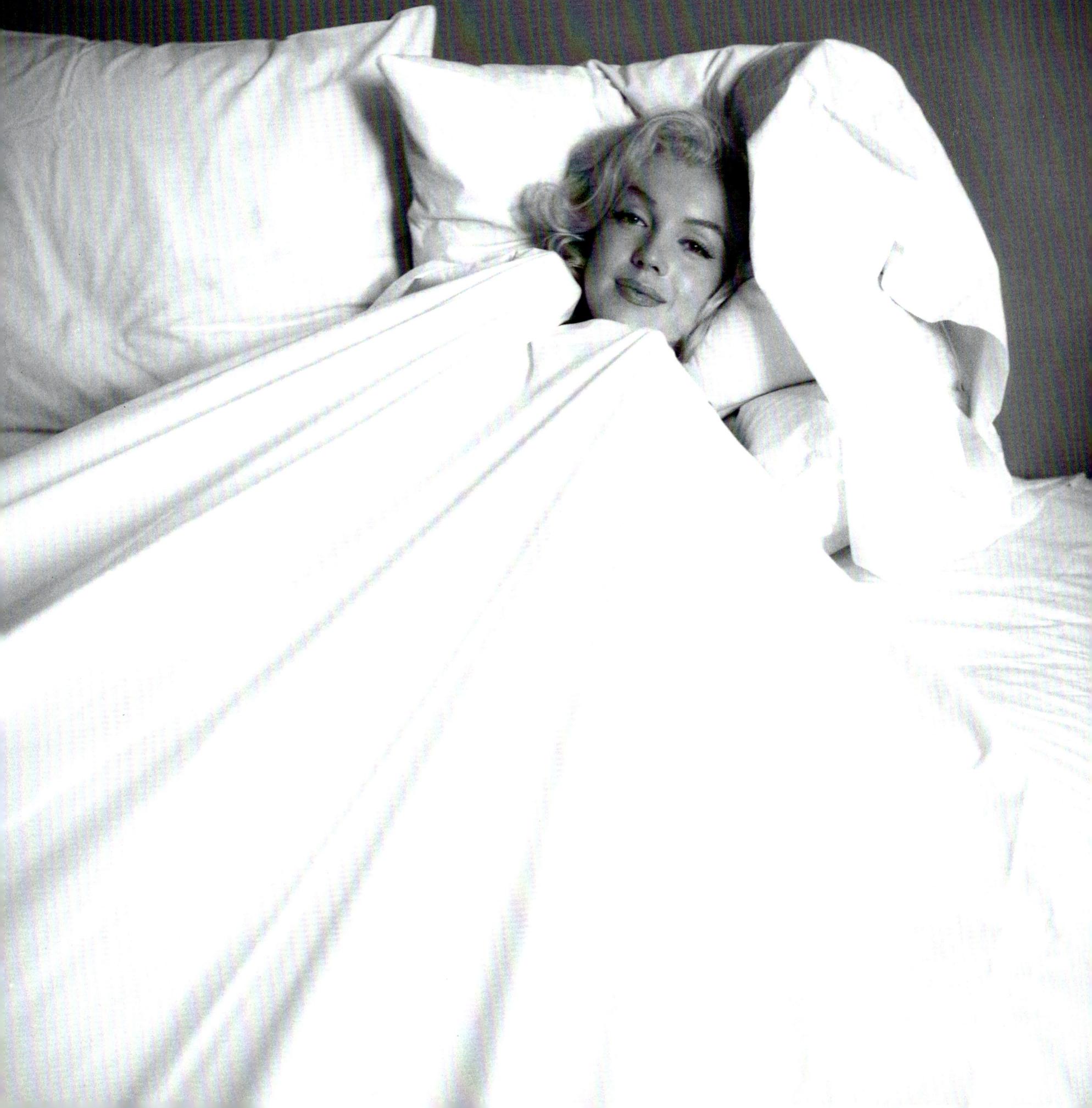

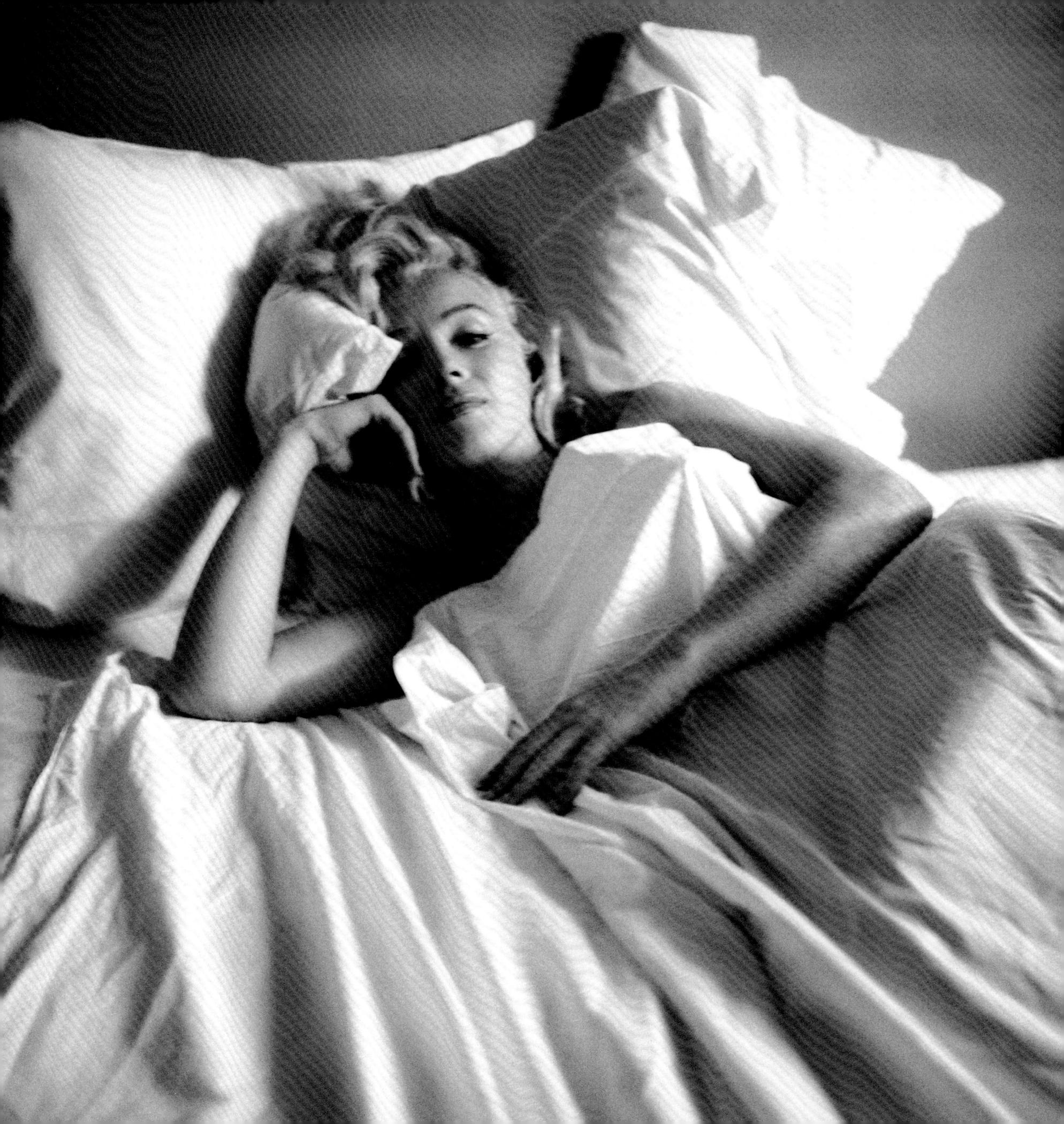

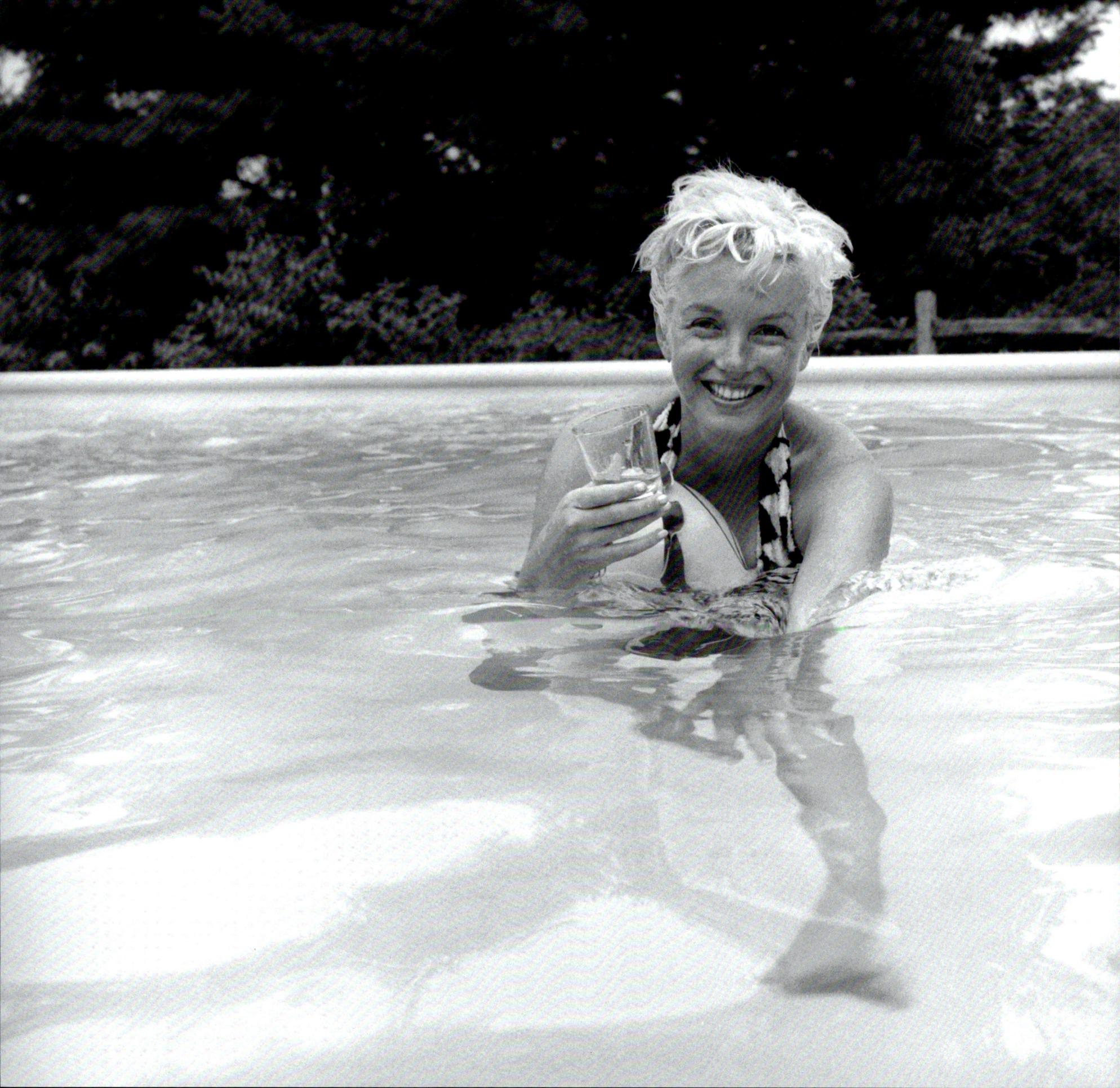

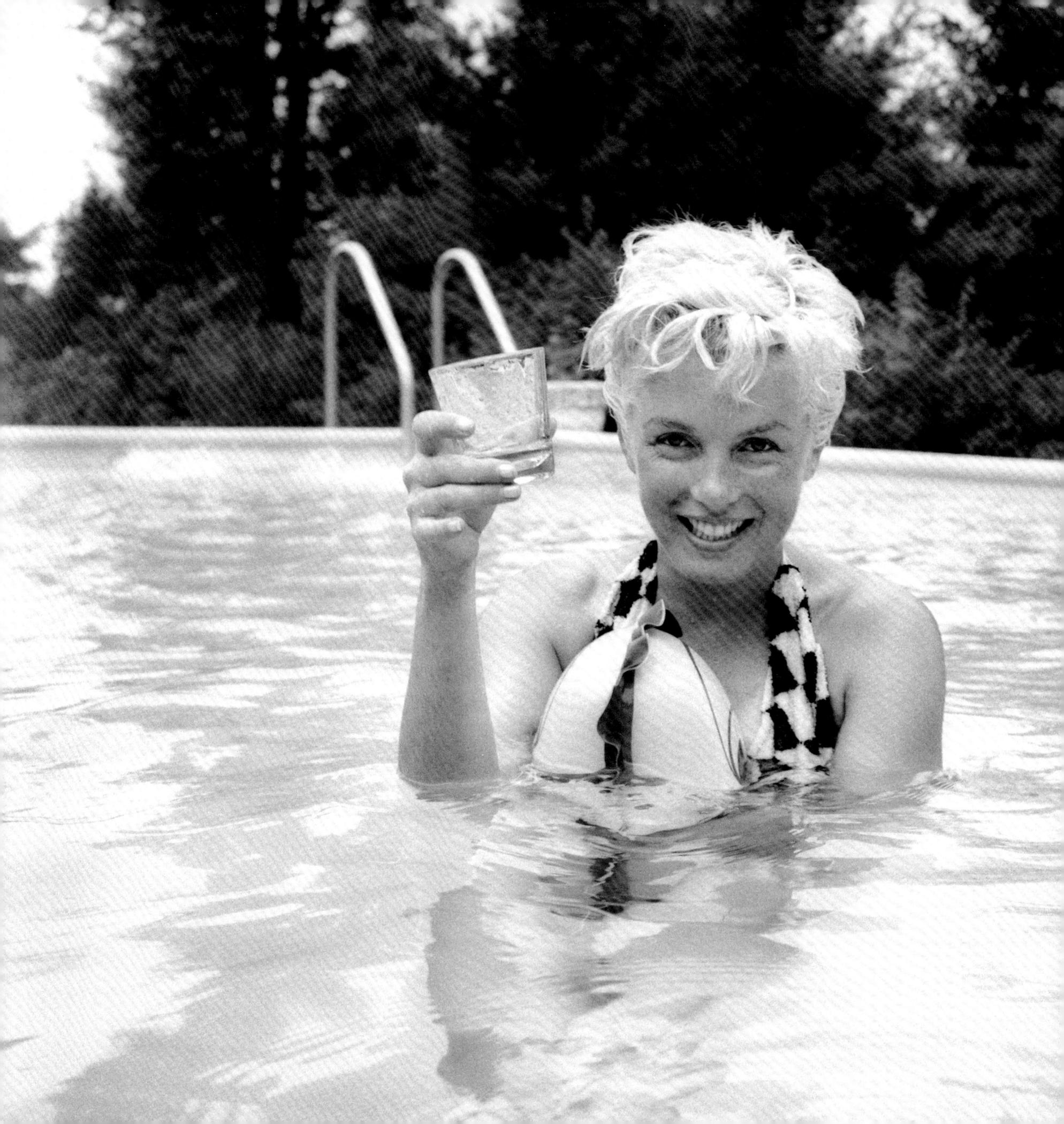

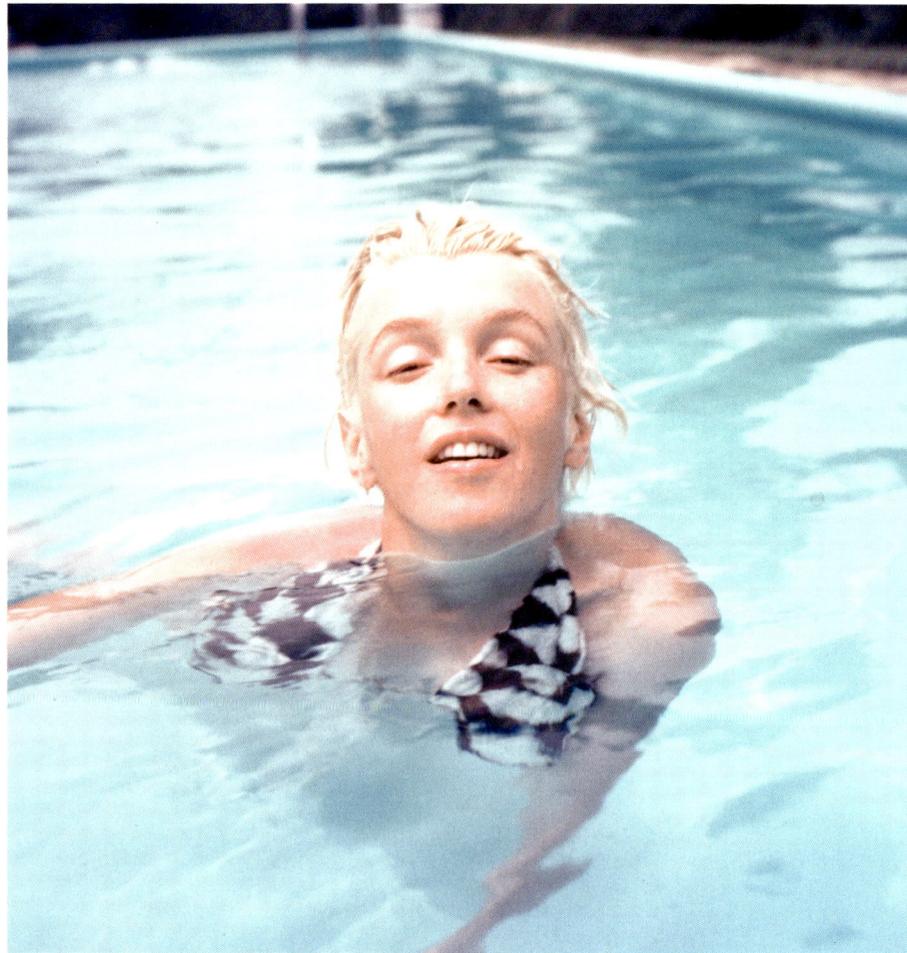

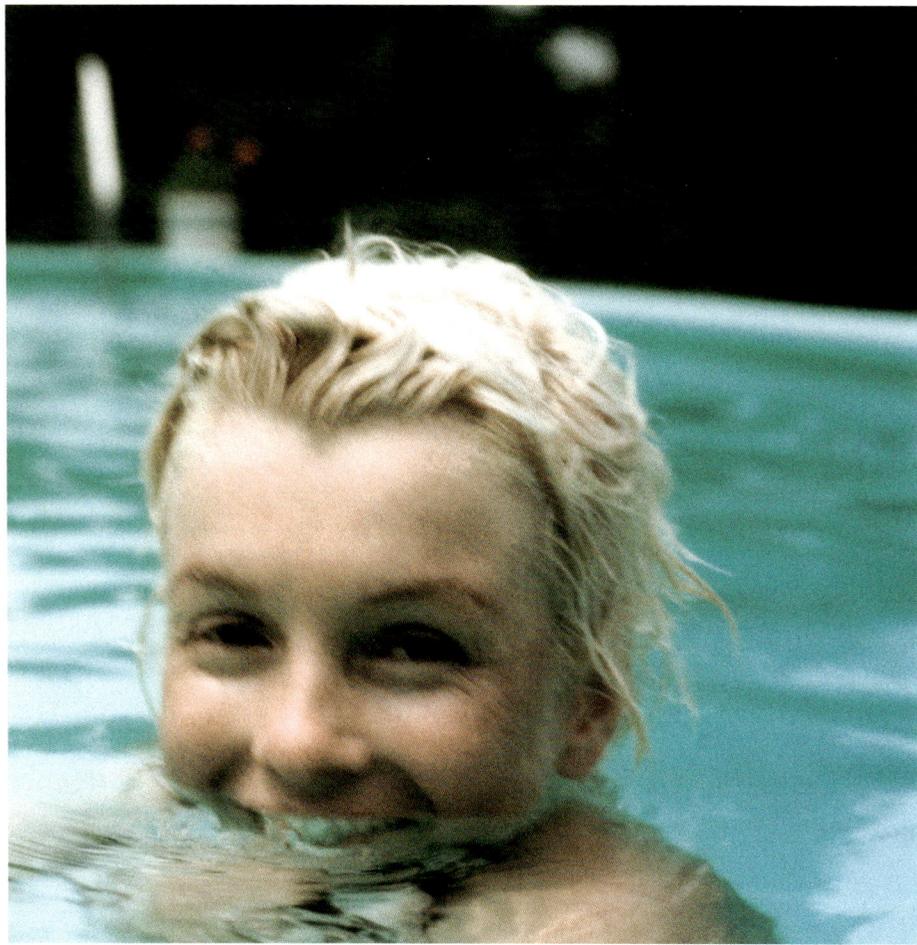

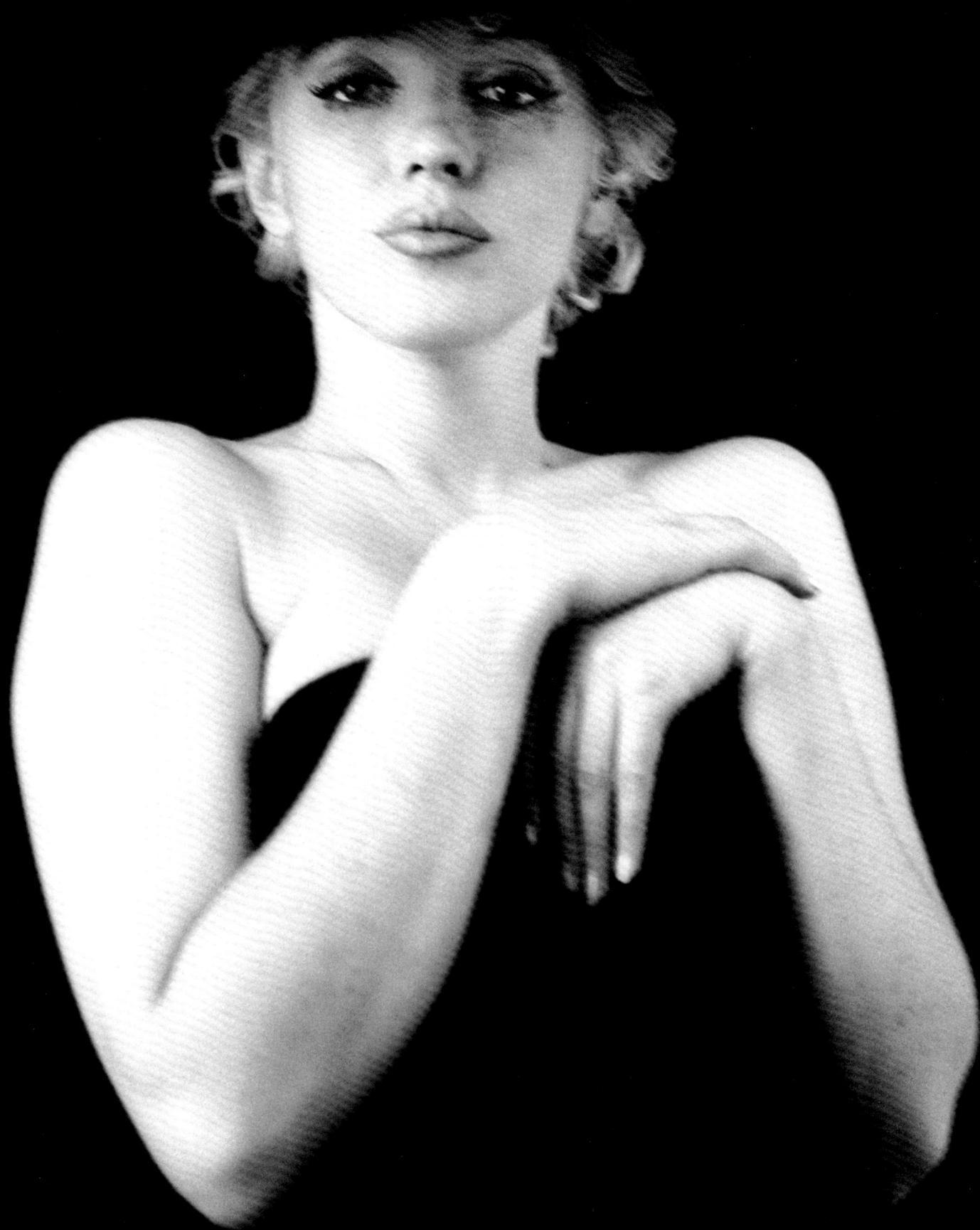

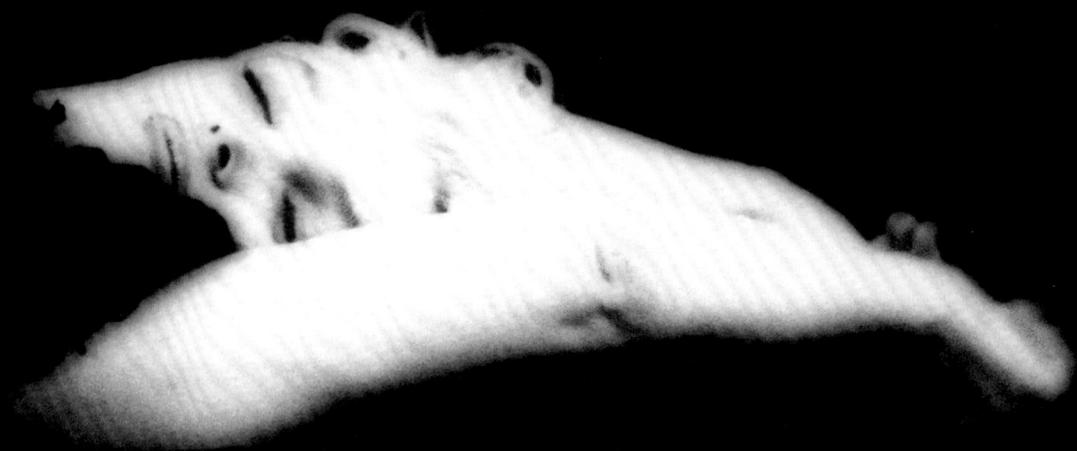

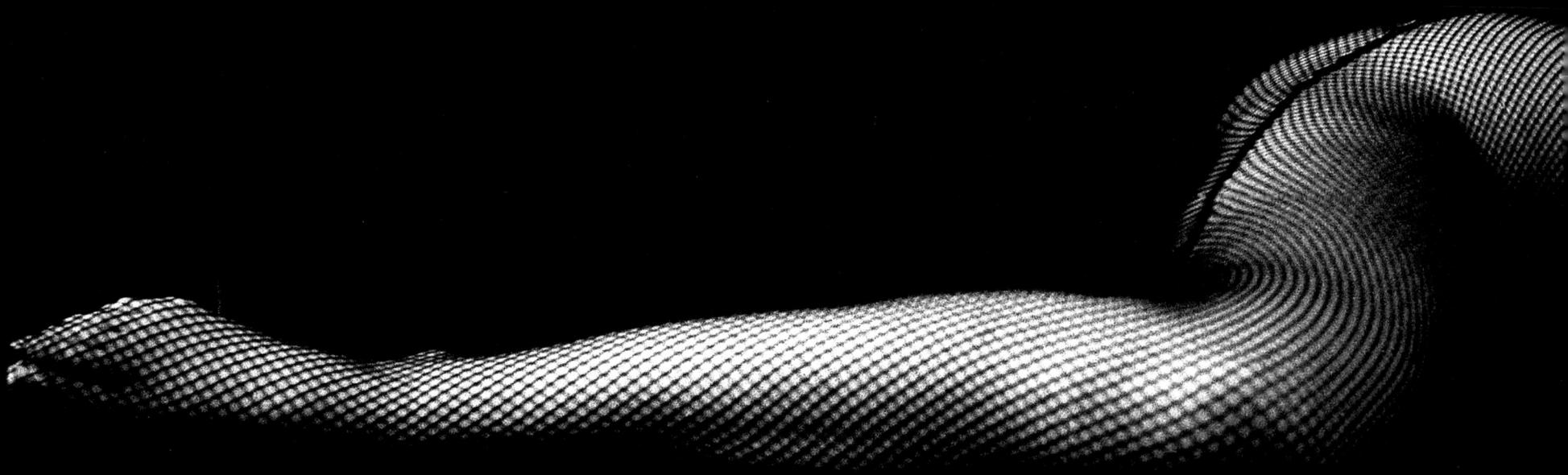

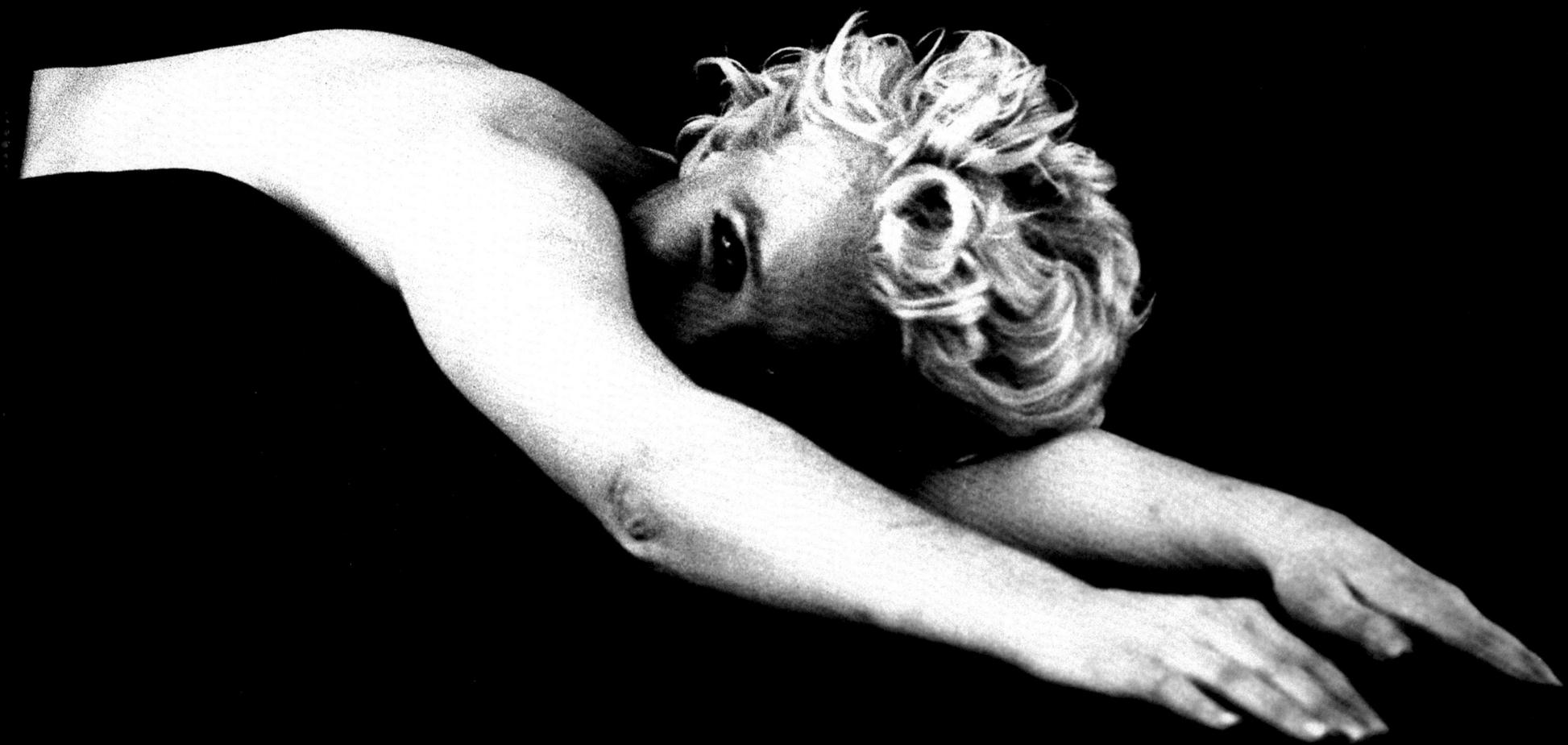

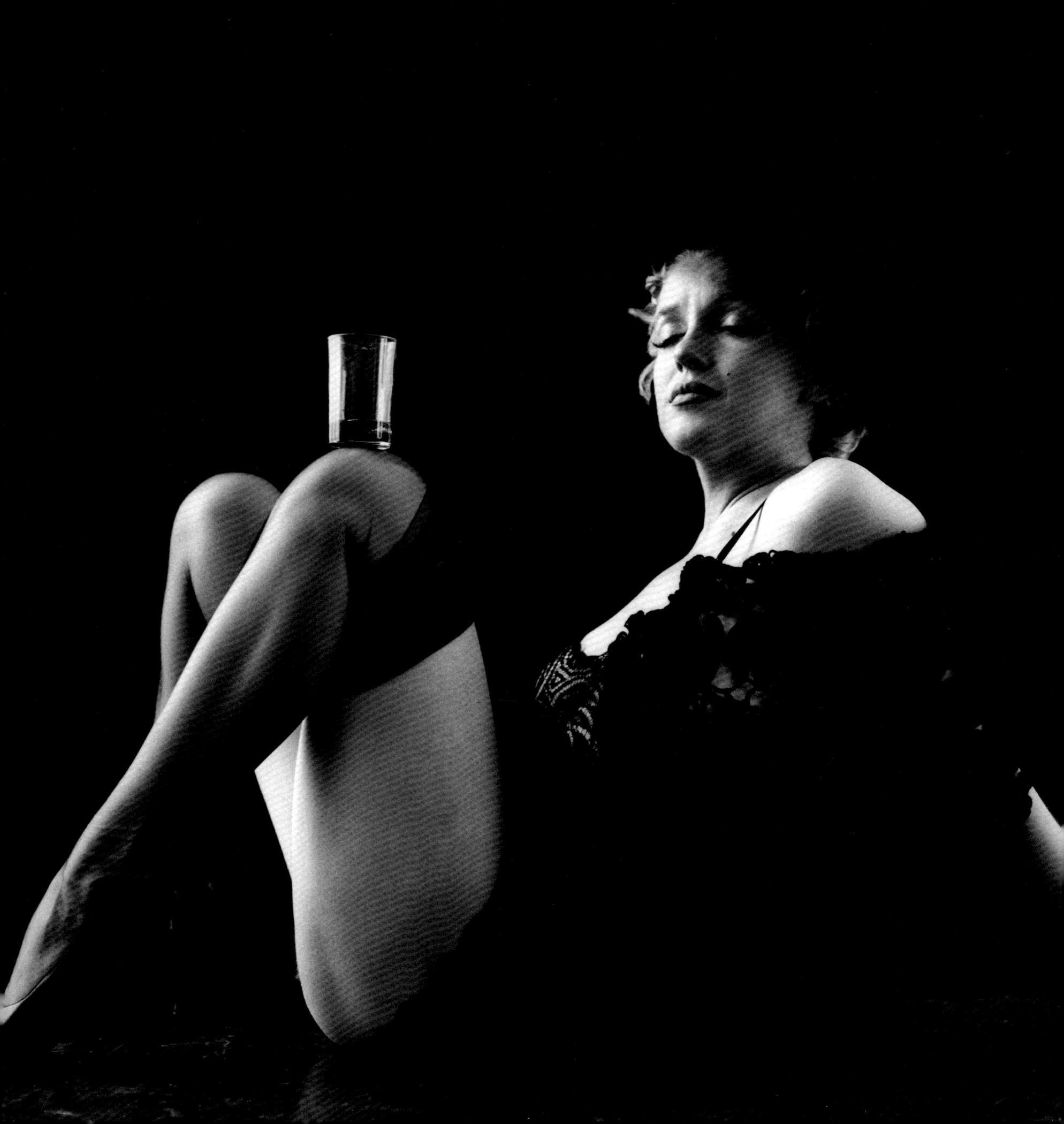

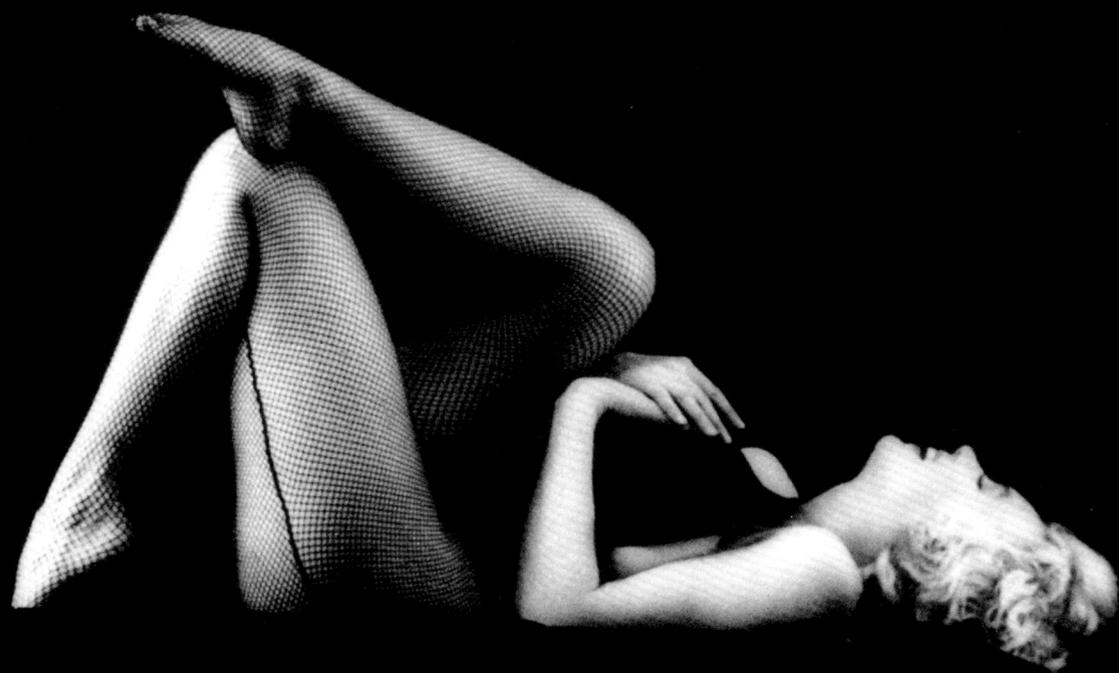

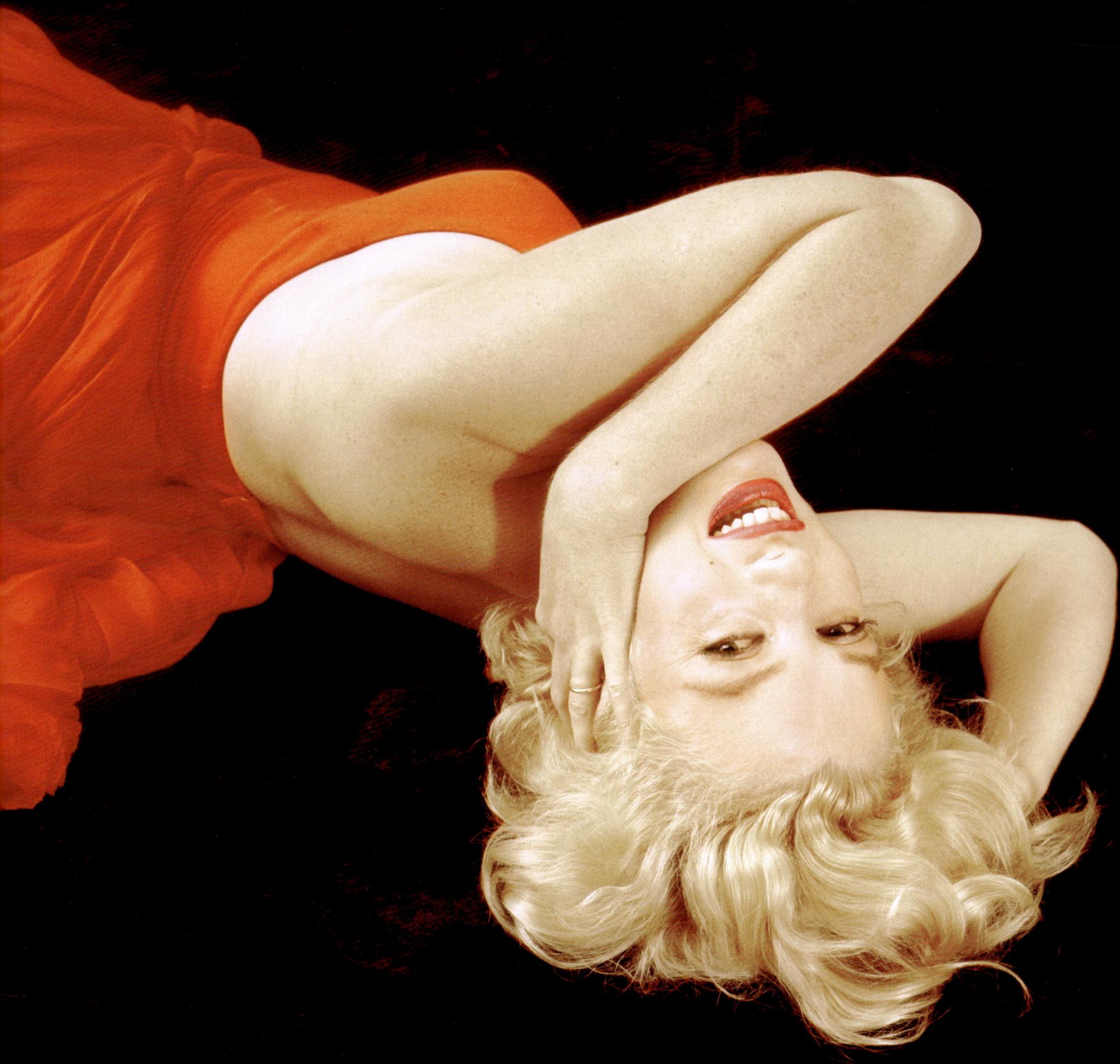

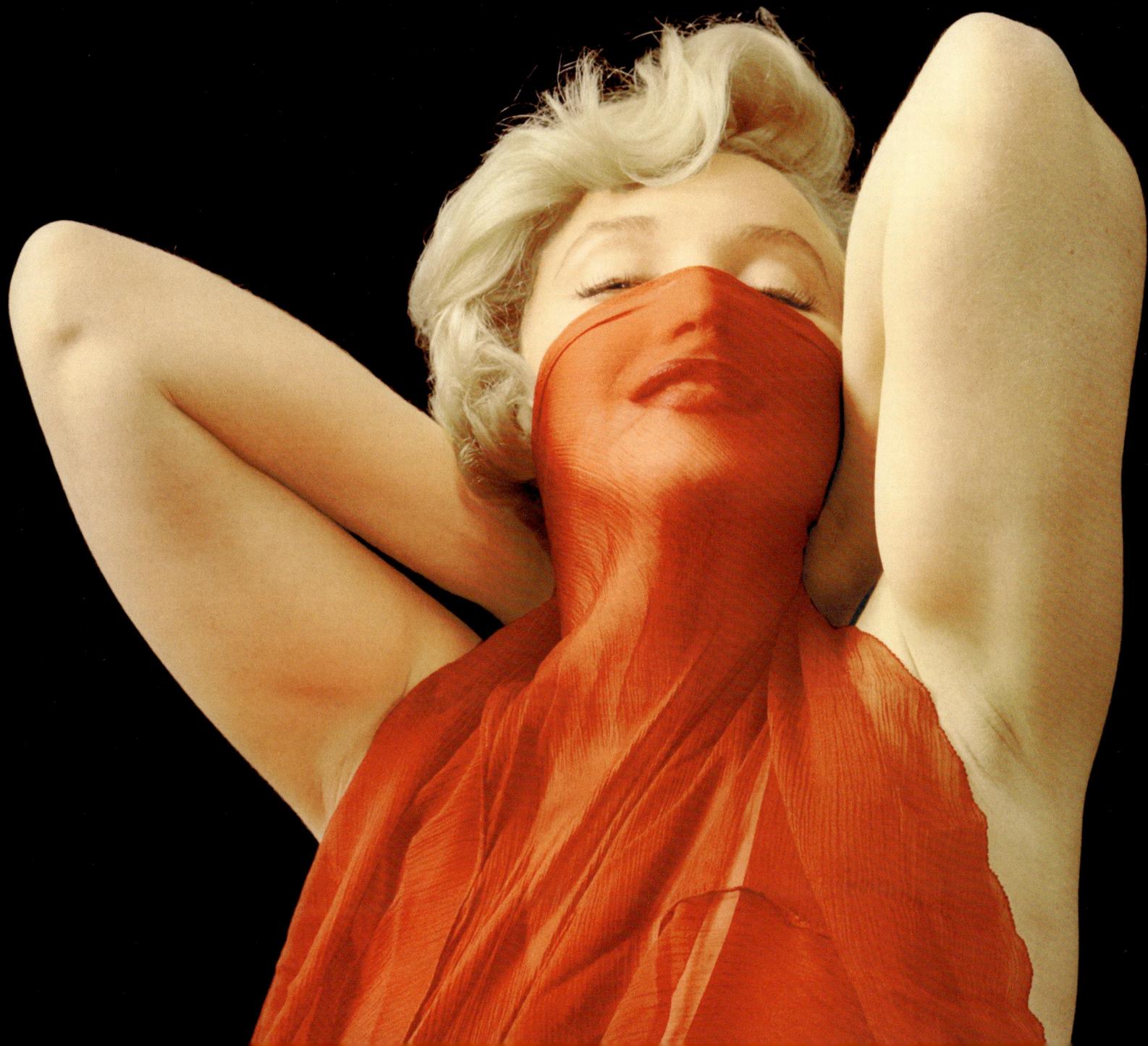

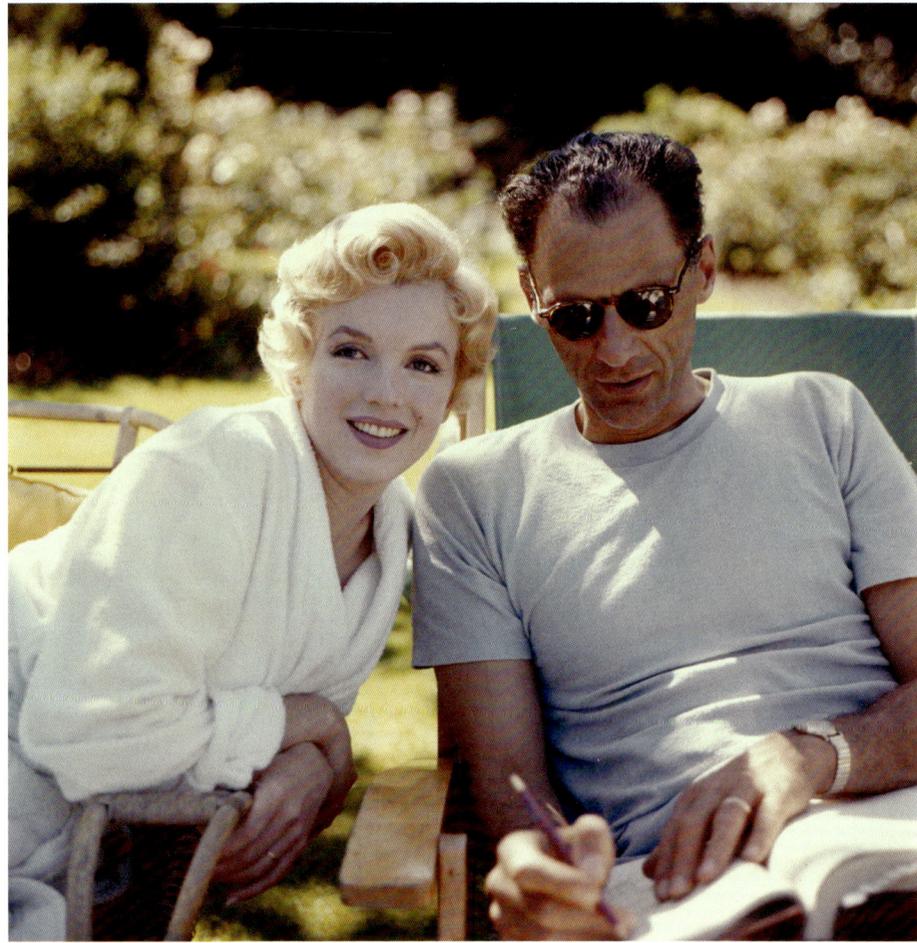

HE (ARTHUR MILLER)
WOULDN'T HAVE
MARRIED ME
IF I HAD BEEN
NOTHING
BUT A DUMB
BLONDE.

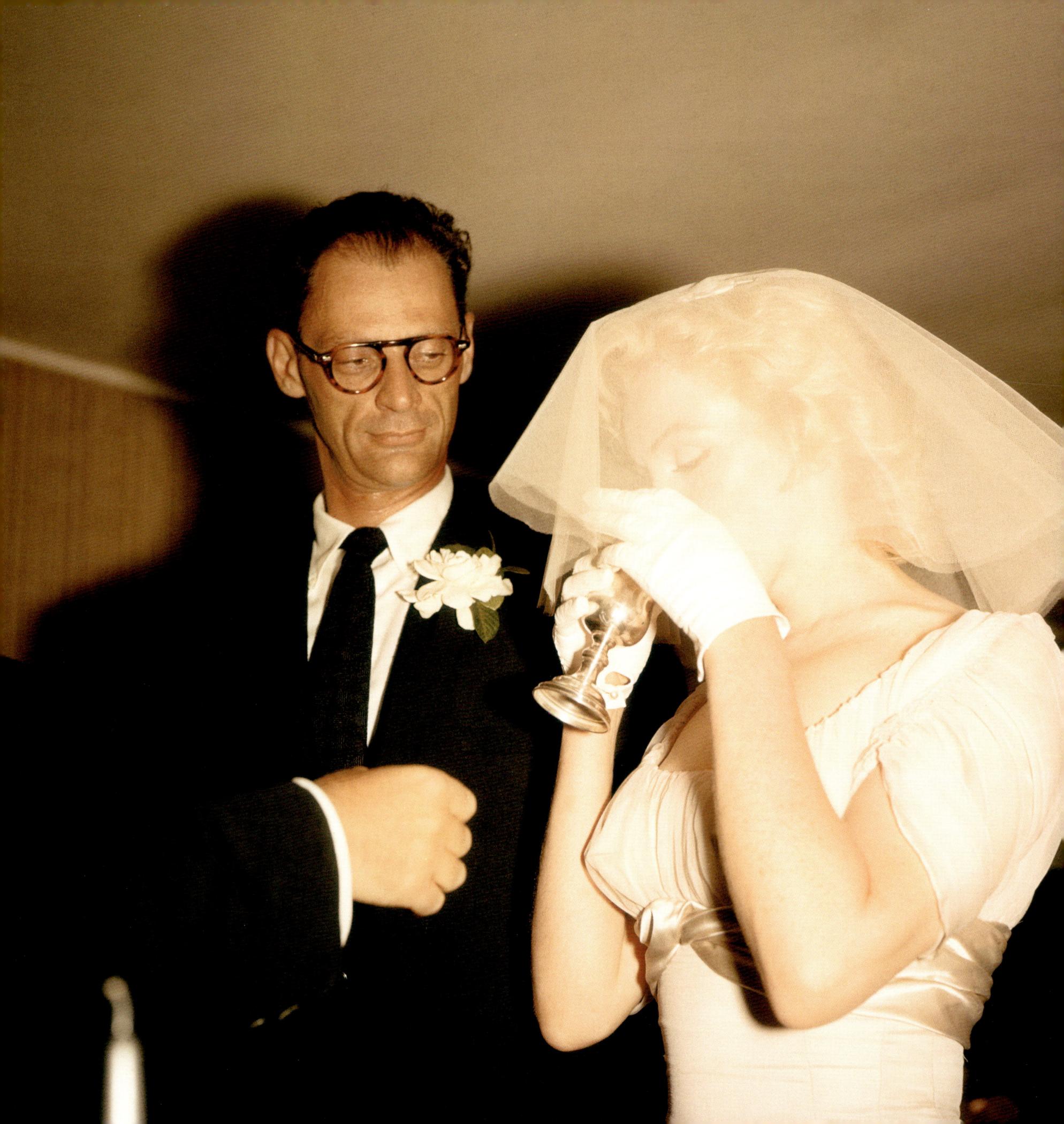

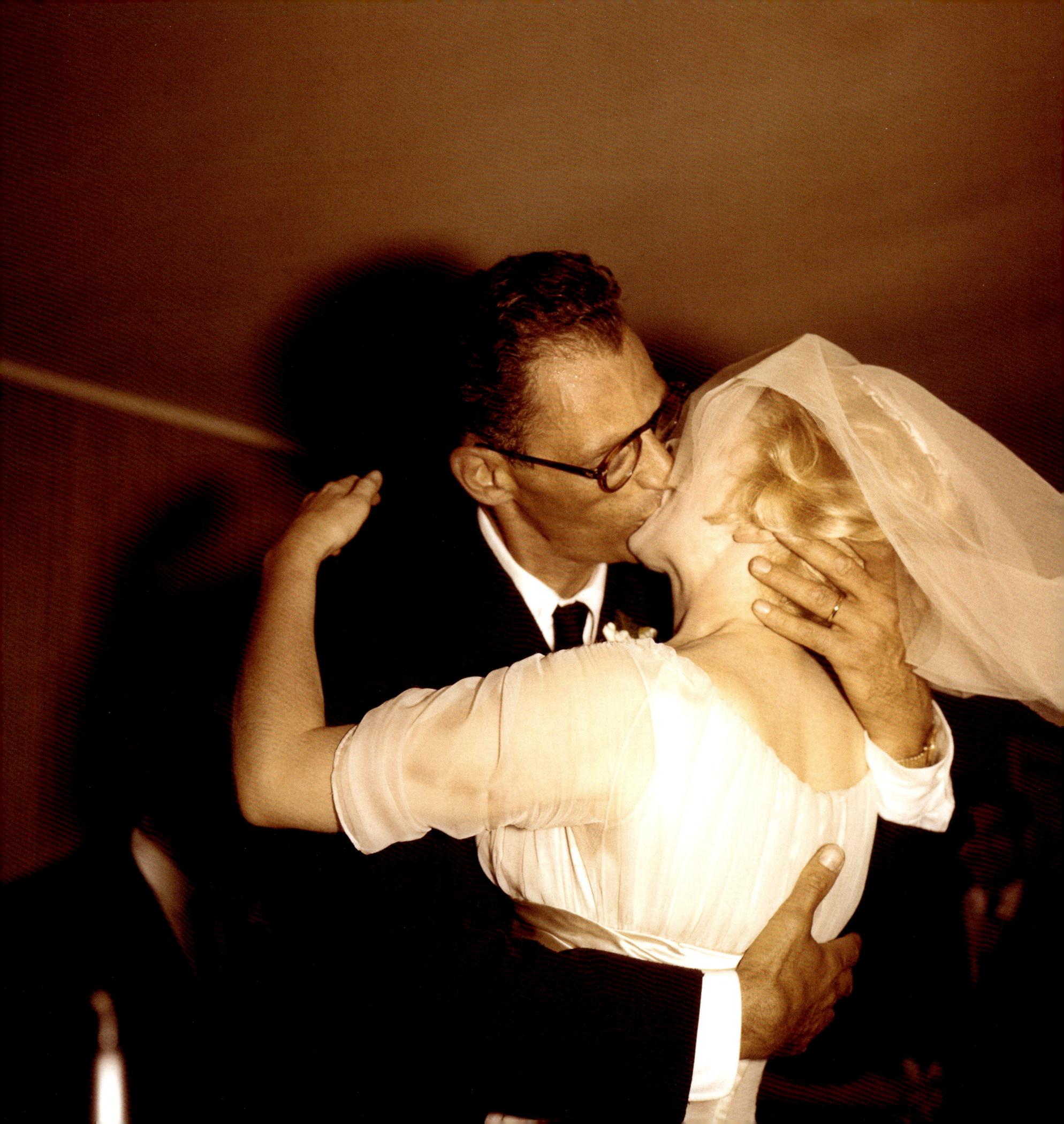

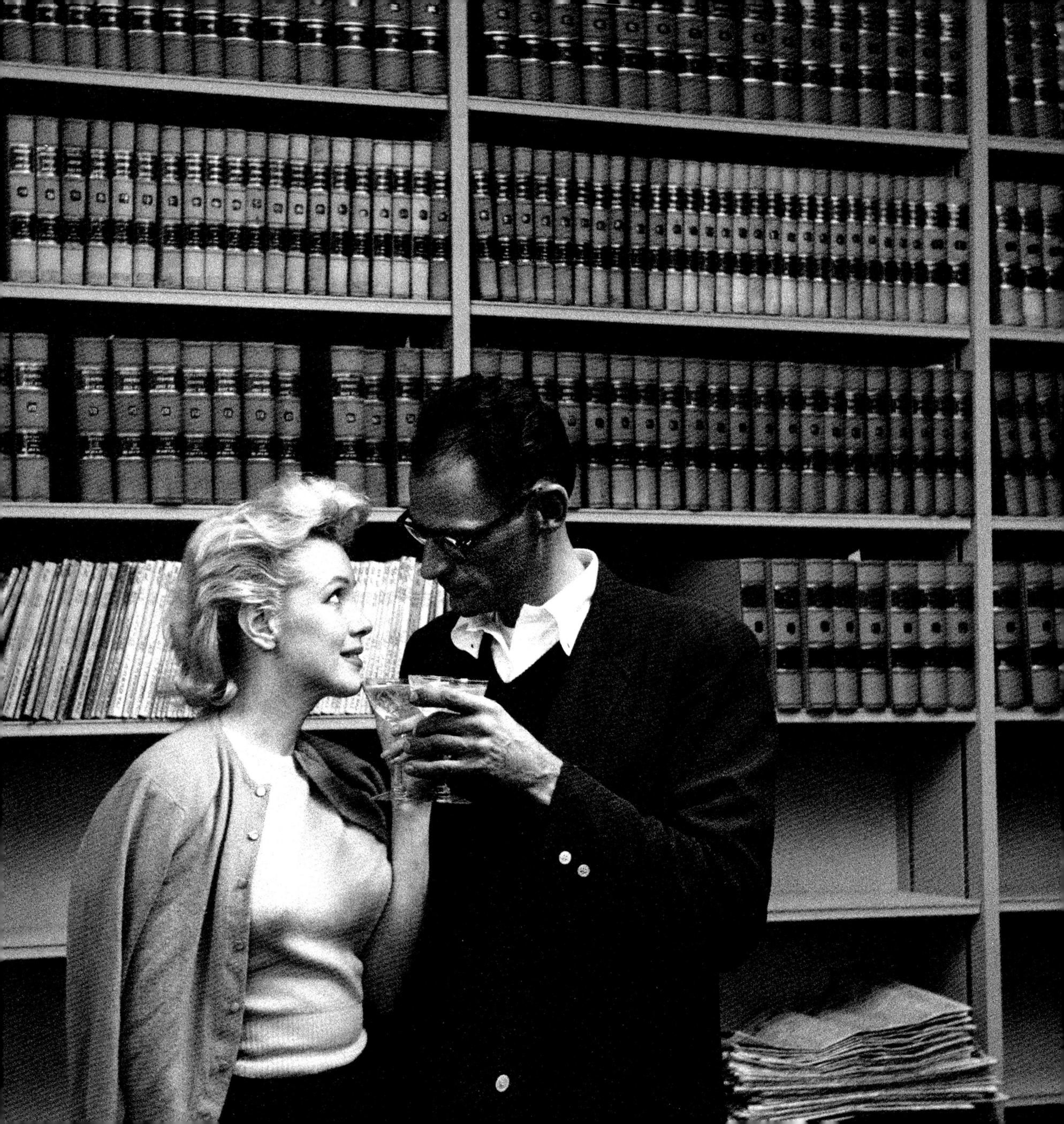

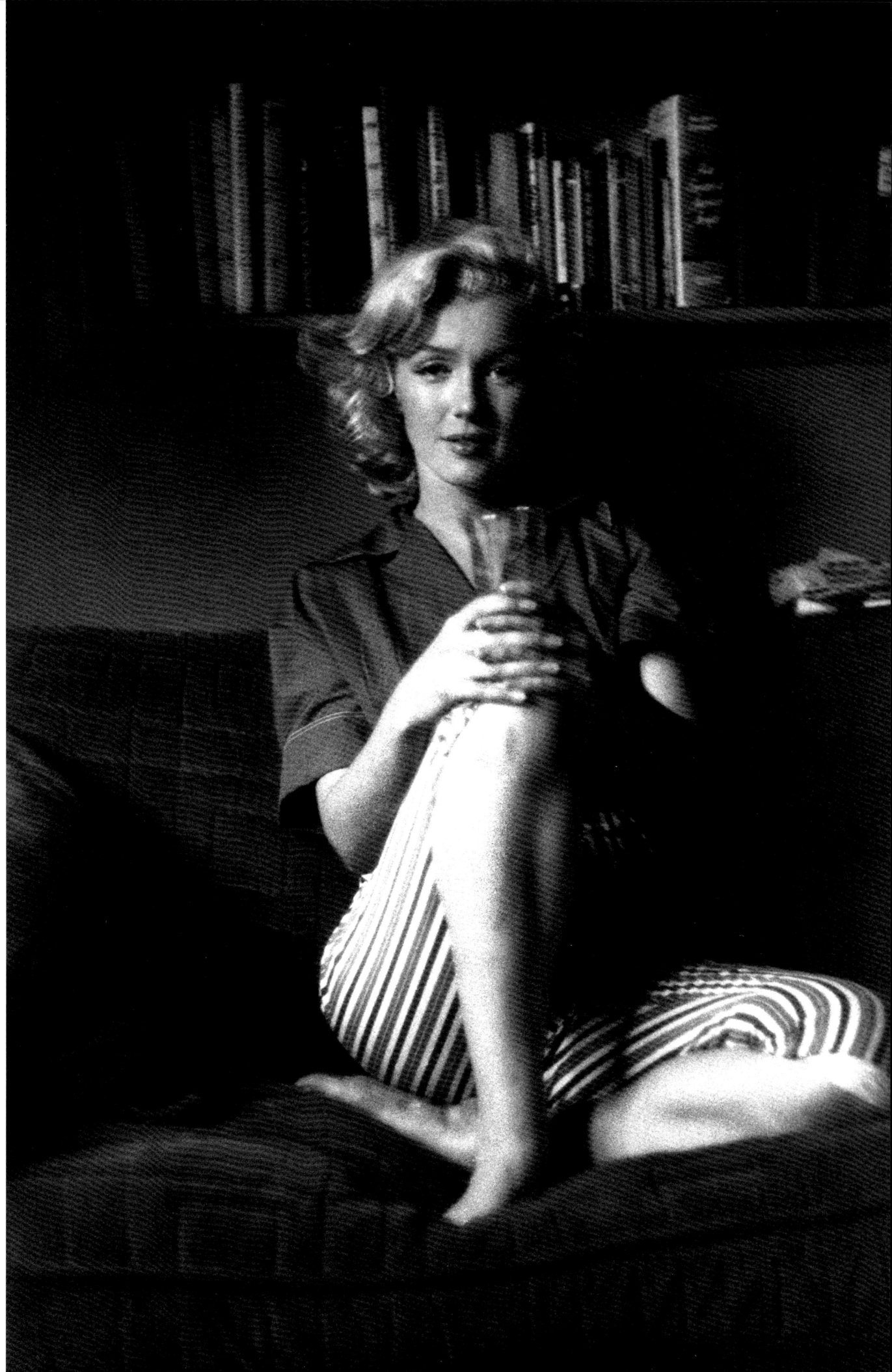

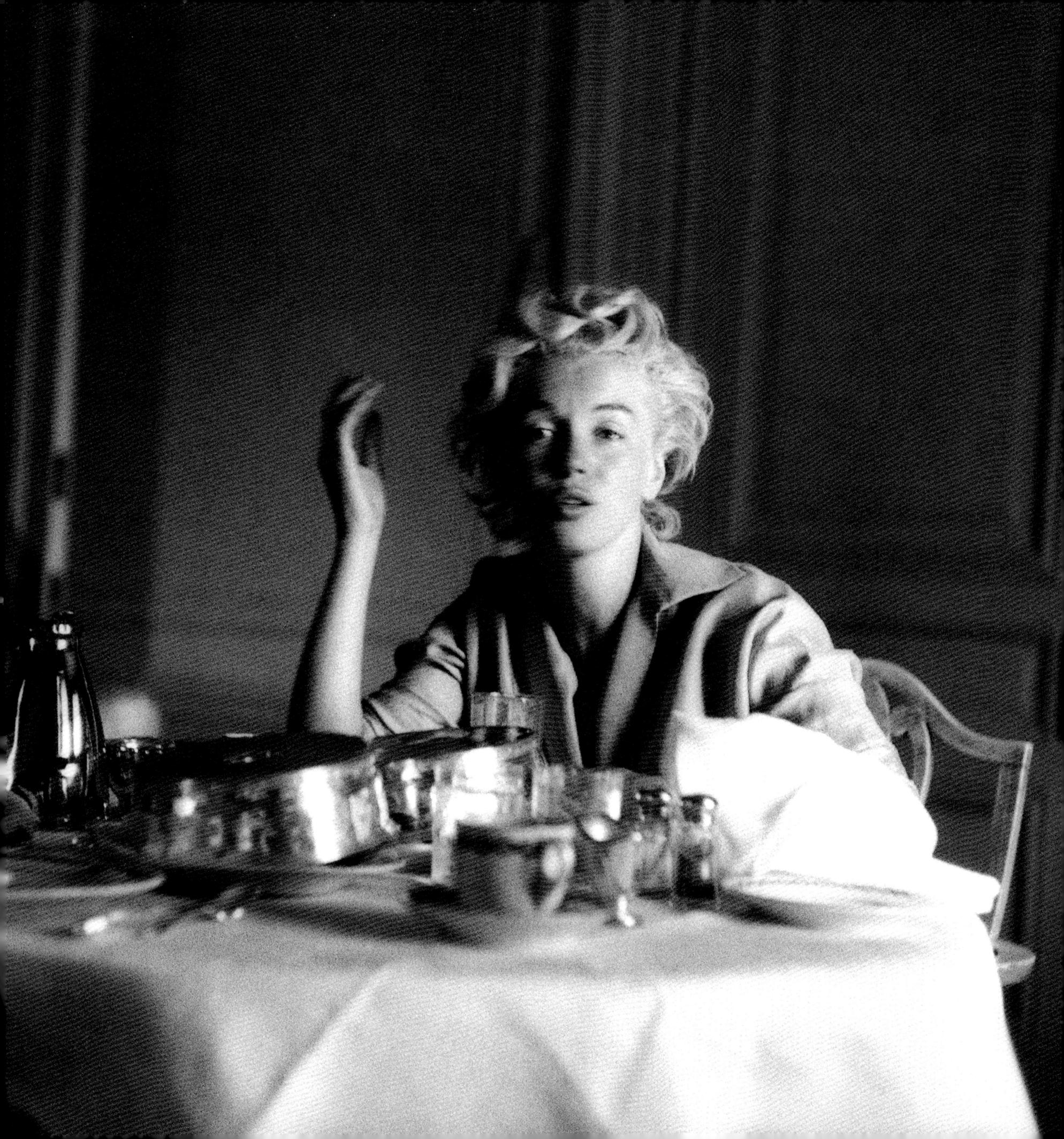

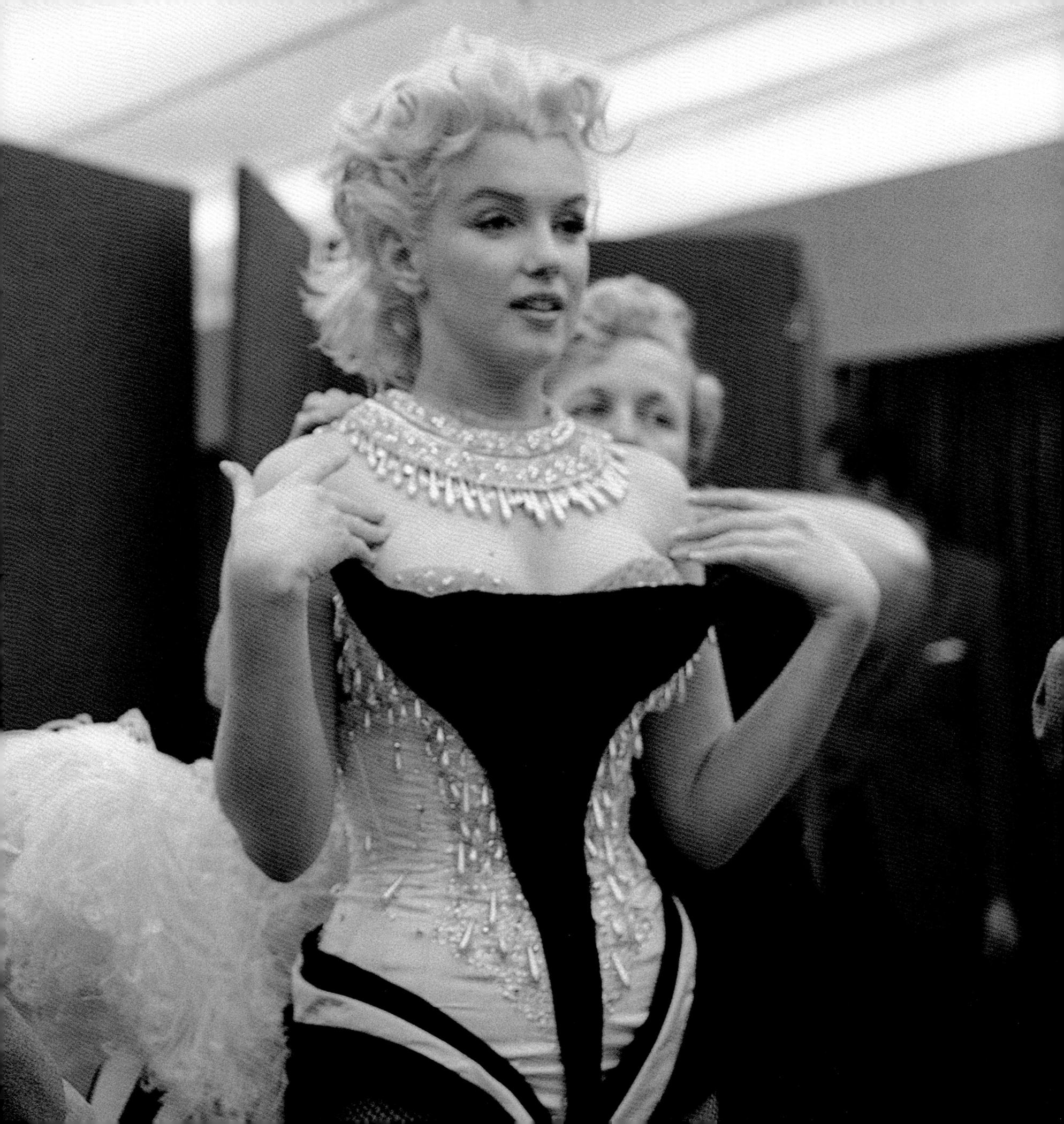

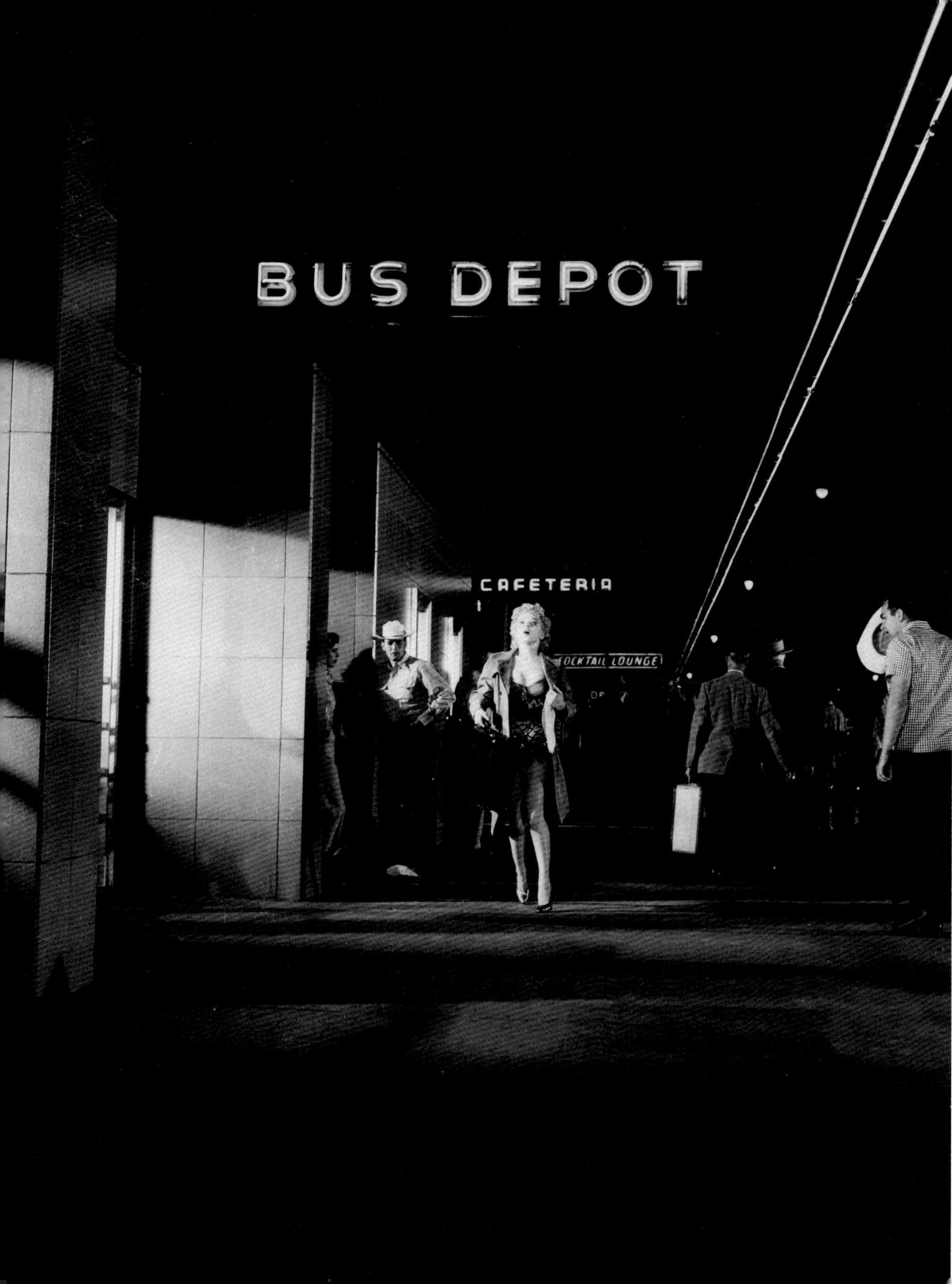

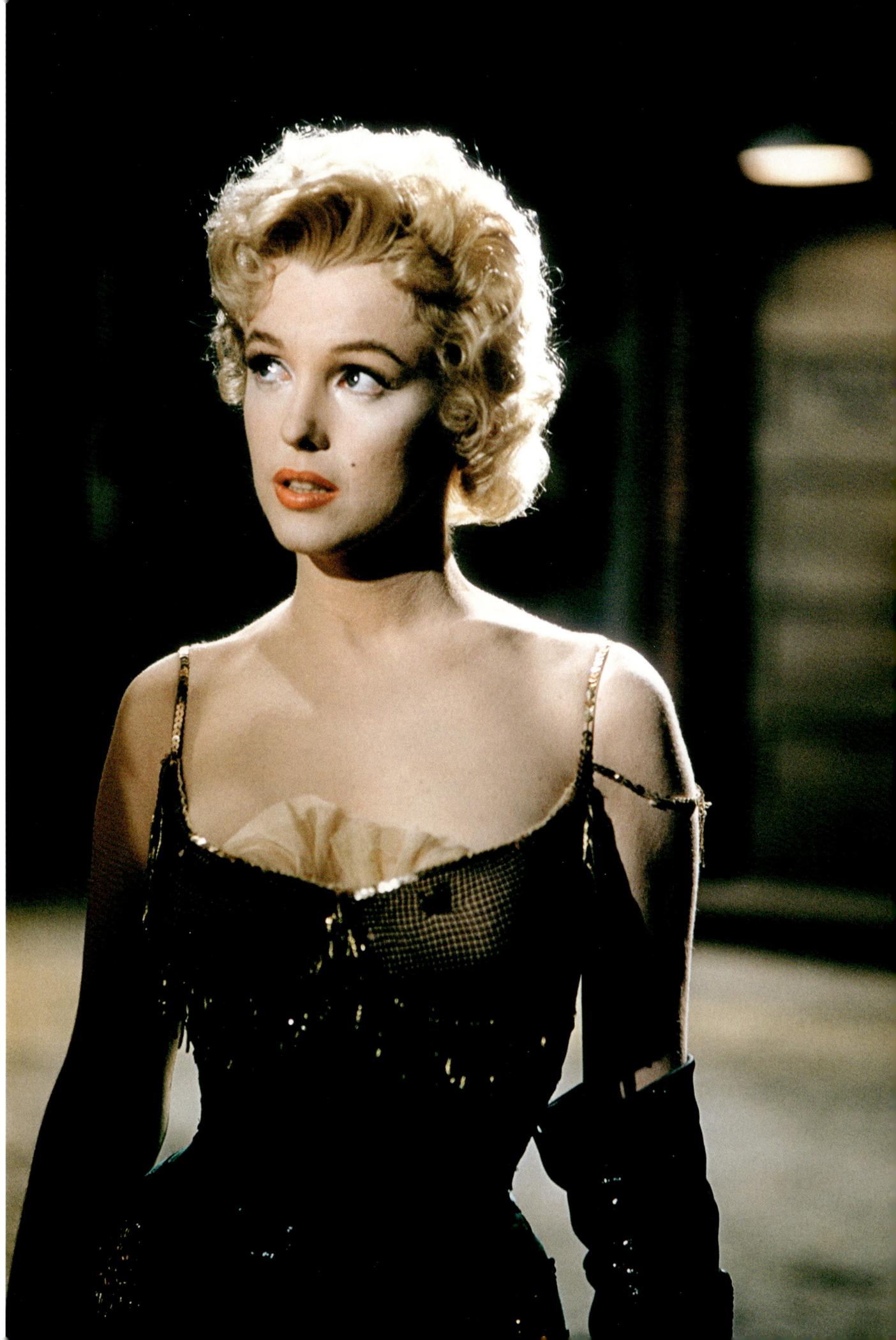

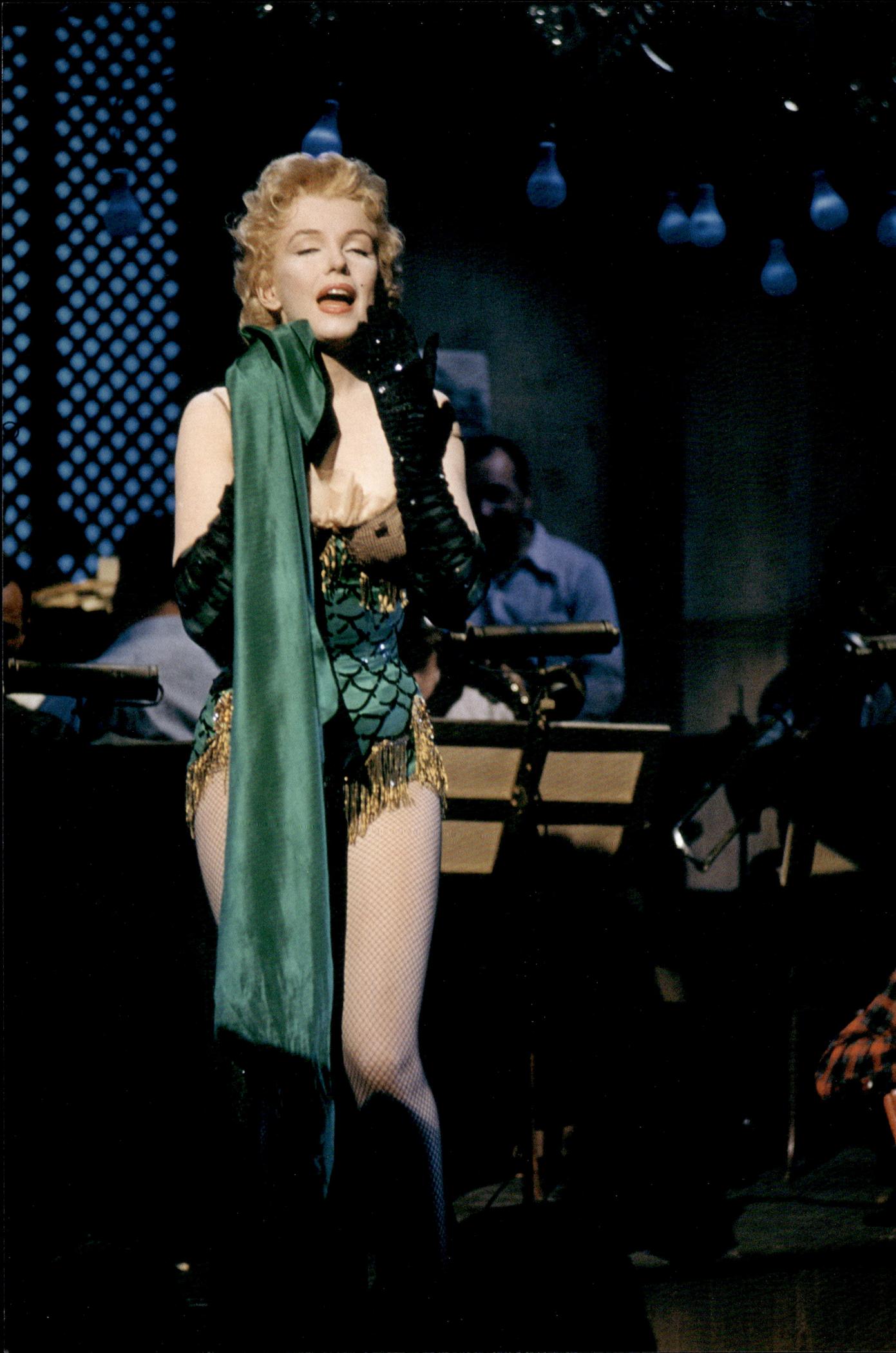

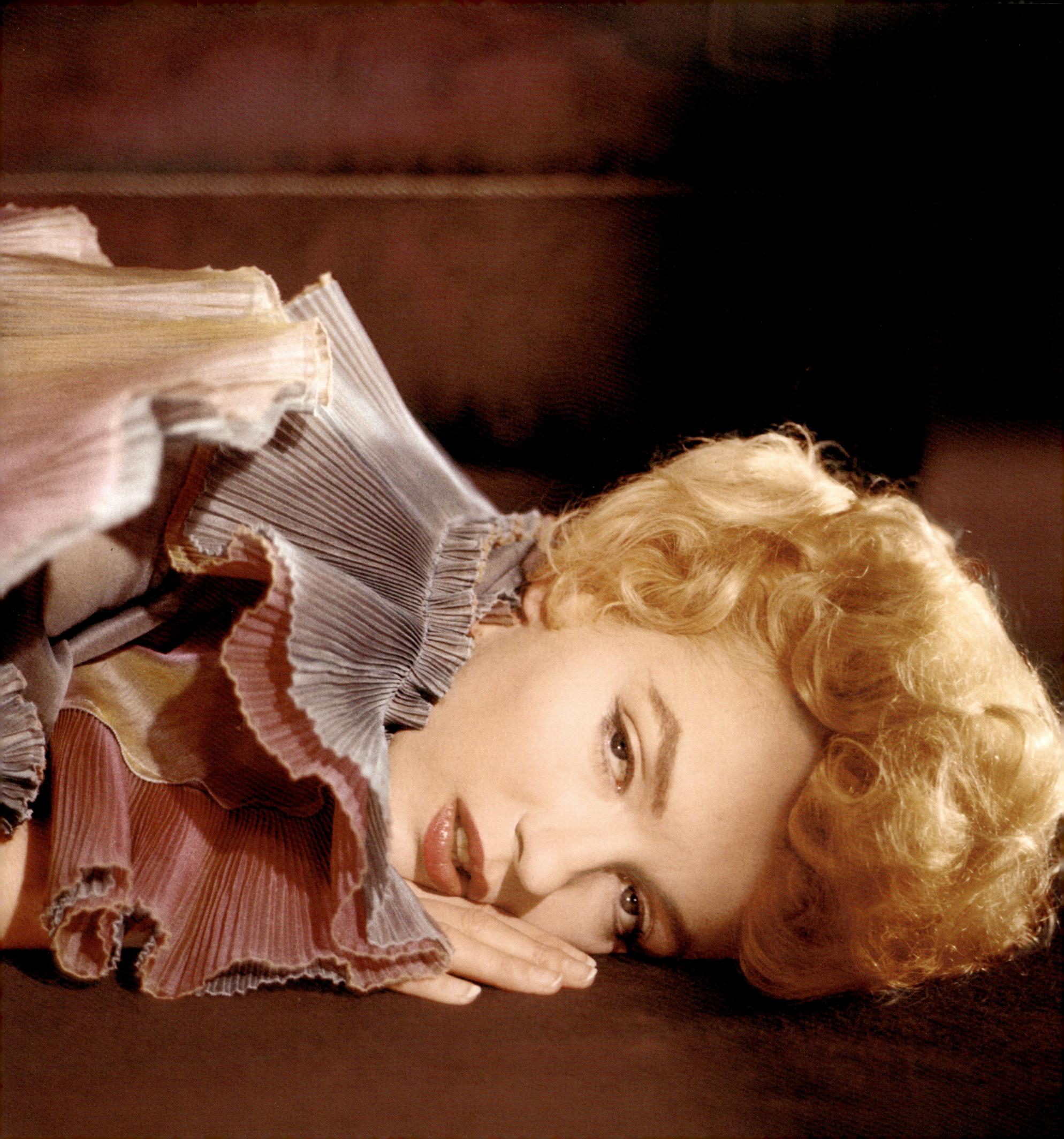

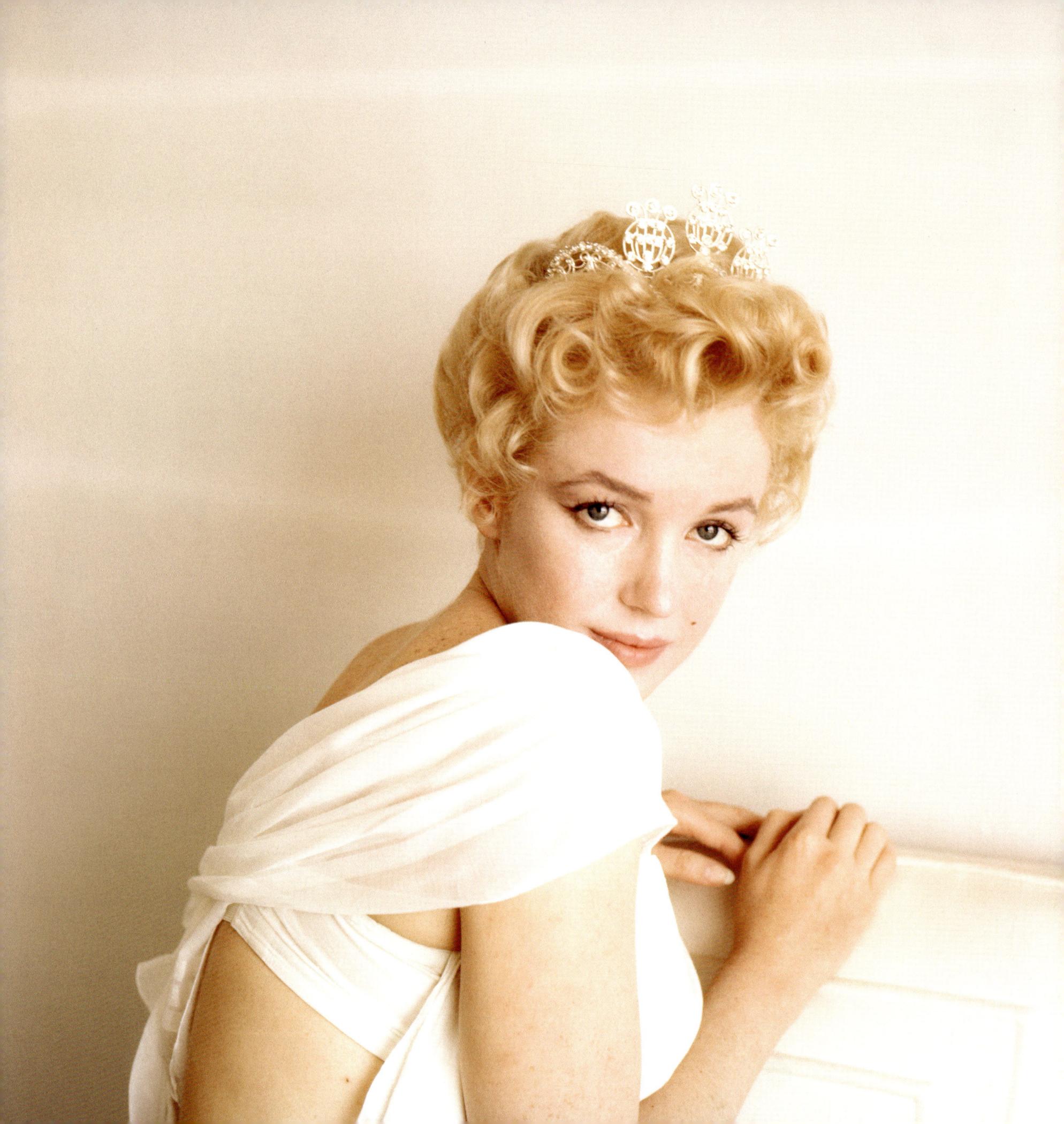

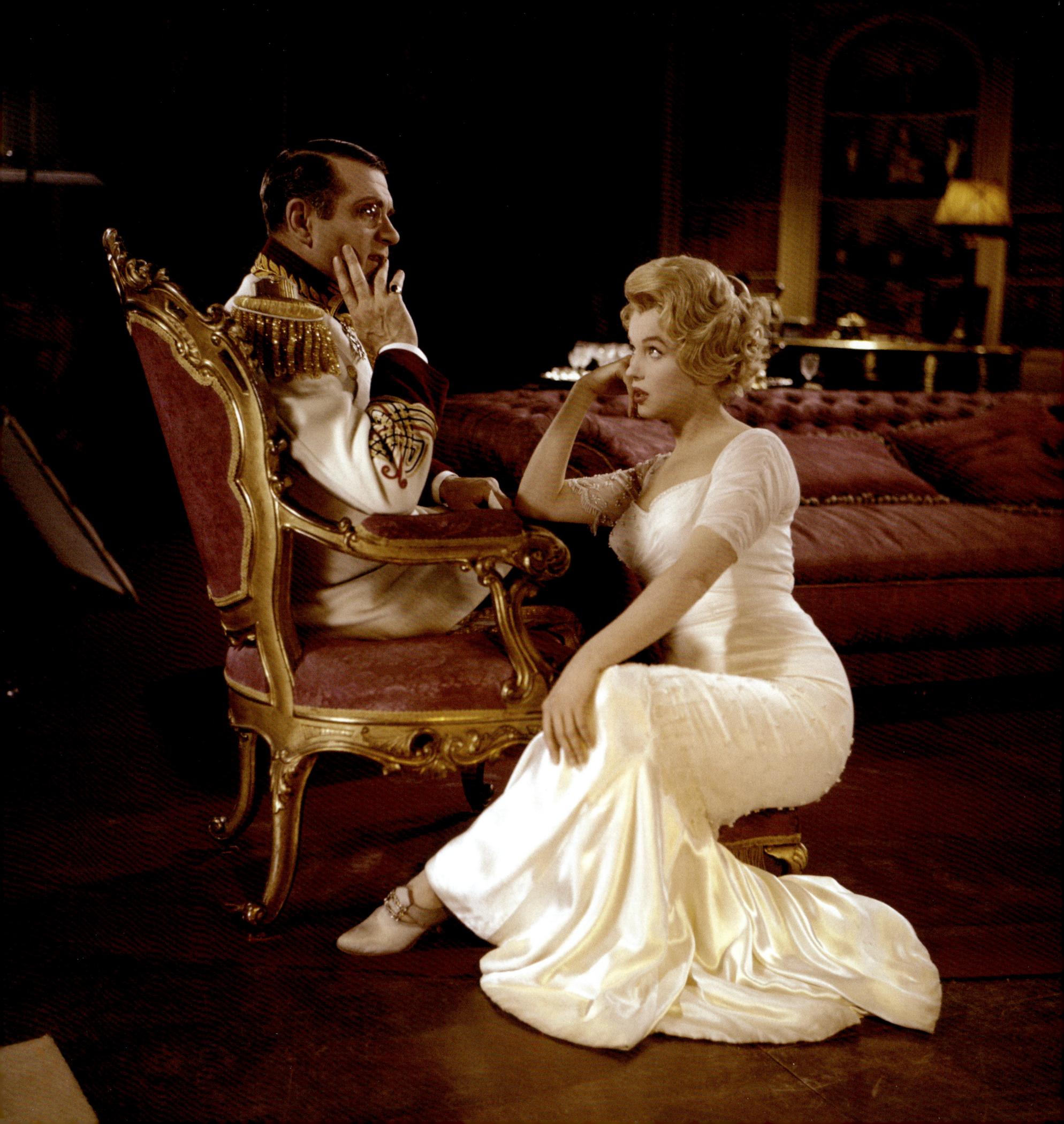

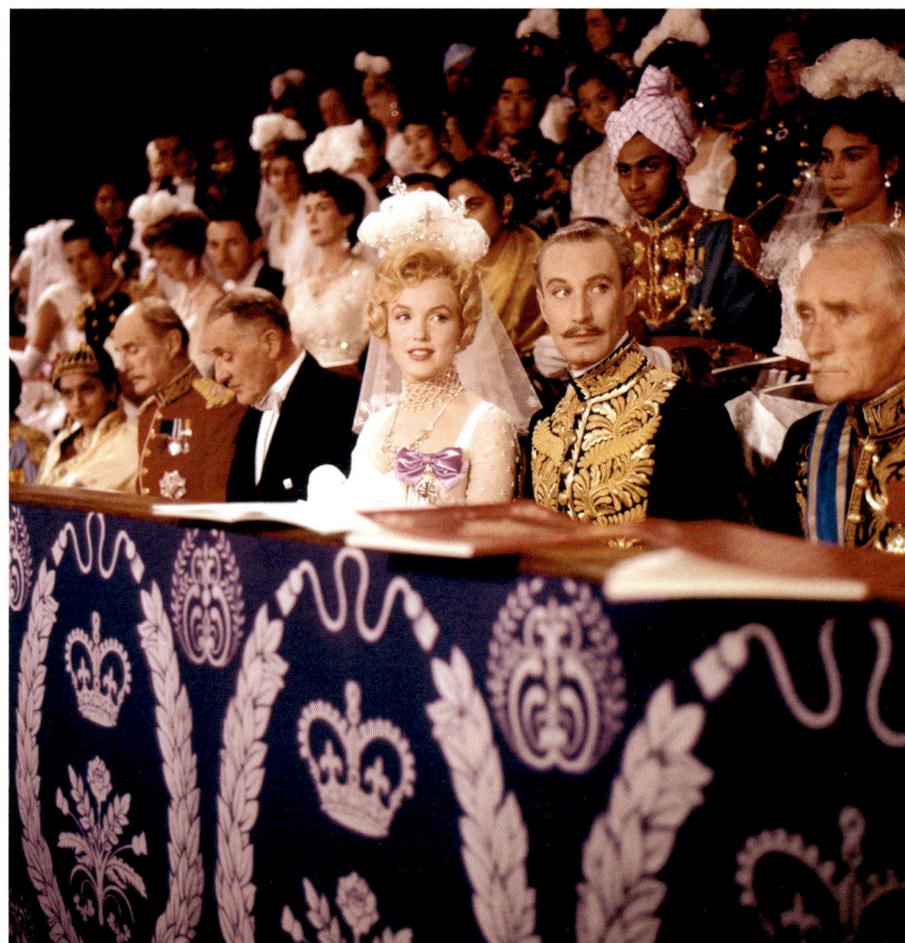

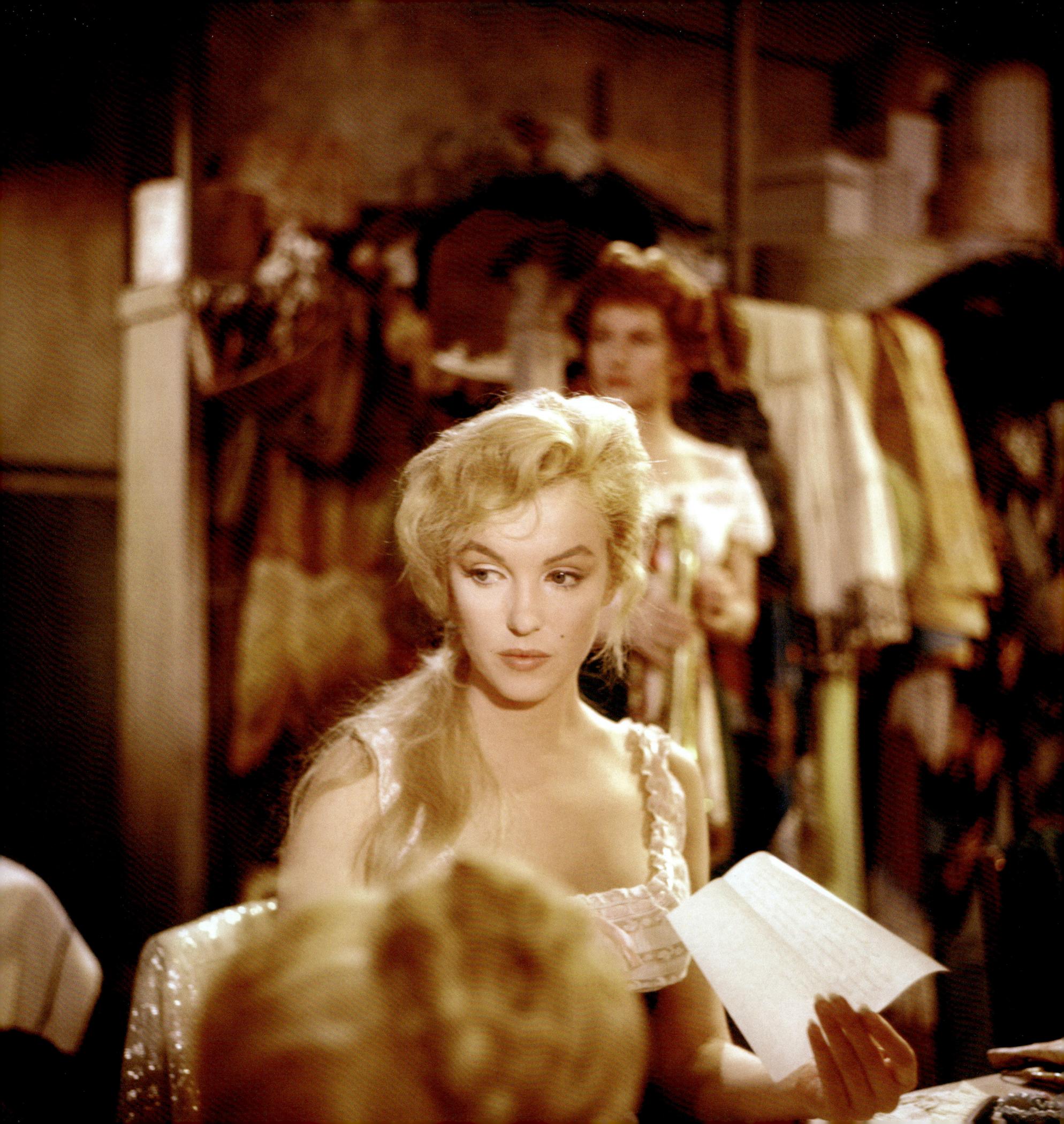

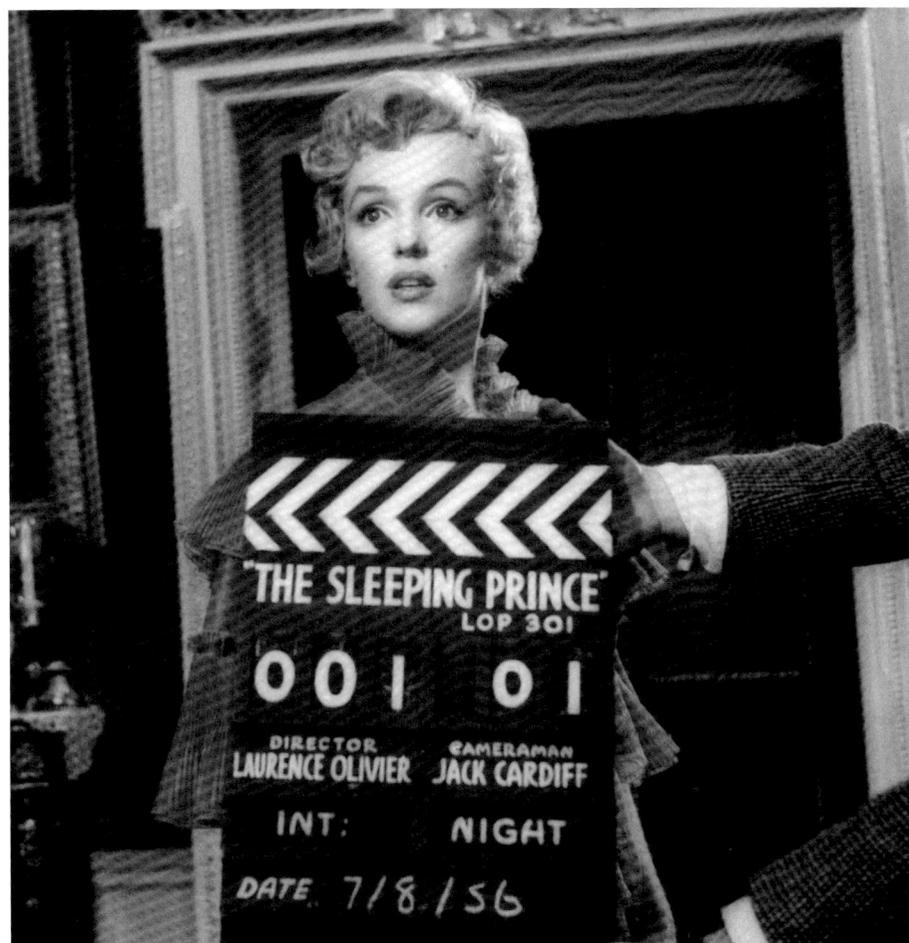

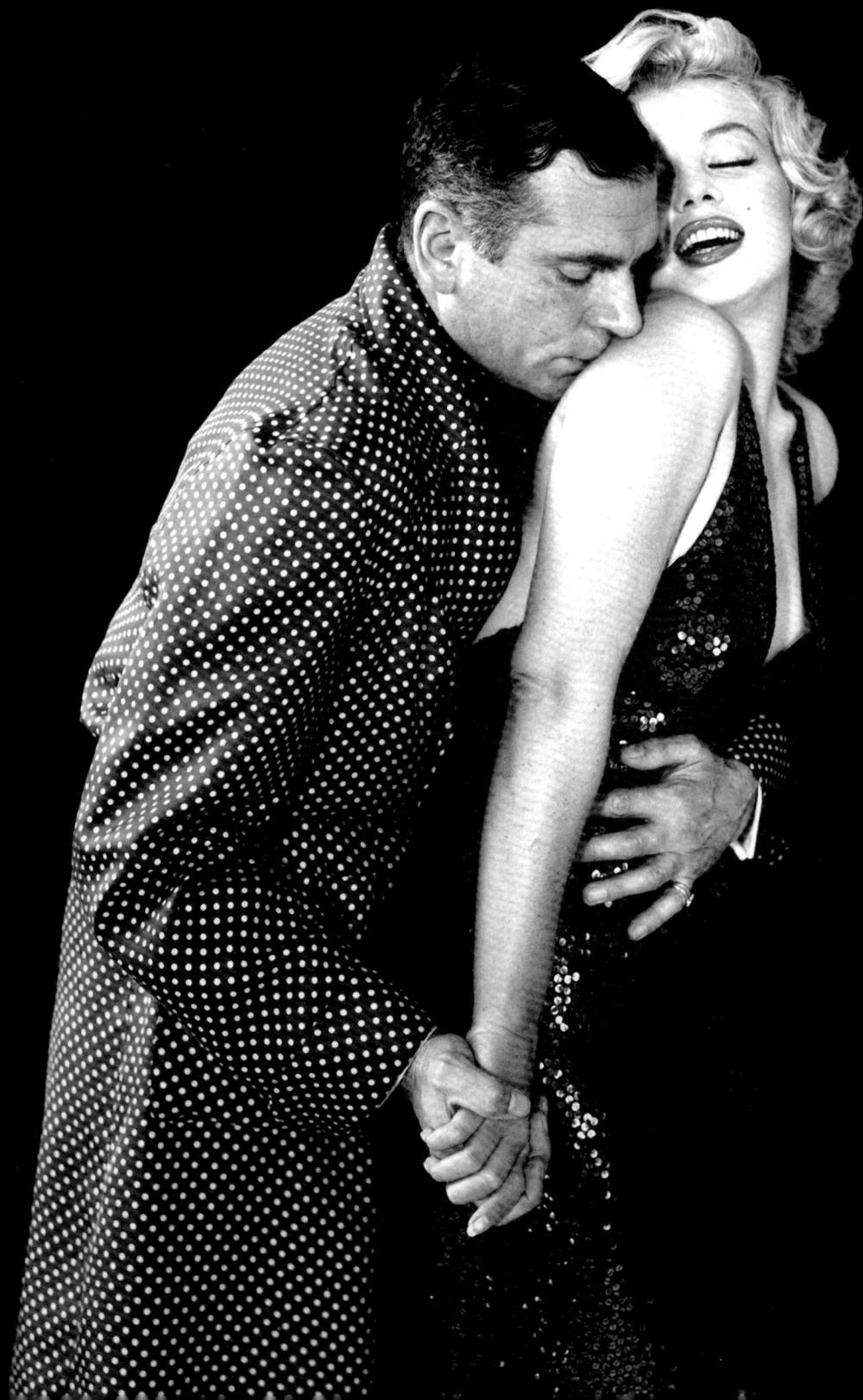

SIR LAURENCE OLIVIER, ACTOR

HER WORK
AND ALTHOUGH SHE HAD
SHE HAD A SUBCONSCIOUS
EXERCISE OF BEING
BUT SHE WAS
ITS MYSTIQUE AND
WHEN BEING
SHE MANAGED ALL THE
WITH
APPARENT

FRIGHTENED HER,
UNDOUBTED TALENT, I THINK
RESISTANCE TO THE
AN ACTRESS.
INTRIGUED BY
HAPPY AS A CHILD
PHOTOGRAPHED;
BUSINESS OF STARDOM
UNCANNY, CLEVER,
EASE.

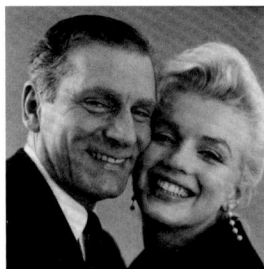

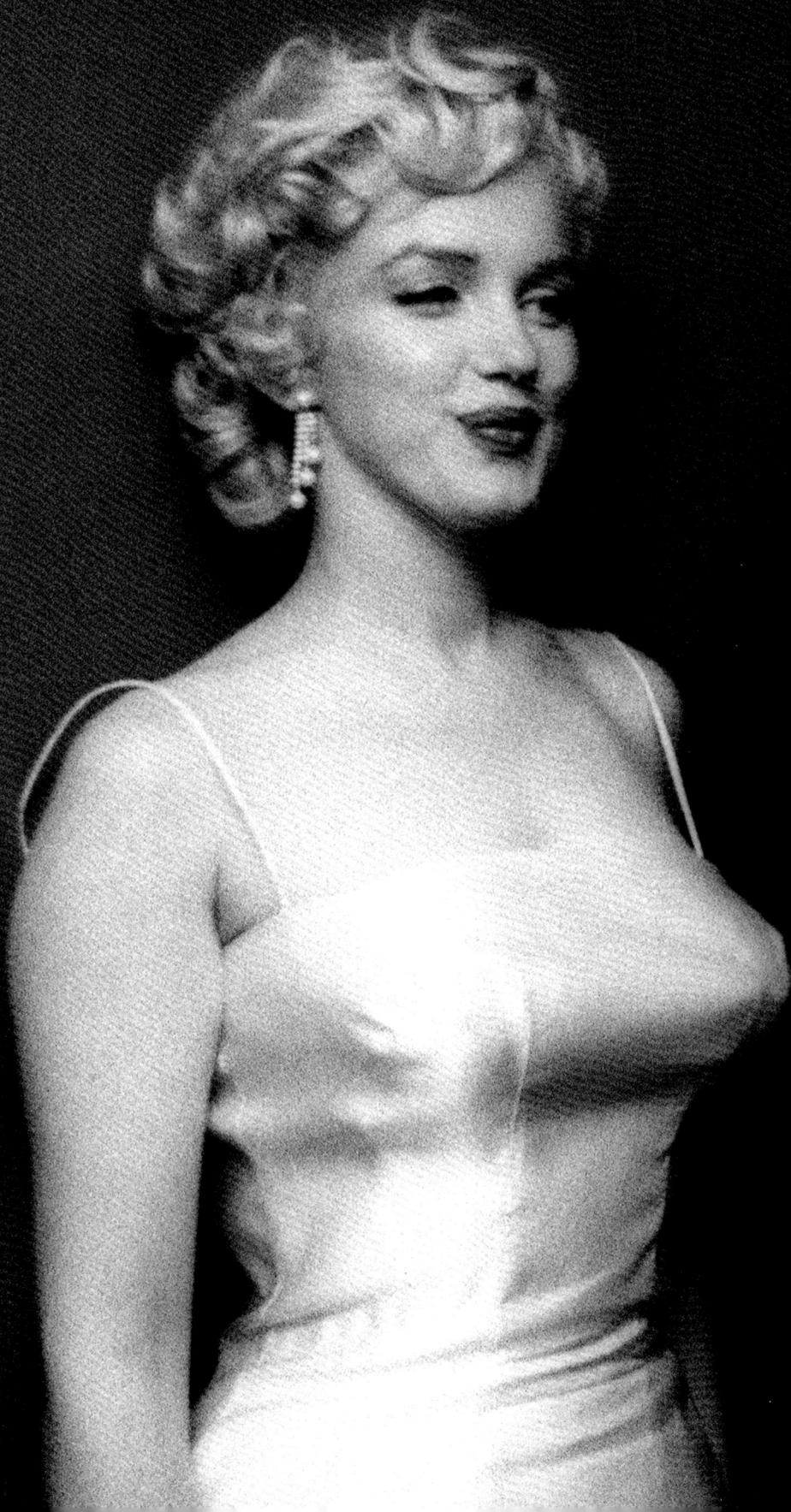

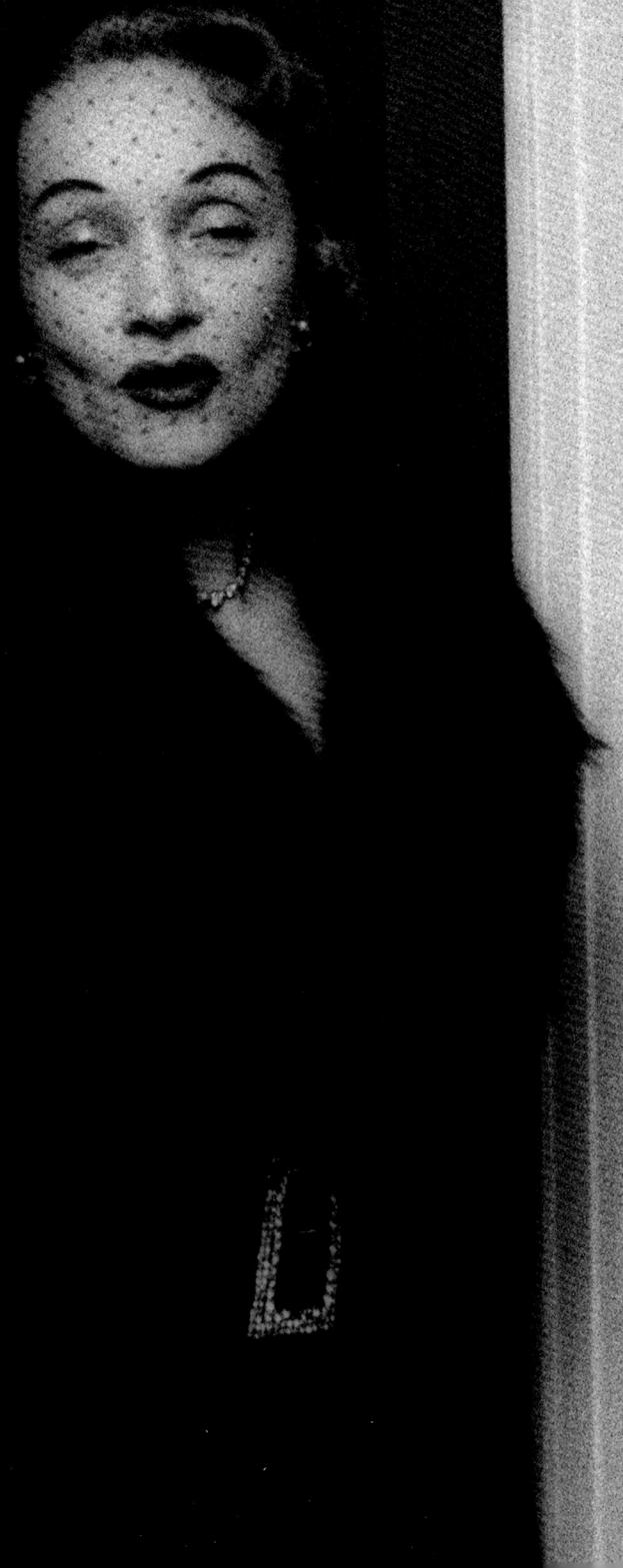

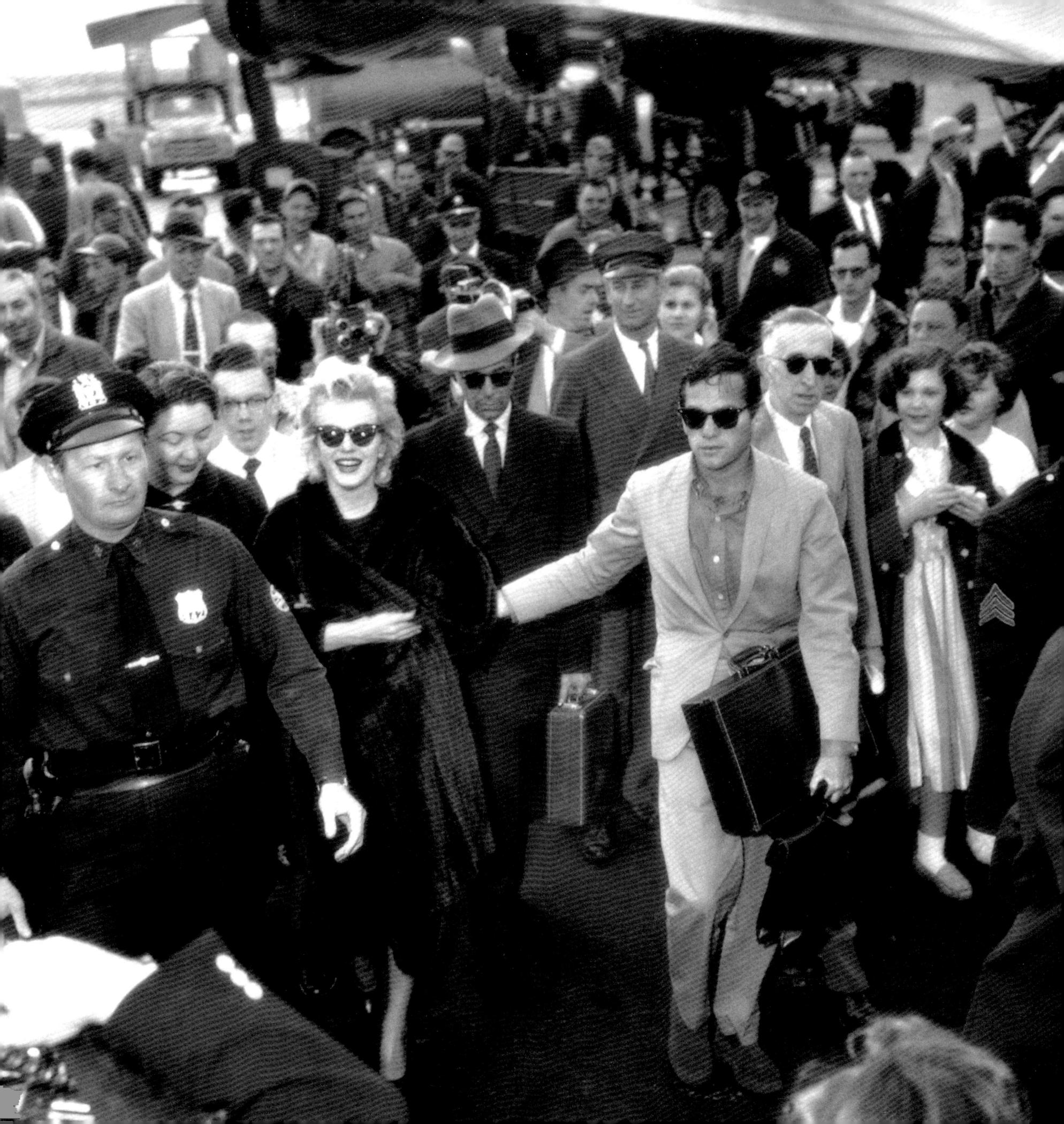

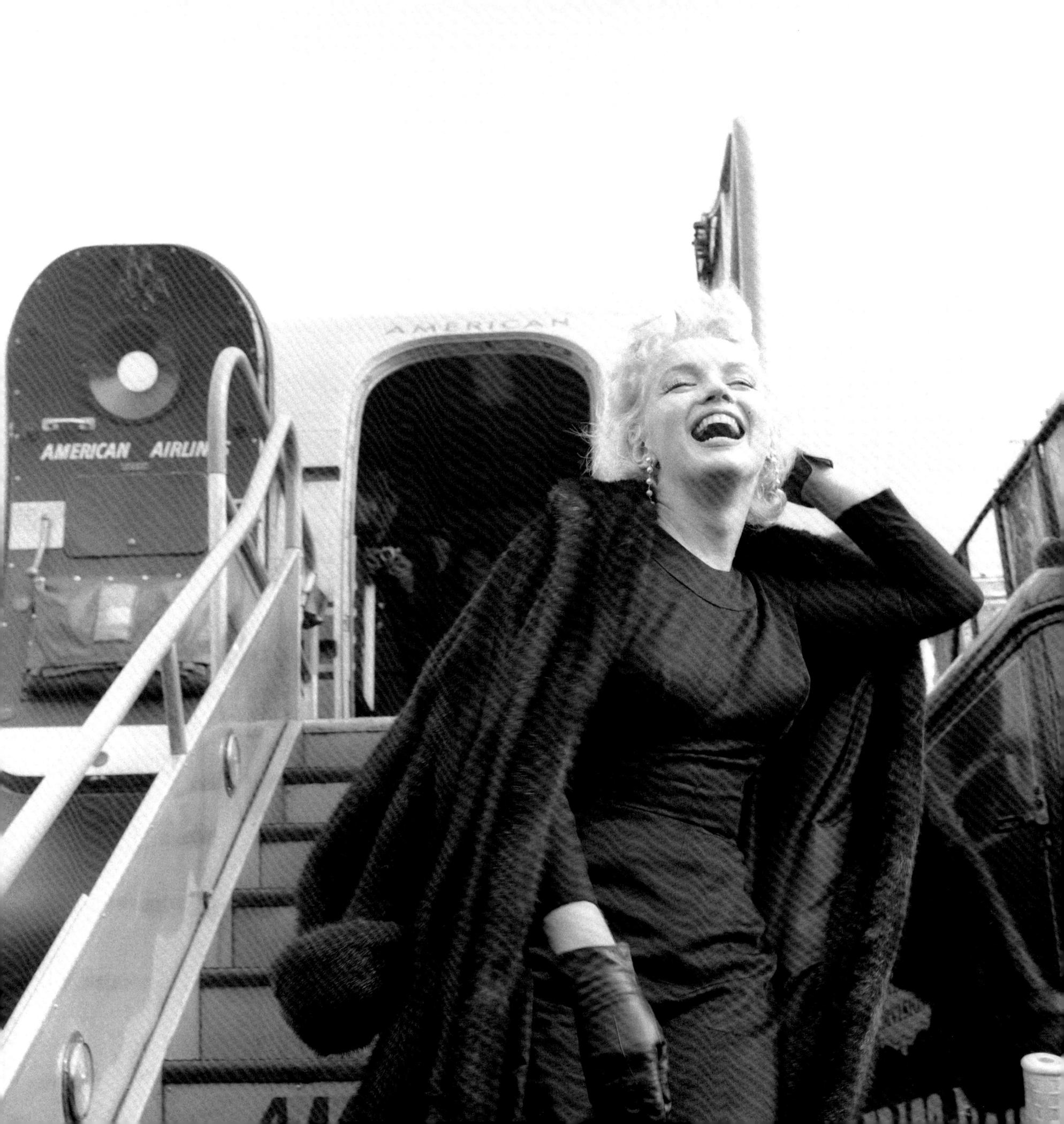

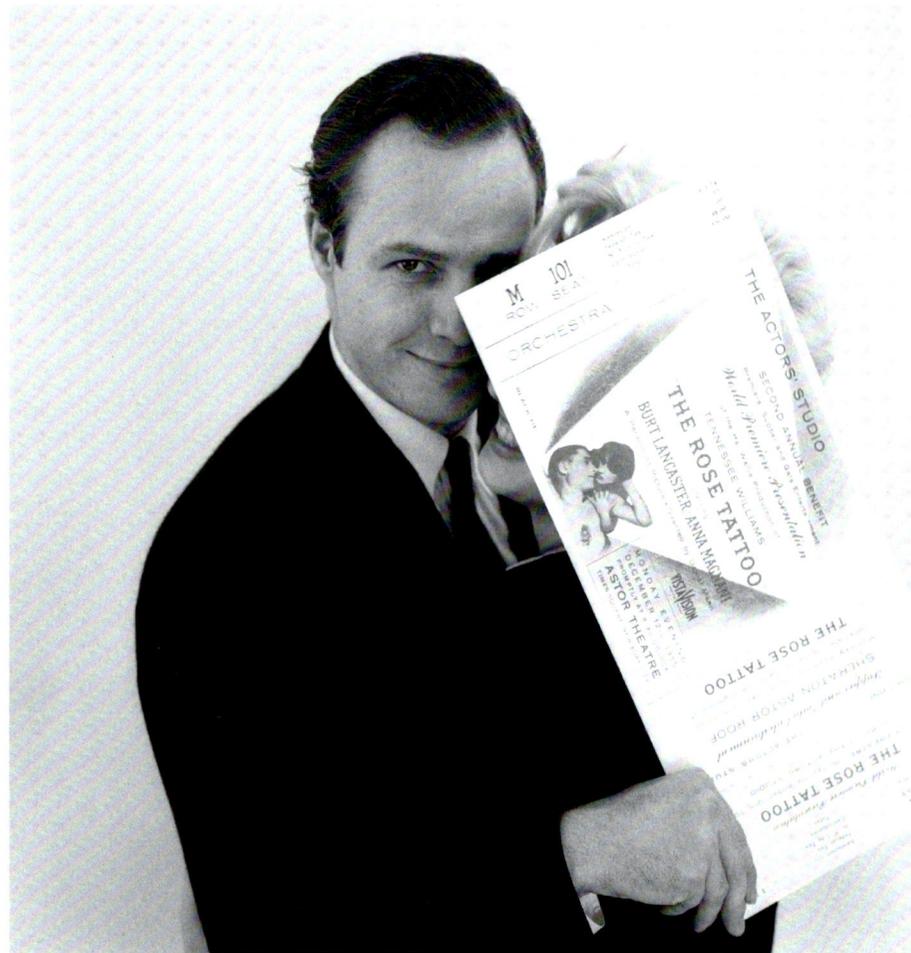

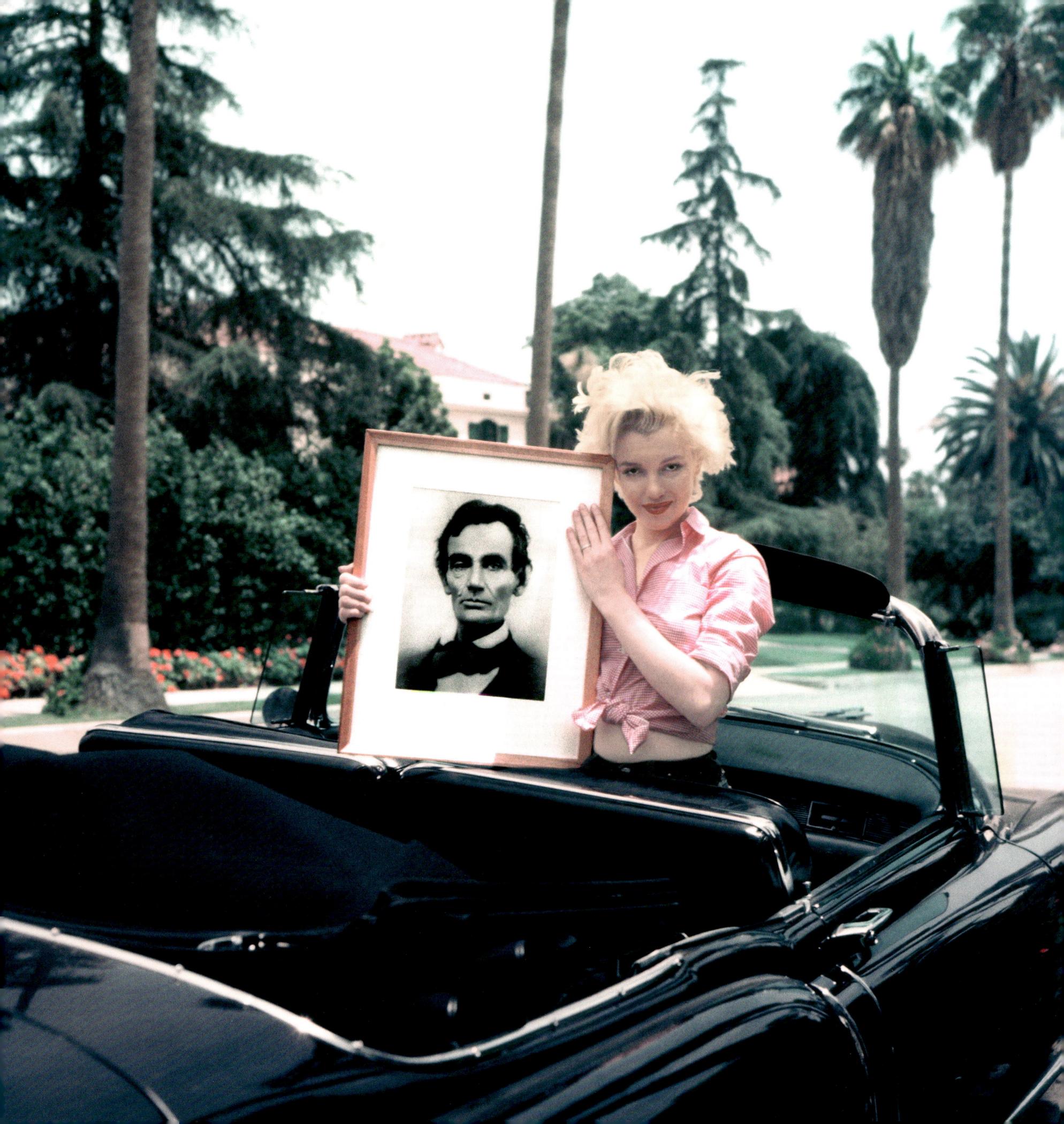

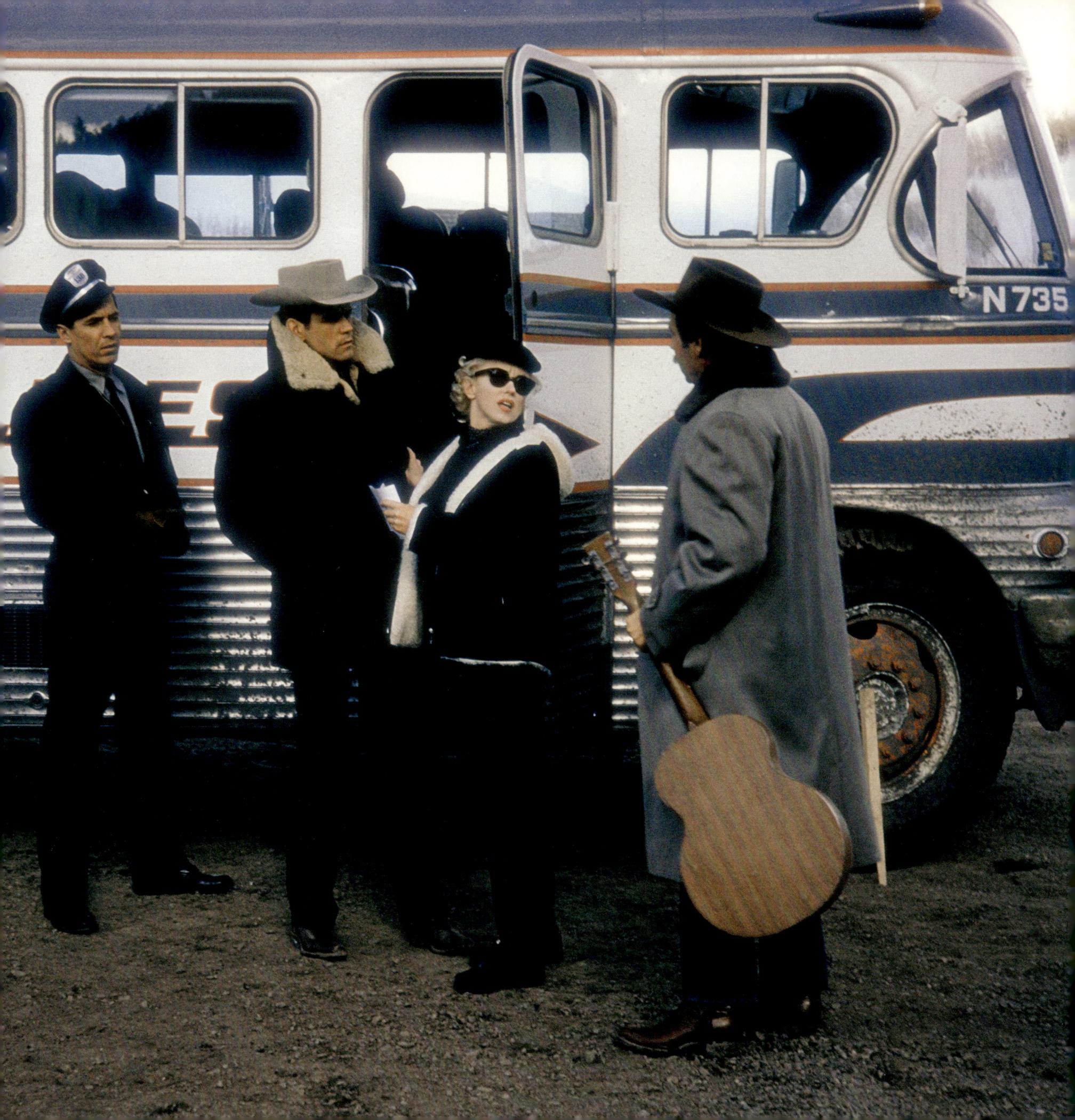

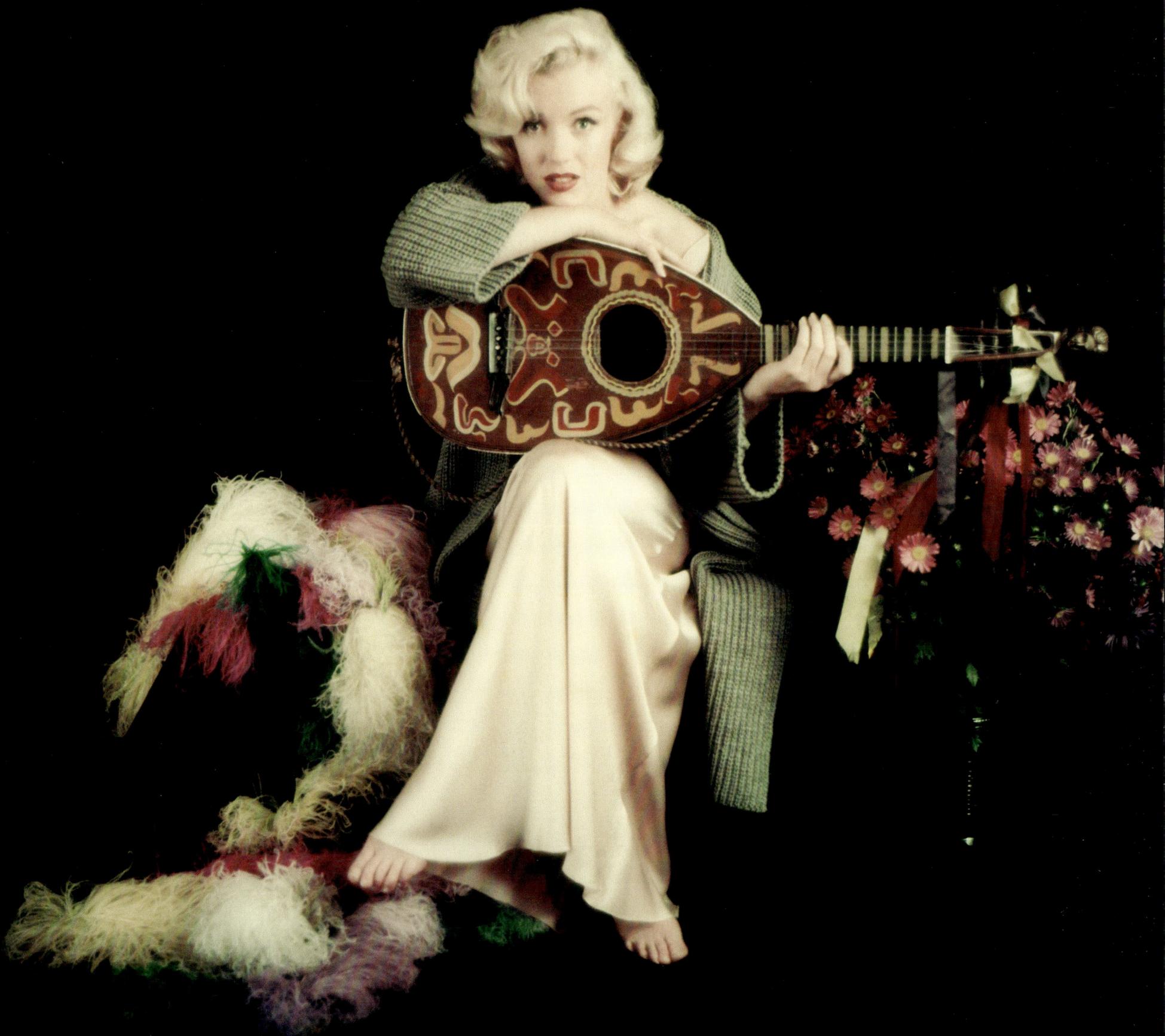

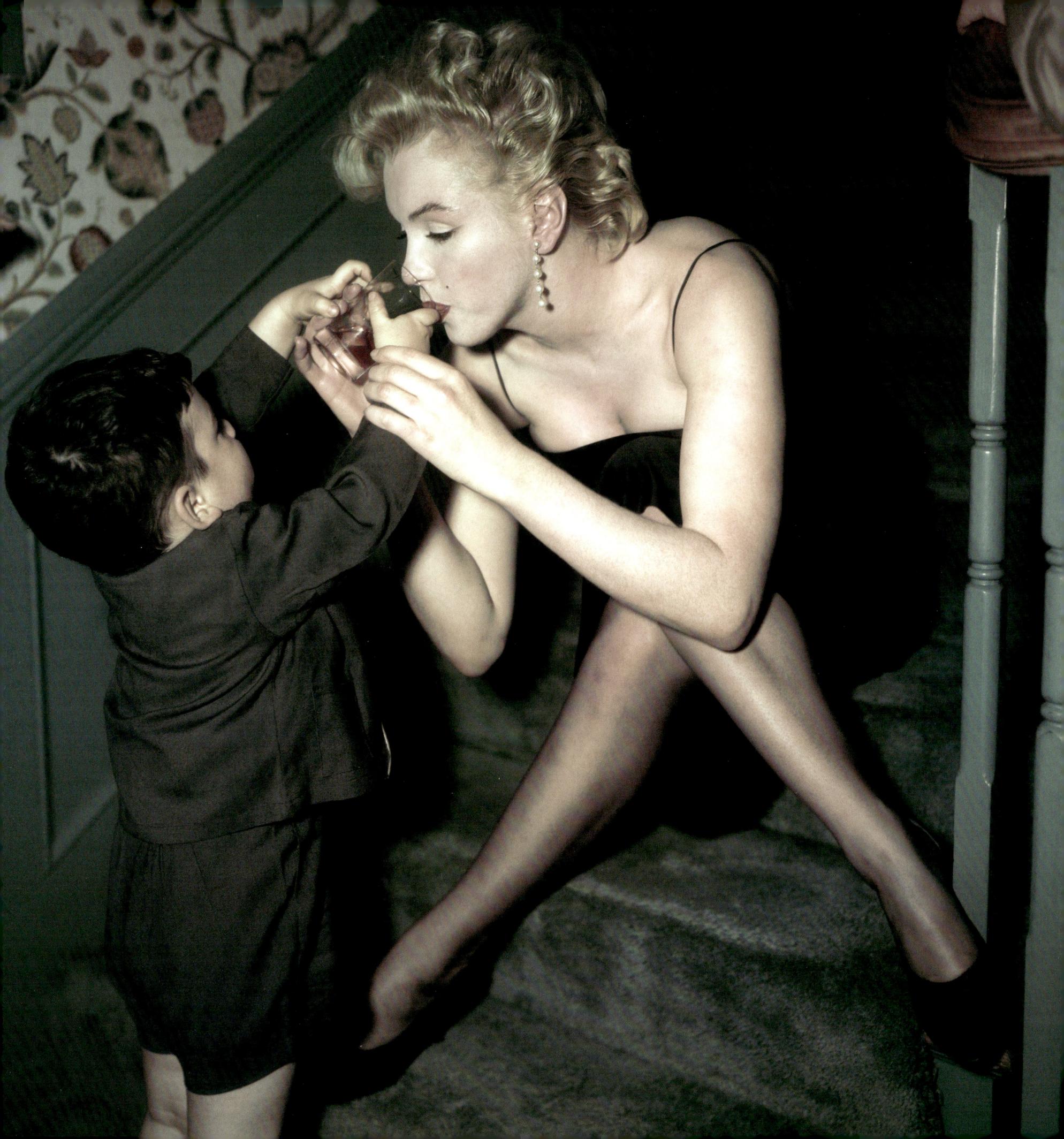

I KNEW
I BELONGED
TO THE PUBLIC
AND TO THE WORLD,
NOT BECAUSE
I WAS TALENTED
OR EVEN
BEAUTIFUL, BUT
BECAUSE I
HAD NEVER
BELONGED TO
ANYTHING OR
ANYONE ELSE.

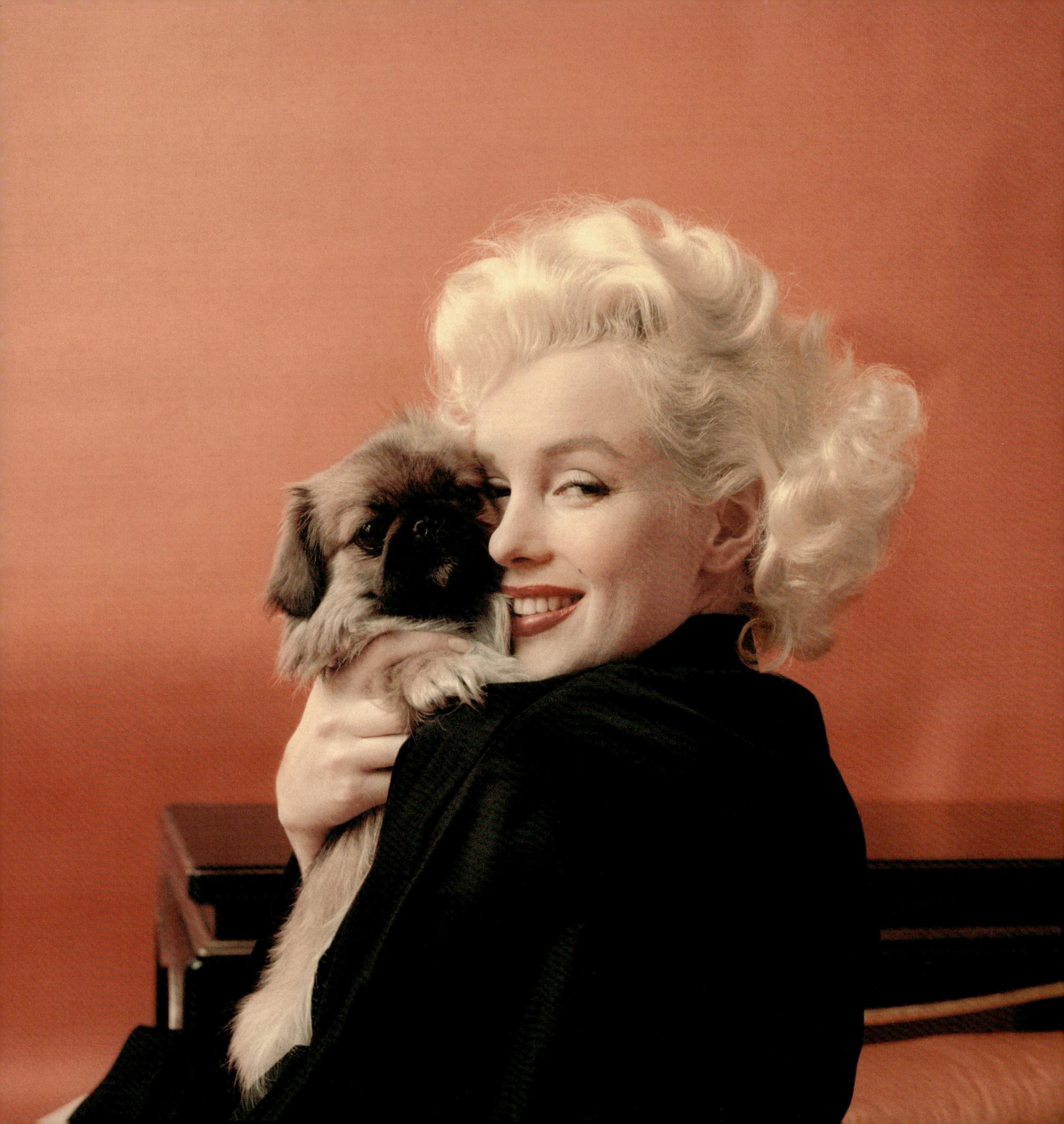

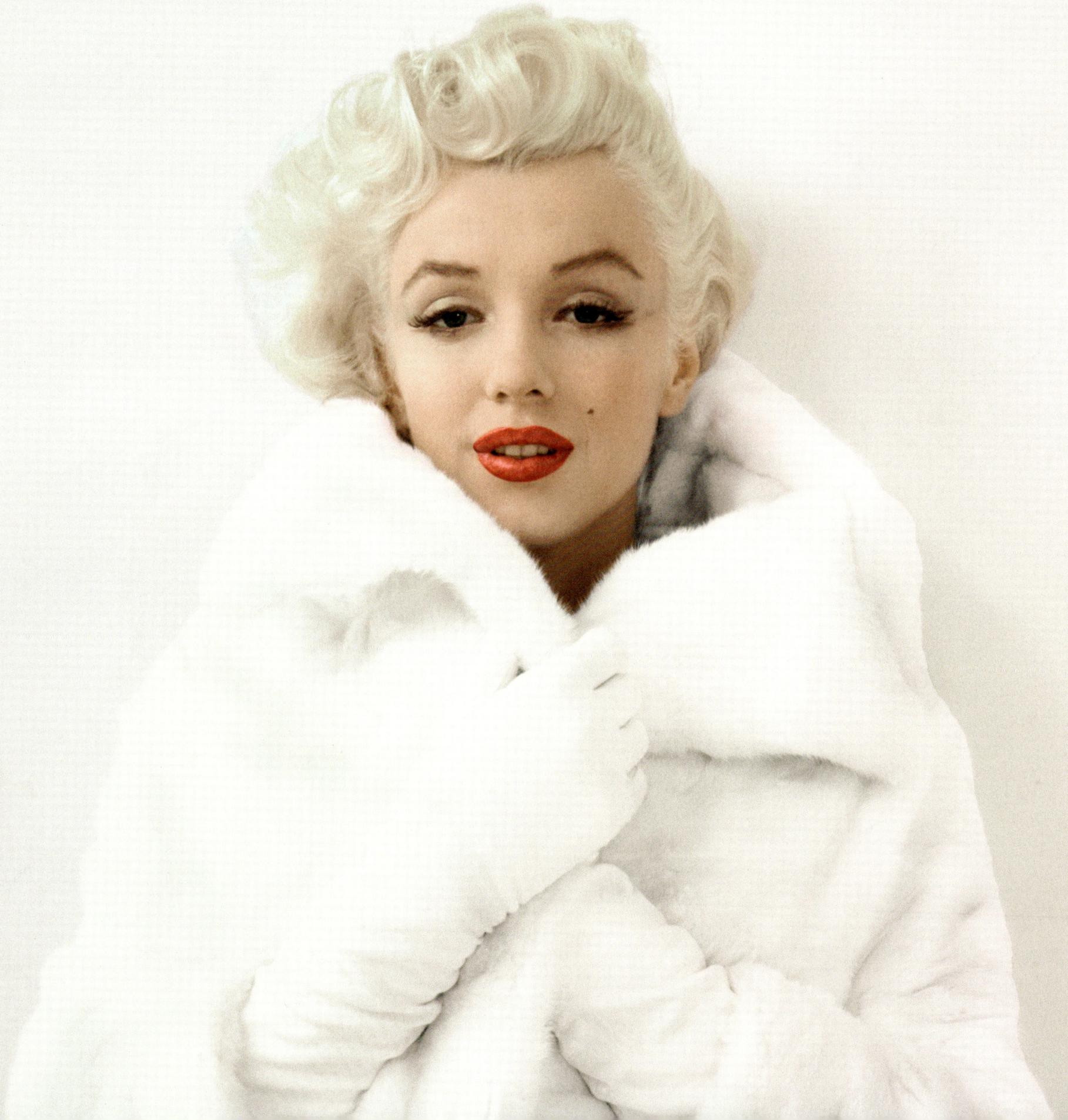

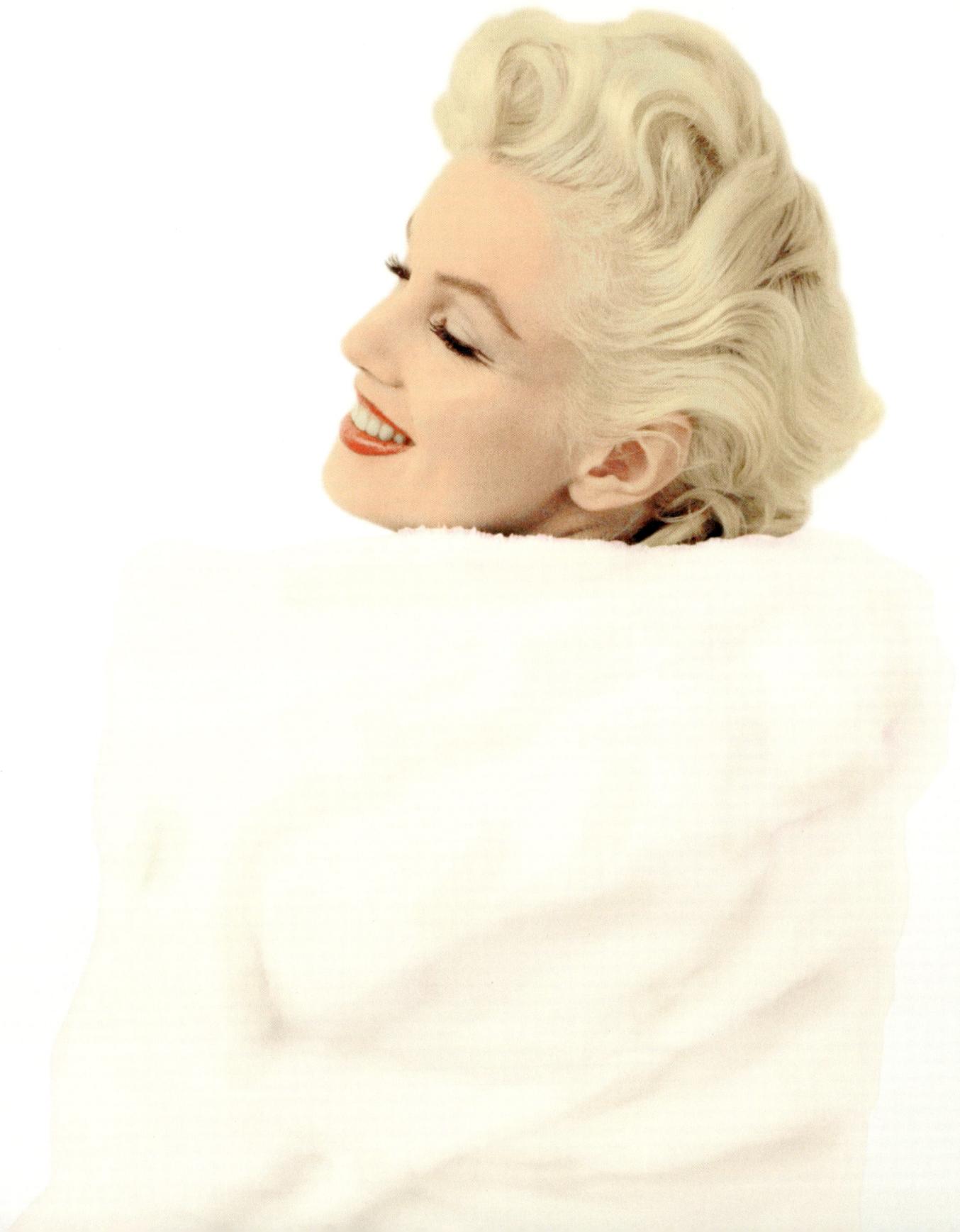

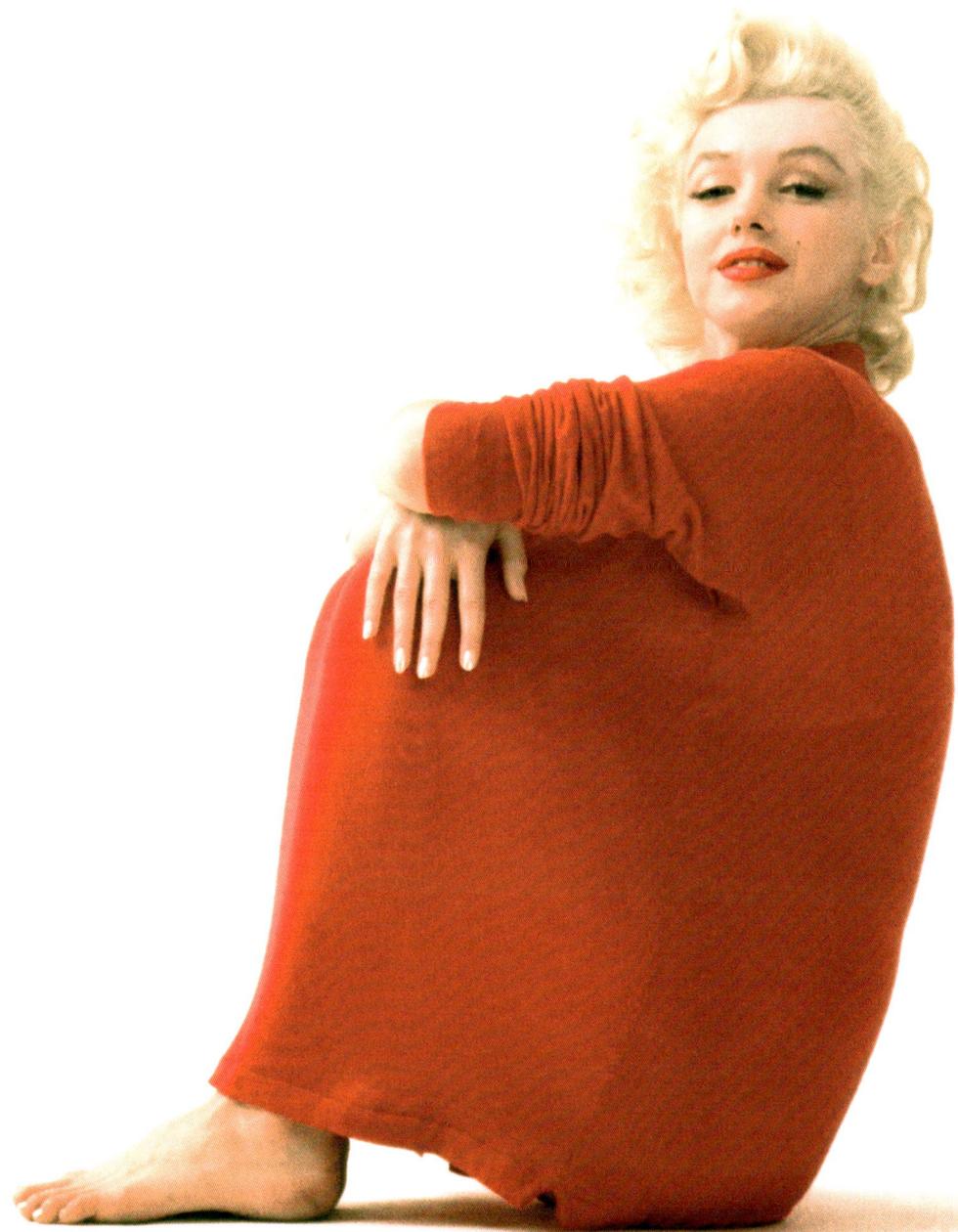

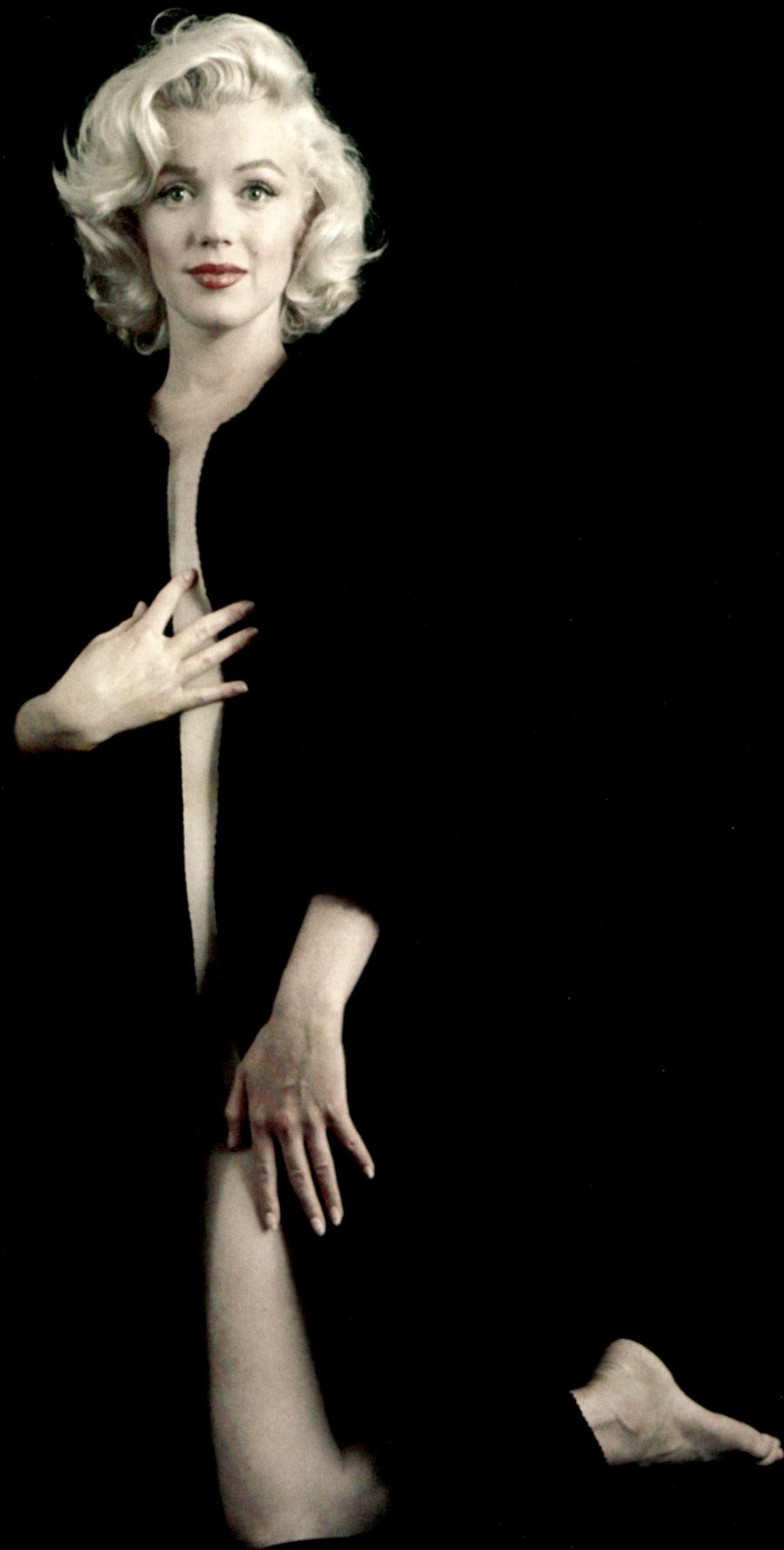

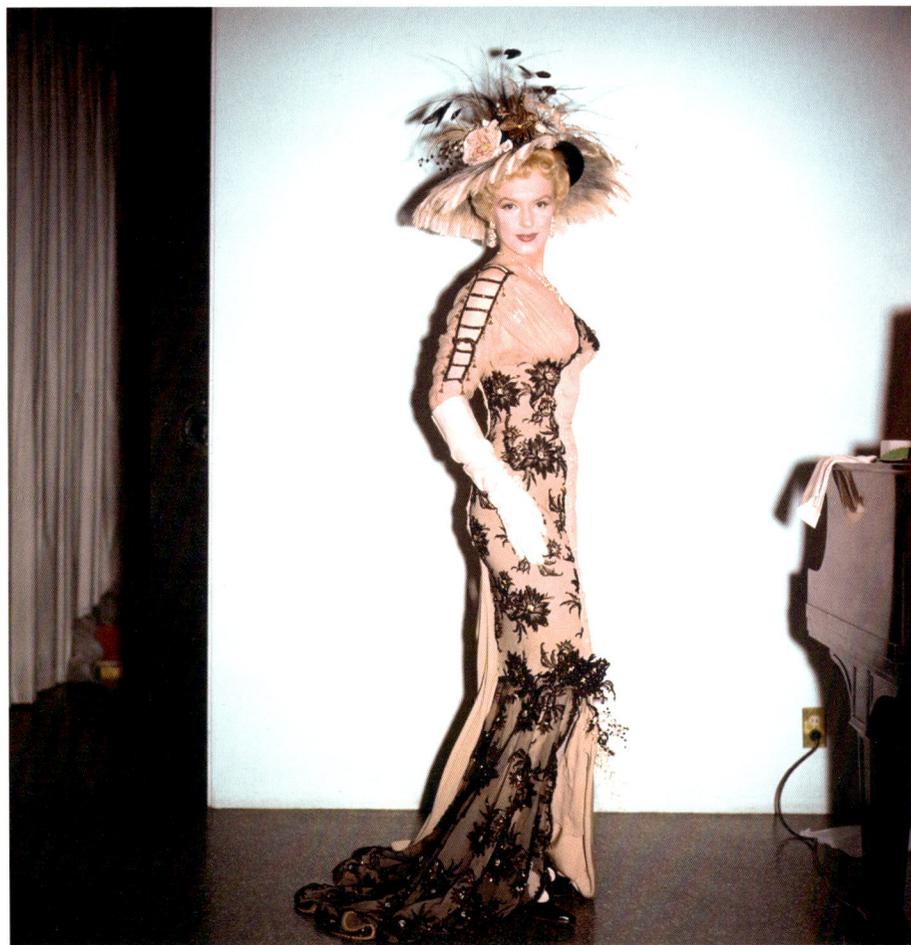

I'VE BEEN
ON A CALENDAR,
BUT NEVER
ON TIME.

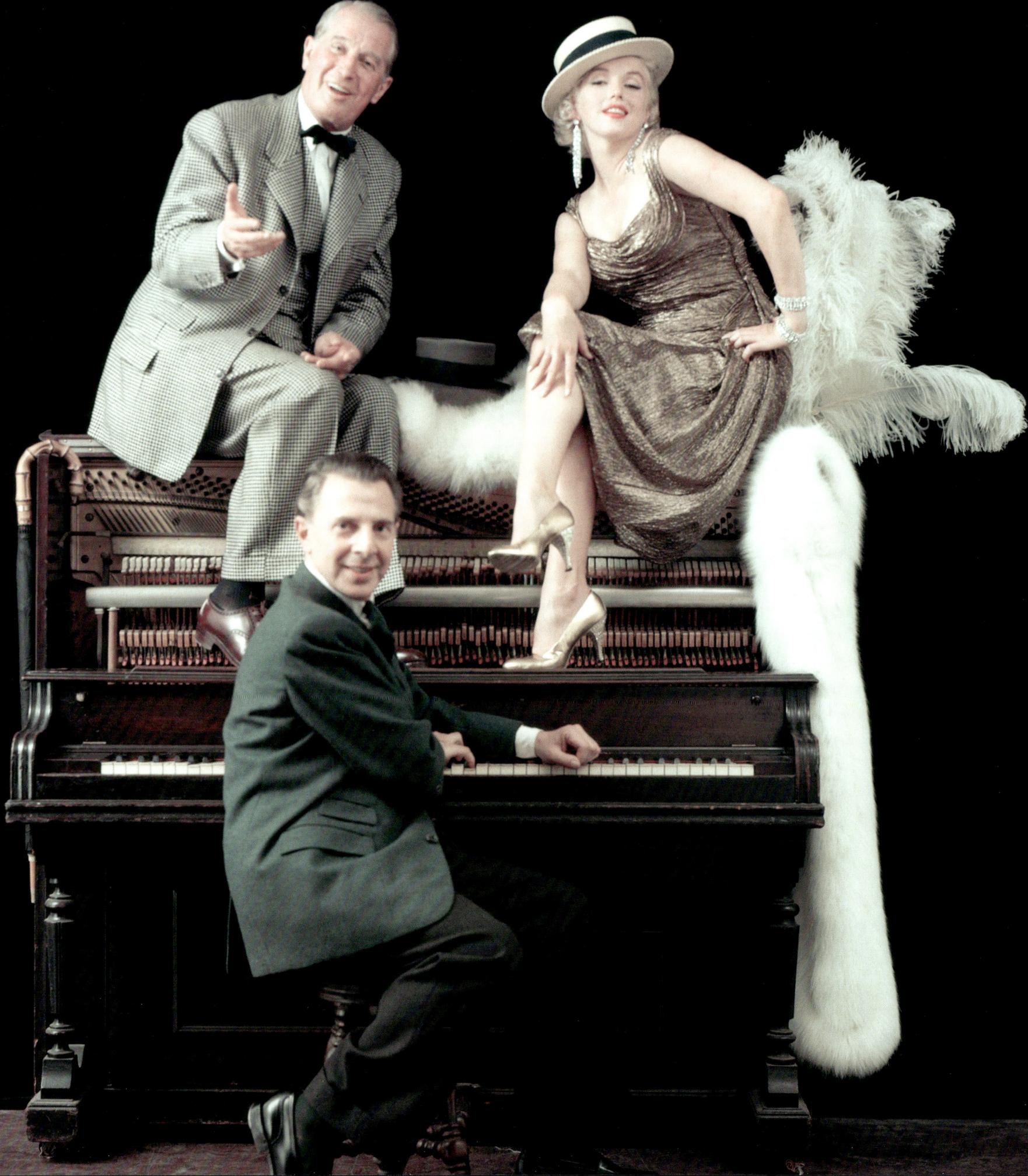

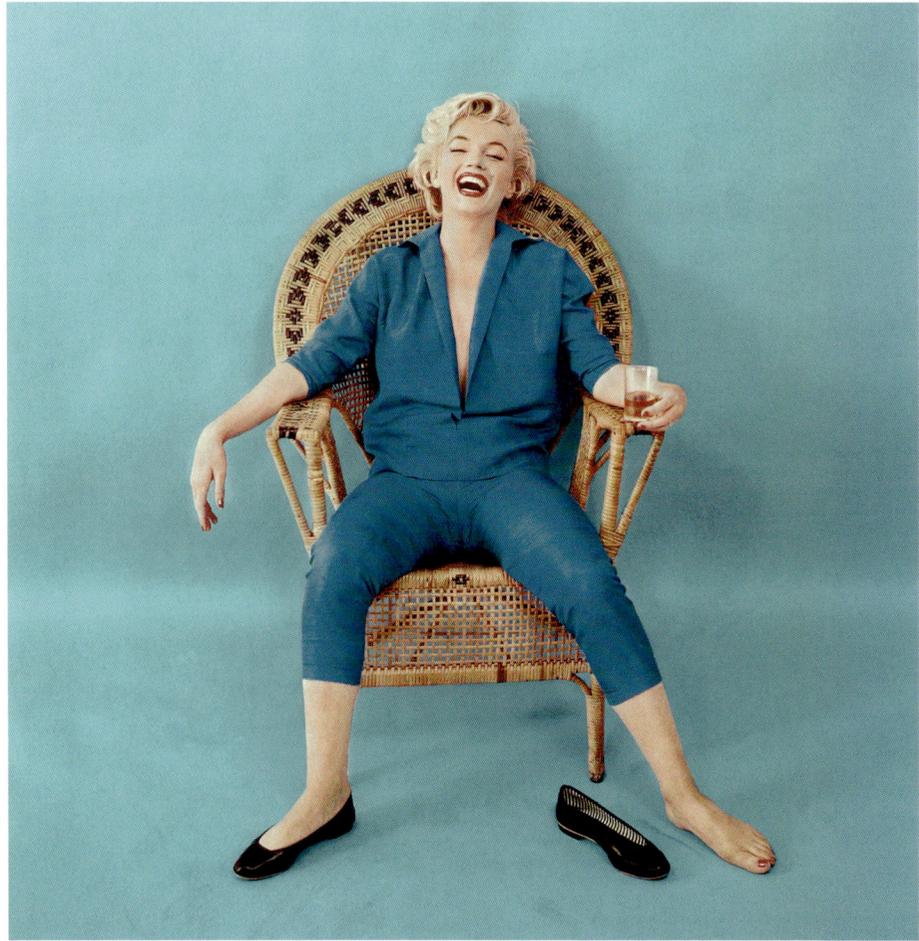

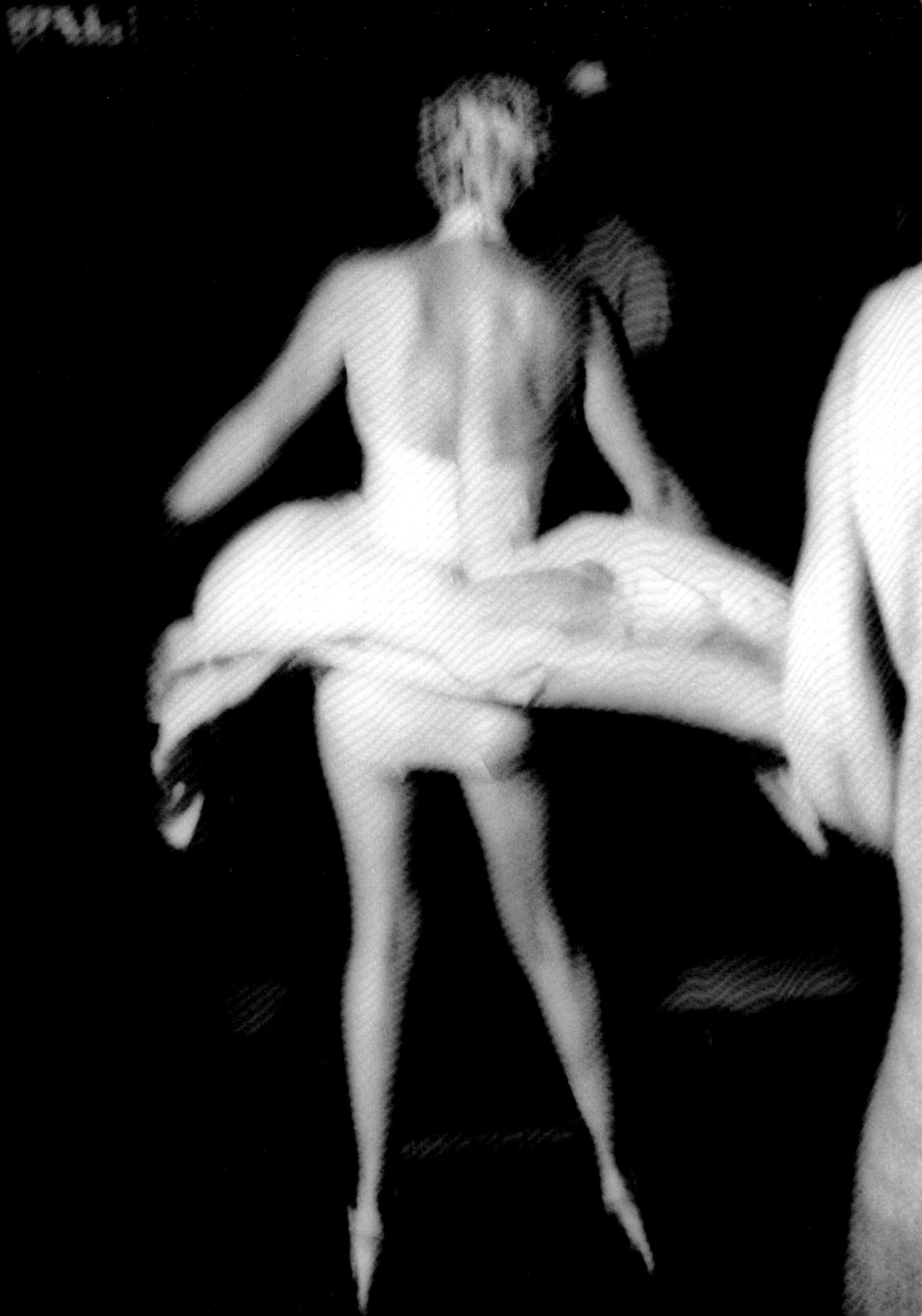

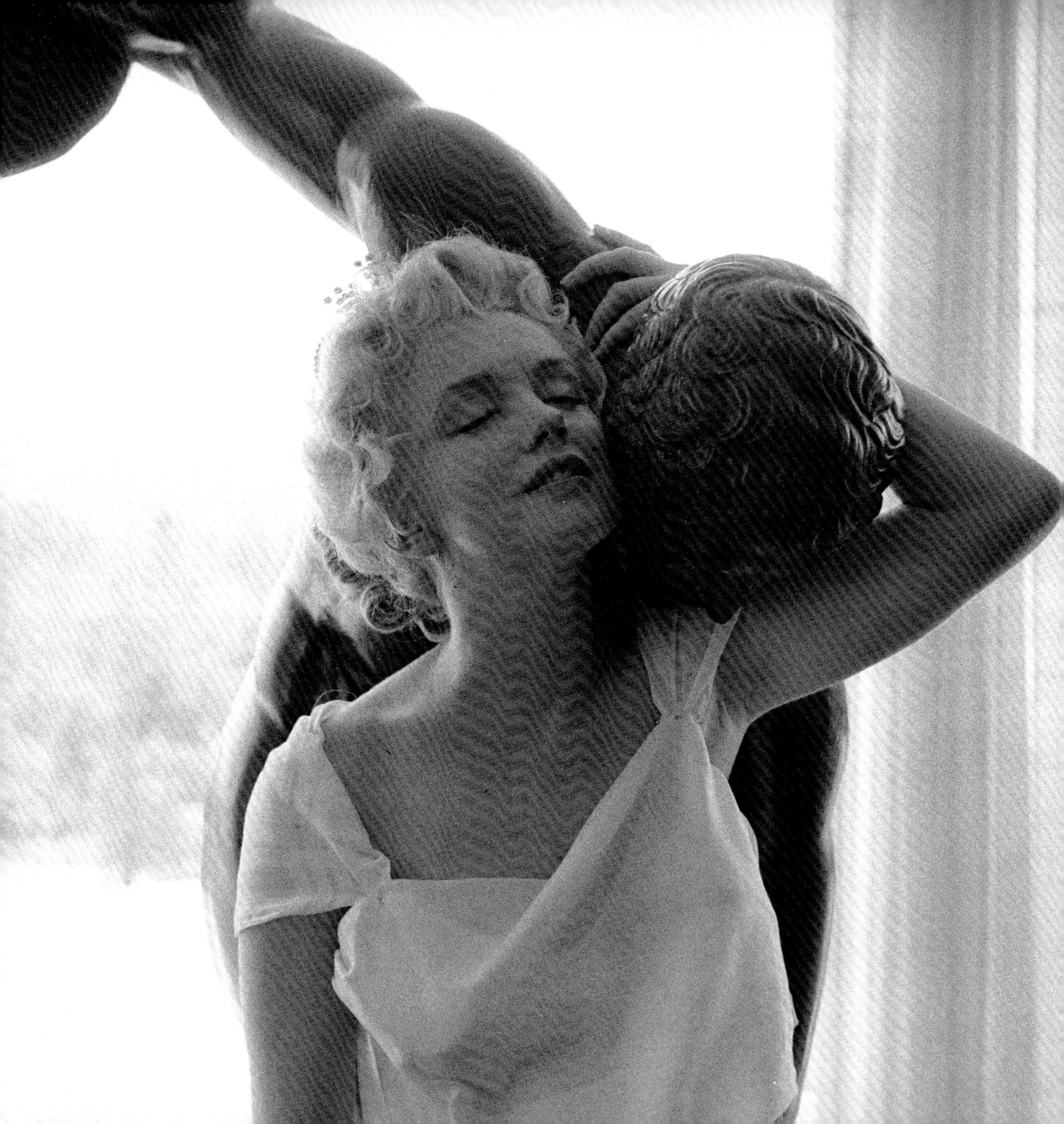

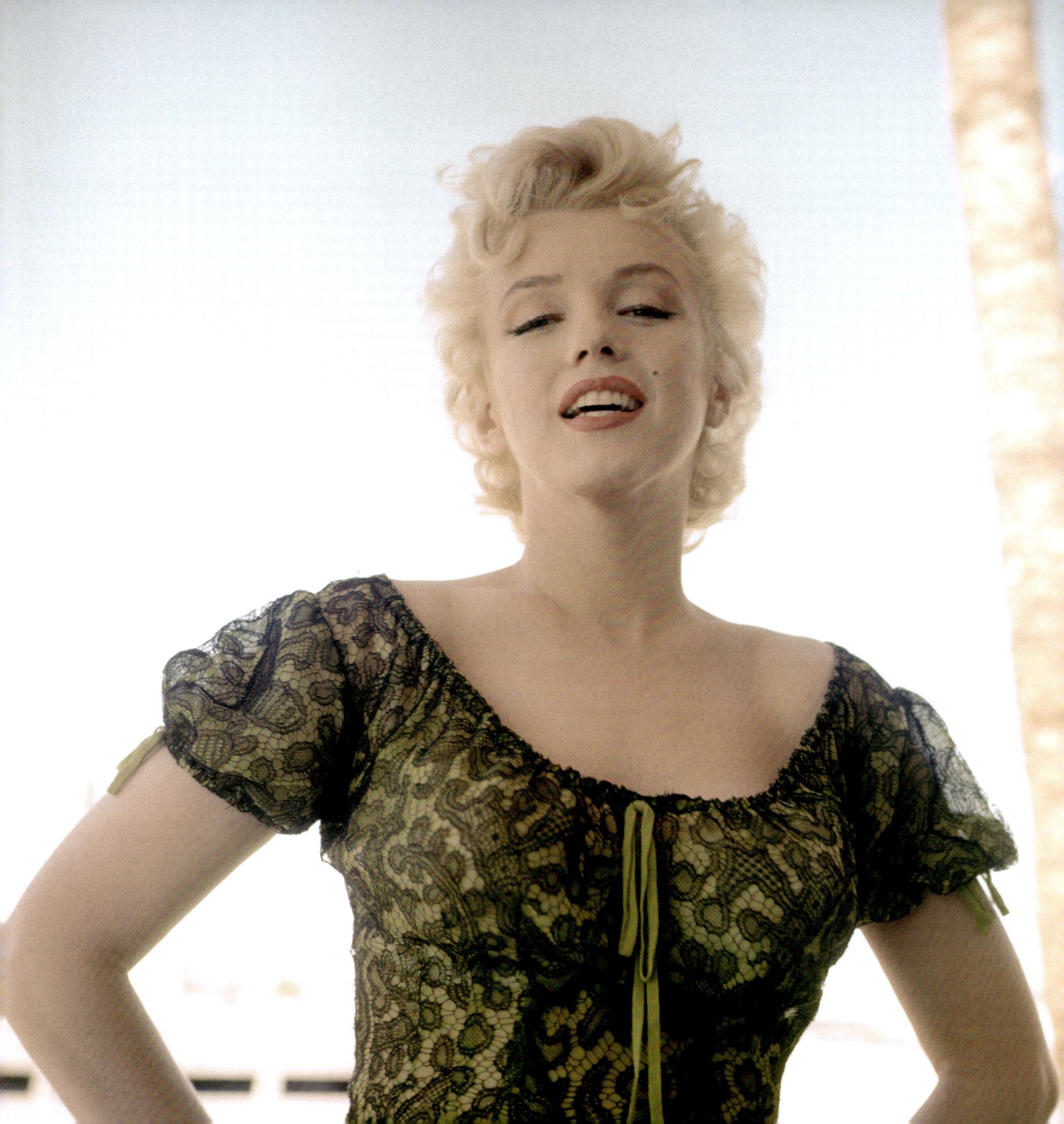

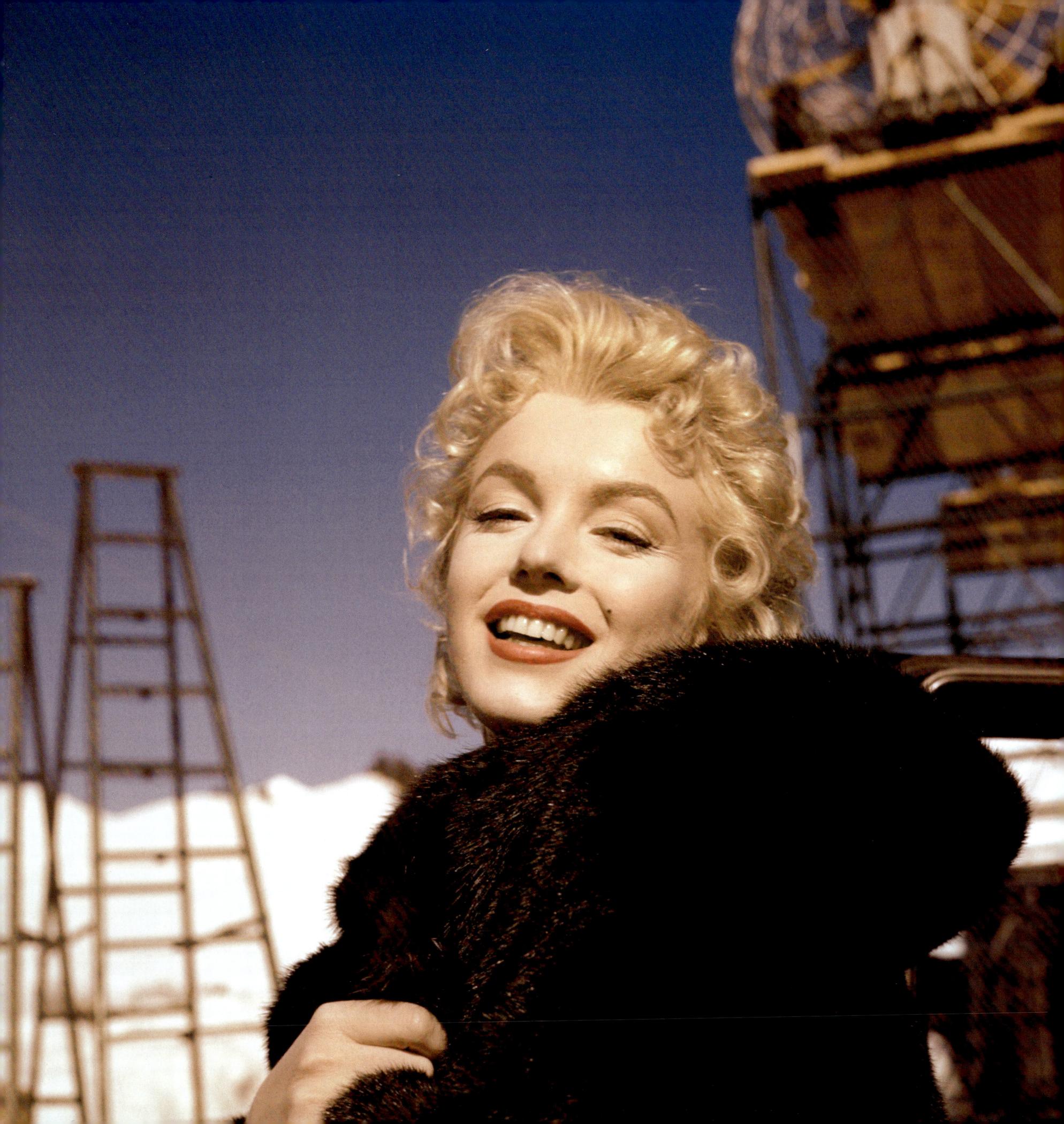

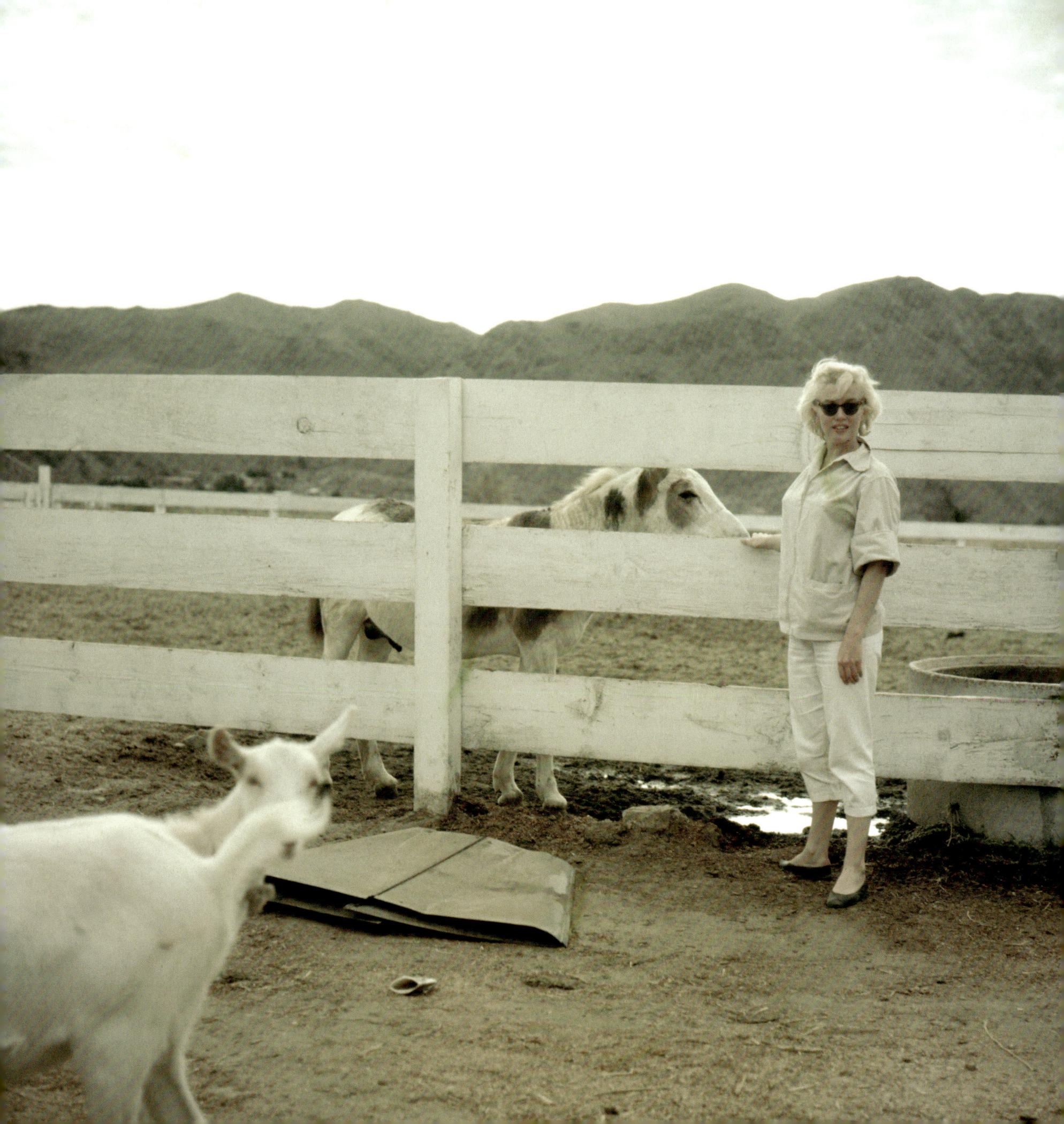

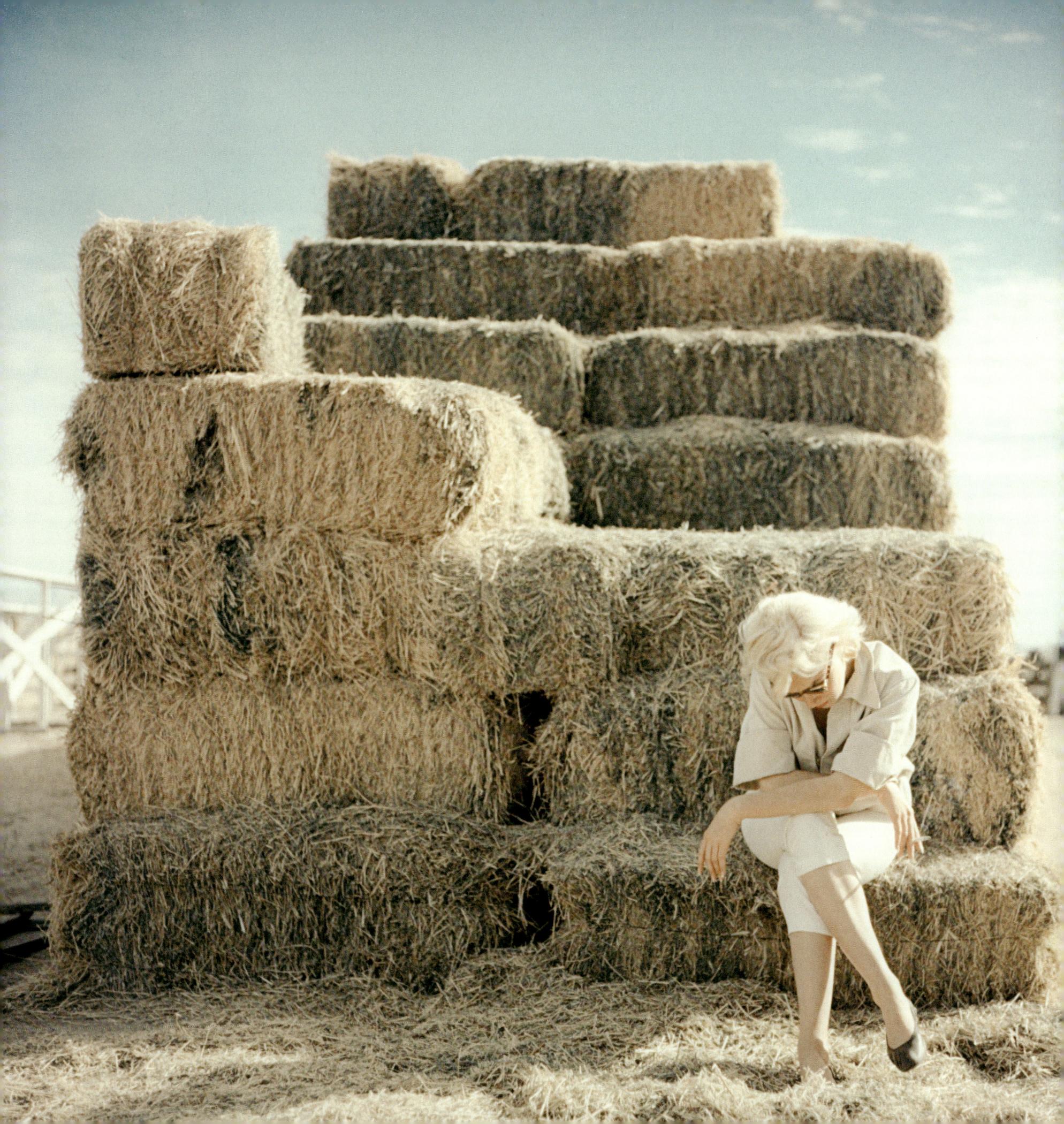

IT'S NOT TRUE THAT I HAD NOTHING ON. I HAD THE RADIO ON.

ON REPORTS OF HER NUDE PHOTOGRAPHS FOR A CALENDAR,
AS QUOTED IN TIME MAGAZINE (1952)

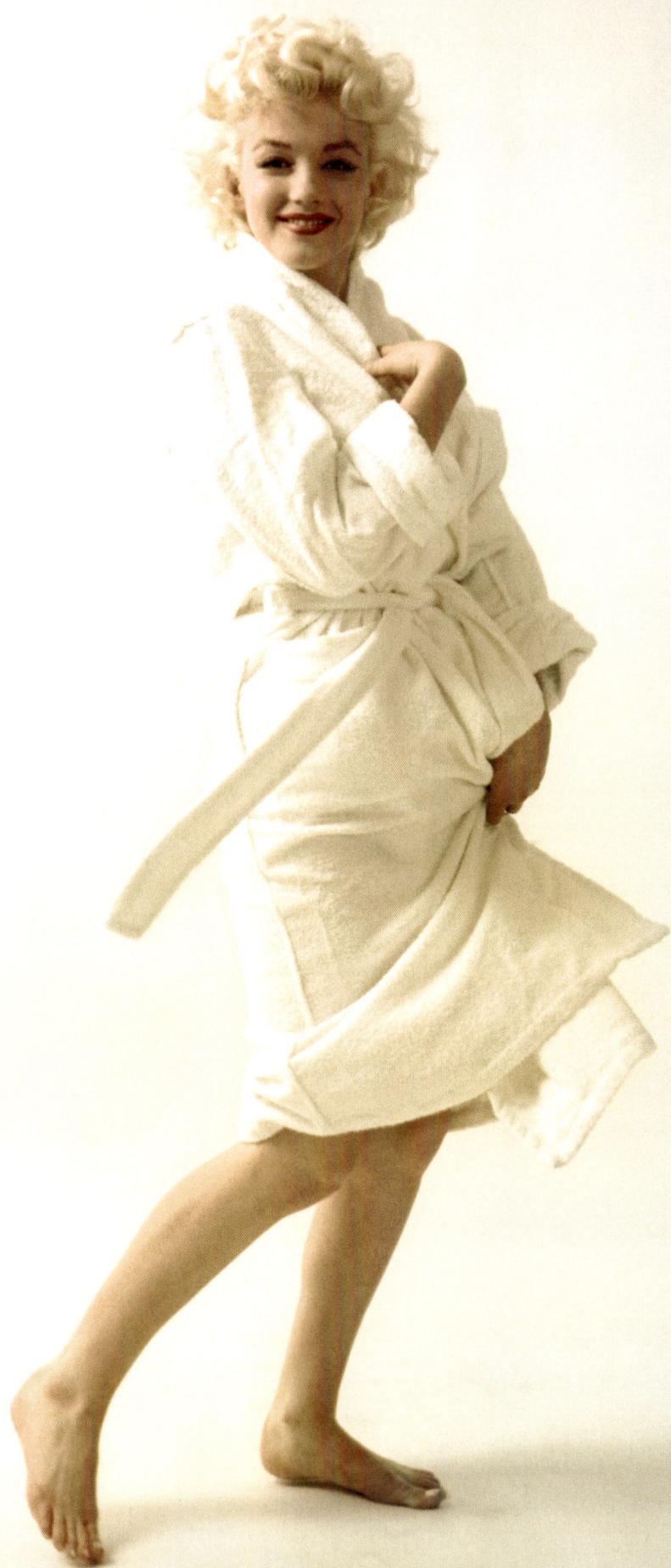

"You are the saddest girl I ever met", said Clark Gable to Marilyn during the shooting for her final film *Something's Got to Give*. She replied: "You are the first man to say so. They usually tell me how happy I am."

Los Angeles, June 1st, 1926. Norma Jeane Mortensen is born in the County Hospital. Later on, the name on the birth certificate will be Norma Jeane Baker.

Norma Jeane's mother Gladys Pearl Mortensen (divorced Baker), née Monroe, hands her third child to foster parents merely two weeks after her birth. There shall never be a certain answer to the question of who the father is, despite many speculations.

In an interview with Georges Belmont, then editor-in-chief of *Marie Claire* magazine, Marilyn Monroe states in 1960: "As far as I can remember, I always lived with other people." Her childhood memories of her mother are those of a woman who sometimes comes to visit her, "that woman with red hair". Norma Jeane lives in many different foster families, staying with the first one until she is seven years old.

In January 1935, Gladys' friend Grace McKee becomes little Norma Jeane's guardian, but as early as in September of the same year, Grace, herself single, sends the eight-year-old girl to an orphanage, to the "Los Angeles Orphans' Home Society". In the course of the next few years, the girl lives with a series of ever-new foster families or in orphanages. After Grace McKee marries in June 1937, Norma Jeane goes back to live with her. The seven-year-old's most fervent wish is to be with the Goddard family forever from now on, but is sent away again several times. Marilyn's happiest period during her youth, as she later often tells it, is the time she spends with Grace's aunt Ana Lower whom she loves dearly. She claims that Lower "never disappointed" her.

Because Grace eventually plans to move away from California together with her husband and his children, Norma Jeane faces the alternative to either return to the state orphanage until she turns 18 – or to get married. "I was almost sixteen years old and decided to marry," Marilyn once said in an interview. Her chosen husband, James Dougherty, the neighbour's son, is 21 years old, a worker in an aircraft factory. Their happiness does not last long: in September 1946, she is then barely 20 years old, Norma Jeane travels to Las Vegas to be divorced.

At this time – Norma Jeane is now working in a plant producing aeroplane ammunition, a job she found with the help of a recommendation from her current mother-in-law, Ethel Dougherty – she is introduced to photographer David Conover, who tells her that her looks might easily earn her five dollars per hour. A very attractive offer – she was earning only 20 dollars per week at the time.

She quits her job at the factory and applies with an agency that eventually agrees to take her on – for advertising photographs and calendars. Sometimes, Norma Jeane spends money on acting lessons, hoping to perhaps make her dreams of an acting career come true. Her face soon appears on several magazines' title pages – a publicity which gains her first contacts in the film industry.

In July 1946, she applies at her first film studio: to Ben Lyon at 20th Century Fox. Two days later, she is in the middle of her first test shootings. She receives her first studio contract near the end of August 1946; a contract guaranteeing her 75$ per week. Now the starlet needs an appropriate name, is Ben Lyon's opinion – and he suggests the name of Marilyn when Norma Jeane insisted to use the name Monroe, her mother's maiden name. After one year of her working as a nameless extra ("I spent most of my time posing for film advertising posters"), Daryl Zanuck, general manager of 20th Century Fox, does not extend the contract.

In March 1948, she signs a six month contract with Columbia Studios – for a weekly wage of 125$. Marilyn takes lessons with acting coach Natasha Lytess, but her career nevertheless makes very slow progress indeed. Suddenly, her big chance comes with Groucho Marx: this legendary comedian is the first famous film personality Marilyn appears with on the screen. At his side, she plays a comic role, namely the stunning buxom wonder in *Love Happy*, and is subsequently able to get some smaller roles in important films. Monroe causes quite a sensation in her role as the gangster's sweetheart Angela Phinlay in Jon Huston's *Asphalt Jungle* shot in 1950, a film that is regarded as her great breakthrough. Following the successful film *Everything About Eve* (1950), she enjoys her only appearance at an Oscar Award Ceremony.

In December 1950, Marilyn Monroe signs a seven year contract with 20th Century Fox. She is introduced to Eliza Kazan, the famous director – as well as to her future husband Arthur Miller, America's most famous stage writer. The final years of 1952 witness the shooting to *Gentlemen Prefer Blondes*. Her rendering of Loreley Lee – and especially her song contribution *Diamonds are a Girl's Best Friend* become legend. This film is a huge success for Marilyn Monroe in 1953, the same year she is able to convince everyone with her part in *Niagara*. Marilyn's fame as a film star is further enhanced by the much praised comedy *How to Marry a Millionaire*.

In October of the same year, Marilyn meets the famous fashion photographer Milton H. Greene whose help is later needed to free her from her contractual duties with 20th Century Fox, an oppressive contract with little opportunity having her say in any matter and a rather low fee for a star.

On 14.01.1954, Marilyn marries baseball star Joe DiMaggio, an American idol. This event makes for enormous publicity all over the world, prompting the film studio to abandon any measures against her because of breach of contract. During their

honeymoon in Japan, Marilyn makes a detour to Seoul, Korea, to entertain the American soldiers stationed there. Joe DiMaggio had also had a difficult youth, being the son of Italian immigrants, Marilyn mentions in an interview. "That's why we got along so well. That was the basis of our marriage." Still, the marriage was ended after just nine months, although their friendship survived the divorce.

In August 1954 begins the shooting of *The Seven Year Itch*, directed by Billy Wilder. Although he considers her to be a "highly gifted actress", Wilder in later interviews often complains about her chronic lateness and "Miss Monroe's" lack of command of her lines. Monroe herself attempted to fight her frequent fear of failure with pills and alcohol. By the mid-1950s, Marilyn is the most successful US-American actress, although she cannot rid herself of the detested label of being the erotic, dumb blonde.

Towards the end of 1954, Marilyn Monroe turns her back on Hollywood to fly to New York where she founds "Marilyn Monroe Productions" together with her friend Milton H. Greene. She also takes acting lessons with Lee Strasberg at the Actors Studio, an influential institution where Marlon Brando, James Dean or Paul Newman studied, too. She wants to be more than an artificial sex goddess and finally leave the image of the shallow, sexy blond behind her.

Unfortunately, Marilyn's need for psychiatric treatment increases at the same time as her wish to develop her artistic skills. She increasingly suffers from insomnia and states of anxiety; she feels insecure and inadequate. For a time, Marilyn visits her psychiatrist Dr. Margaret Hohenberg in New York every day.

In February 1956, she returns to Los Angeles. 20th Century Fox agrees to cooperate with the new production company and once more includes films with Marilyn Monroe into the programme.

On June 29, 1956, Marilyn is married to Arthur Miller in a registry office ceremony. Two days later, they celebrate their wedding according to Jewish rites. Even before Marilyn can prove her serious acting talent beyond anything burlesque in *Misfits*, directed by John Huston, she brilliantly plays the role of lascivious singer Sugar in the comedy *Some Like it Hot* by Billy Wilder – fully doing justice to her image as a sex goddess. The film is nominated for six Oscars, and Marilyn is celebrated as a comedian.

However, her private crises accumulate: in 1960s, during the shooting of *Misfits*, a film whose script Arthur Miller wrote specifically for his wife, Monroe and Miller decide to divorce. On January 20, 1961, the divorce becomes valid in Mexico (Ciudad Juarez). On February 7, Marilyn is admitted to the Payne Whitney Psychiatric Clinic, branch of the New York Hospital. Joe DiMaggio rushes to her side and is her most important support that spring.

In March 1962, Marilyn receives the "World's Film Favorite" prize at the Golden Globe Awards. In April, she begins working on the film *Something's Got to Give*. Producer Henry Weinstein is shocked by the poor psychological and physical shape his star is in. In August, the film production is interrupted, and the film company fires Marilyn – after some great outrage when she decided to appear at Madison Square Garden on the occasion of John F. Kennedy's birthday on May 19 (regardless of a tight shooting schedule) – and to sing her legendary "Happy Birthday".

This will be Monroe's final public appearance. She dies in the night of Saturday, August 4 to Sunday, August 5, 1962 at the age of 36, of an overdose of Nembutal and chloral hydrate. The circumstances of her death were never cleared up completely. Her psychiatrist Dr. Ralph Greenson finds her dead in her bed on the morning of August 5, holding the phone receiver in her hand. Marilyn is buried on 08.08.1962 at Westwood Memorial Park Cemetery.

Because of insufficient police enquiries, contradicting evidence from witnesses and the rumour that Marilyn Monroe had had an affair with both US President John F. Kennedy and his brother Robert, there is speculation about the true reasons behind her death to this day. Was it a suicide, murder – or a tragic, fatal error on the part of a woman who had been addicted to pills for years – and had lost both the overview about her dosage and her life.

SECRETLY, I HAD THE FEELING OF NOT BEING ABSOLUTELY "REAL", SOMETHING LIKE A WELL-EXECUTED FAKE.

MARILYN MONROE 1960.

„Du bist das traurigste Mädchen, das ich je gesehen habe", hat Clark Gable bei den Dreharbeiten zu ihrem letzten Film „Something's got to give" zu Marilyn gesagt. Sie entgegnete: „Du bist der erste Mann, der das gesagt hat. Gewöhnlich sagen sie mir, wie glücklich ich bin."

Los Angeles, 1. Juni 1926. Norma Jeane Mortensen wird im County Hospital geboren. Ihr Name auf der Geburtsurkunde lautet später Norma Jeane Baker.

Norma Jeanes Mutter Gladys Pearl Mortensen (geschiedene Baker), geborene Monroe, gibt ihre Tochter, ihr drittes Kind, bereits zwei Wochen nach ihrer Geburt zu Pflegeeltern. Wer der Vater ist, wird, trotz vieler Spekulationen, nie mit Sicherheit bekannt werden.

In einem Interview mit Georges Belmont, dem damaligen Chefredakteur des Magazins „Marie Claire", gibt Marilyn Monroe 1960 zu Protokoll: „So weit ich mich zurückerinnern kann, habe ich immer bei anderen Leuten gelebt." Ihre Mutter ist in ihren Kindheitserinnerungen die Frau, die sie ab und zu besuchen kommt, „die Frau mit den roten Haaren". Norma Jeane lebt in vielen Pflegefamilien, bei der ersten bleibt sie, bis sie sieben Jahre alt ist.

Im Januar 1935 wird Gladys Freundin Grace McKee zum Vormund der kleinen Norma Jeane. Doch bereits im September desselben Jahres gibt die alleinstehende Grace das achtjährige Mädchen in das Waisenhaus „Los Angeles Orphans Home Society". In den nachfolgenden Jahren lebt das Mädchen immer wieder bei neuen Pflegefamilien oder Waisenhäusern. Nachdem Grace McKee im Juni 1937 geheiratet hat, nimmt sie Norma Jeane wieder zu sich. Die Siebenjährige wünscht sich sehnlichst, sie könnte nun endgültig bei der Familie Goddard bleiben, wird aber immer wieder weggegeben. Die glücklichste Phase ihrer Jugend verbringt Marilyn, so erzählt sie später oft, bei Graces Tante Ana Lower, die sie sehr liebt. Von ihr sei sie „nie enttäuscht" worden.

Weil Grace schließlich zusammen mit ihrem Mann und seinen Kindern aus Kalifornien wegziehen will, wird Norma Jeane vor die Alternative gestellt, entweder zurück ins staatliche Waisenhaus zu ziehen, bis sie 18 Jahre alt ist - oder zu heiraten. „Ich war fast sechzehn und habe mich fürs Heiraten entschieden", sagt Marilyn einmal in einem Interview. Der Auserwählte, der Nachbarsjunge James Dougherty, ist 21 Jahre alt und arbeitet in einer Flugzeugfabrik. Das Glück ist nur von kurzer Dauer: Im September 1946, sie ist gerade einmal 20 Jahre alt, fährt Norma Jeane nach Las Vegas und lässt sich scheiden.

In der Zeit, als sie – nach Fürsprache ihrer damaligen Schwiegermutter Ethel Dougherty – in einer Fabrik für Flugzeugmunition jobbt, lernt Norma Jeane den Fotografen David Conover kennen. Conover erzählt ihr, mit ihrem Aussehen könne sie leicht fünf Dollar die Stunde verdienen. Ein verlockendes Angebot - bis dahin verdiente sie 20 Dollar in der Woche.

Sie kündigt in der Fabrik und bewirbt sich bei einer Agentur, die sie schließlich auch nimmt – für Werbefotos und für Kalender. Von Zeit zu Zeit leistet sich Norma Jeane Schauspielunterricht, um sich möglicherweise ihren Traum von einer Schauspielkarriere zu erfüllen. Bald ist ihr Gesicht auf gleich mehreren Magazin-Titelseiten zu sehen – und diese Publicity verschafft ihr die ersten Kontakte zur Filmbranche.

Im Juli 1946 spricht sie im ersten Filmstudio vor: bei Ben Lyon von 20th Century Fox. Zwei Tage später macht sie erste Testaufnahmen. Ende August 1946 erhält sie ihren ersten Studiovertrag mit der Fox, der ihr 75 Dollar pro Woche garantiert. Nun müsste ein passender Name für das Starlet her, findet Ben Lyon – und er schlägt Marilyn vor, nachdem Norma Jeane auf Monroe bestand, den Mädchennamen ihrer Mutter. Nach einem Jahr als namenlose Komparsin („Ich verbrachte die meiste Zeit damit, für die Werbefotografien der Filme zu posieren"), verlängert Daryl Zanuck, Chef der 20th Century Fox, den Vertrag nicht weiter.

Im März 1948 schließt sie einen Halbjahresvertrag mit den Columbia Studios – für 125 Dollar wöchentlich. Bei der Schauspiellehrerin Natasha Lytess nimmt Marilyn Unterricht, doch die Karriere verläuft zunächst schleppend. Da kommt mit Groucho Marx die große Chance: Der legendäre Komiker ist die erste berühmte Filmpersönlichkeit, mit der Marilyn auf der Leinwand zu sehen ist. Sie spielt an Marx' Seite eine komische Rolle als hinreißendes Kurvenwunder in „Love Happy" und ergattert anschließend kleine Rollen in wichtigen Filmen. Viel Aufsehen erregt Monroe mit ihrer Rolle als Gangsterliebchen Angela Phinlay in John Hustons „Asphalt Dschungel" von 1950. Der Film gilt als ihr großer Durchbruch. Nach dem erfolgreichen Film „Alles über Eva" (1950) hat sie ihren einzigen Auftritt bei den Oscar-Verleihungen.

Im Dezember 1950 unterschreibt Marilyn Monroe einen Siebenjahresvertrag mit der 20th Century Fox. Sie lernt den bekannten Regisseur Eliza Kazan kennen – und ihren späteren Ehemann Arthur Miller, Amerikas berühmtester Bühnenautor. In den letzten Wochen des Jahres 1952 beginnen die Dreharbeiten zu „Gentlemen Prefer Blondes" („Blondinen bevorzugt"). Ihre Darstellung der Lorelei Lee – und vor allem ihr Songbeitrag „Diamonds are a Girl's Best Friend" sind legendär. Der Film wird 1953 ein Riesenerfolg für Marilyn Monroe, die im selben Jahr bereits in „Niagara" überzeugen konnte. Die ebenso viel gelobte Komödie „How to Marry a Millionaire" steigert Marilyns Starruhm weiter.

Im Oktober desselben Jahres trifft Marilyn den bekannten Fashion-Fotografen Milton H. Greene, mit dessen Hilfe sie sich später aus den Verpflichtungen bei der 20th Century Fox befreit, einem Knebelvertrag mit wenig Mitspracherecht und für einen Star verhältnismäßig geringer Gage.

Am 14.1.1954 heiratet Marilyn den Baseball-Star Joe DiMaggio, ein amerikanisches Idol. Das Ereignis sorgt weltweit für gigantische Publicity, und das Filmstudio sieht von Maßnahmen wegen Vertragsbruchs ab. Während ihrer Hochzeitsreise nach Ja-

pan macht Marilyn einen Abstecher nach Seoul, Korea, um die dort stationierten amerikanischen Soldaten zu unterhalten. Als Sohn italienischer Einwanderer hätte auch Joe DiMaggio eine schwierige Jugend gehabt, erzählt Marilyn in einem Interview. „Deshalb verstanden wir uns ziemlich gut. Es war die Grundlage unserer Ehe." Doch nach bereits neun Monaten war die Ehe beendet. Ihre Freundschaft allerdings überdauert die Scheidung.

Die Dreharbeiten zu „The Seven Year Itch" („Das verflixte siebte Jahr") beginnen im August 1954 unter der Regie von Billy Wilder. Auch wenn er sie für eine „begnadete Schauspielerin" hält, beklagt sich Wilder in Interviews später oft über das chronische Zuspätkommen und die Textunsicherheiten der „Miss Monroe", die ihre häufigen Versagensängste regelmäßig mit Tabletten und Alkohol bekämpft. Mitte der fünfziger Jahre ist Marilyn die erfolgreichste Schauspielerin der USA, allerdings klebt das ihr verhasste Klischee der erotischen, dummen Blondine an ihr.

Ende 1954 kehrt Marilyn Monroe Hollywood den Rücken, fliegt nach New York und gründet mit ihrem Freund Milton H. Greene die „Marilyn Monroe Productions". Zudem nimmt sie Schauspielunterricht bei Lee Strasberg im Actors Studio, einer einflussreichen Institution, an der auch Marlon Brando, James Dean oder Paul Newman absolvierten. Sie will mehr sein als eine artifizielle Sexgöttin. Sie will das Image des oberflächlichen sexy Blondchens endlich loswerden.

Doch zeitgleich mit Marilyns Wunsch nach künstlerischer Weiterentwicklung nehmen ihre psychiatrischen Behandlungen zu. Sie leidet mehr und mehr unter ihrer Schlaflosigkeit und unter Angstzuständen, sie fühlt sich unsicher und unzulänglich. Zeitweise besucht Marilyn in New York jeden Tag ihre Psychiaterin Dr. Margaret Hohenberg.

Im Februar 1956 kehrt sie nach Los Angeles zurück; 20th Century Fox will mit der neuen Produktionsgesellschaft zusammenarbeiten und nimmt wieder Filme mit Marilyn Monroe ins Programm.

Am 29. Juni 1956 heiratet Marilyn Arthur Miller standesamtlich und zwei Tage später nach jüdischem Ritus. Noch bevor Marilyn in „Misfits" unter der Regie von John Huston ihr ernsthaftes schauspielerisches Können, jenseits jeder Burleske, beweisen kann, brilliert sie als laszive Sängerin Sugar – ganz gemäß ihrem Image als Sexgöttin - in der Komödie „Some Like it Hot" („Manche mögen's heiß") von Billy Wilder. Der Film ist für sechs Oscars nominiert worden, Marilyn wird als Komödiantin gefeiert.

Doch die privaten Krisen reißen nicht ab: Im Jahr 1960, während der Dreharbeiten zu „Misfits", dessen Skript Arthur Miller extra für seine Frau schrieb, beschließen Monroe und Miller, sich scheiden zu lassen. Am 20. Januar 1961 wird die Scheidung in Mexiko (Ciudad Juarez) vollzogen. Am 7. Februar wird Marilyn in die Payne Whitney Psychiatric Clinic des New York Hospitals eingeliefert. Joe diMaggio eilt an ihre Seite und ist in diesem Frühjahr ihre wichtigste Hilfe.

Im März 1962 erhält Marilyn den „World's Film Favorite" Preis bei den Golden Globe Awards. Im April beginnen die Dreharbeiten zu dem Film „Something's Got to Give". Der Produzent Henry Weinstein ist erschrocken über die schlechte psychische und physische Verfassung seines Stars. Im August wird die Produktion des Filmes abgebrochen. Marilyn wird von der Filmgesellschaft gefeuert – zuvor gab es große Aufregung, weil sie es sich trotz dringender Drehtermine nicht nehmen ließ, am 19. Mai des Jahres zur Geburtstagsfeier von John F. Kennedy im Madison Square Garden zu erscheinen – und ihr legendäres „Happy Birthday" zu singen.

Es wird der letzte große öffentliche Auftritt der Monroe sein. Sie stirbt in der Nacht von Samstag, den 4. August auf Sonntag, den 5. August 1962, unter bis heute nicht eindeutig geklärten Umständen im Alter von 36 Jahren an einer Überdosis von Nembutal und Choralhydrat. Ihr Psychiater Dr. Ralph Greenson findet sie am Morgen des 5. August tot auf ihrem Bett. In der Hand hält sie ihren Telefonhörer. Am 8. August 1962 wird Marilyn auf dem Westwood Memorial Park Cemetery begraben.

Aufgrund unzulänglicher Ermittlungen der Polizei, widersprüchlicher Zeugenaussagen und der Gerüchte, Marilyn Monroe habe sowohl mit US-Präsident John F. Kennedy als auch mit seinem Bruder Robert eine Affäre gehabt, wird bis heute über die wahren Hintergründe ihres Todes spekuliert. War es Selbstmord, Mord – oder der tragische, tödliche Irrtum einer Frau, die jahrelang tablettenabhängig war – und nicht nur den Überblick über ihre Dosierungen, sondern wohl auch über ihr Leben verloren hatte.

ICH HABE INSGEHEIM DAS GEFÜHL GEHABT, NICHT VOLLKOMMEN "ECHT" ZU SEIN, SO ETWAS WIE EINE GUT GEMACHTE FÄLSCHUNG.

MARILYN MONROE 1960.

« Tu es la fille la plus triste que j'ai jamais vue » a déclaré Clark Gable à Marilyn sur le tournage de son dernier film « Something's got to give ». Elle lui répondit : « Tu es le premier à dire ça. D'habitude, les hommes me disent à quel point je suis heureuse. »

Los Angeles, 1er juin 1926. Norma Jeane Mortensen naît dans le County Hospital. Le nom qui figure sur son certificat de naissance deviendra plus tard Norma Jeane Baker.

La mère de Norma Jeane, Gladys Pearl Mortensen (divorcée Baker), née Monroe, confie sa fille, son troisième enfant, deux semaines à peine après sa naissance à des parents nourriciers. L'identité du père, en dépit de nombreuses spéculations, ne sera jamais connue avec certitude.

Dans une interview accordée en 1960 à Georges Belmont, alors rédacteur en chef du magazine « Marie Claire », Marilyn Monroe fait noter dans le compte-rendu : « Aussi loin que je me souvienne, j'ai toujours vécu chez d'autres gens. » Dans ses souvenirs d'enfance, sa mère est la femme qui lui rend visite de temps en temps, « la femme aux cheveux rouges ». Norma Jeane vit dans de nombreuses familles d'accueil, la première la gardera jusqu'à l'âge de sept ans.

En janvier 1935, Grace McKee, une amie de Gladys, devient la tutrice de la petite Norma Jeane. Mais dès septembre de la même année, Grace, célibataire, place la petite fille de huit ans dans un orphelinat, le « Los Angeles Orphans Home Society ». Dans les années qui suivront, la petite fille habitera à maintes reprises dans de nouvelles familles d'accueil ou des orphelinats. Après son mariage en juin 1937, Grace McKee reprend Norma Jeane chez elle, la jeune fille de onze ans souhaite plus que tout rester définitivement dans la famille Goddard, mais elle est encore et toujours confiée à des tiers. La période la plus heureuse de sa jeunesse, Marilyn la passe, ainsi qu'elle le racontera souvent par la suite, chez la tante de Grace, Ana Lower, qu'elle aime tendrement. Elle ne l'aurait « jamais déçue ».

Grace voulant finalement déménager avec son mari et ses enfants hors de Californie, Norma Jeane est placée devant le choix, soit de retourner à l'orphelinat public jusqu'à l'âge de 18 ans, soit de se marier. « J'avais presque seize ans et je me suis décidée pour le mariage », explique Marilyn dans une interview. L'élu, James Dougherty est un jeune voisin de 21 ans qui travaille dans une usine aéronautique. Le bonheur ne sera que de courte durée : en septembre 1946, Norma Jeane qui vient tout juste d'avoir 20 ans part pour Las Vegas et divorce.

Employée – suite à l'intervention de sa belle-mère d'alors, Ethel Dougherty – dans une fabrique de munitions pour avions, Norma Jeane fait la connaissance du photographe David Conover qui lui affirme qu'avec son physique, elle pourrait facilement gagner cinq dollars à l'heure. Une offre alléchante pour elle, qui gagne jusqu'alors 20 dollars par semaine.

Elle démissionne de l'usine et postule auprès d'une agence qui finira aussi par la prendre – pour des photos publicitaires et des calendriers. De temps à autre, Norma Jeane s'offre des cours d'art dramatique pour réaliser éventuellement son rêve d'une carrière d'actrice. Son visage fait bientôt simultanément la une de plusieurs magazines – cette publicité lui procure les premiers contacts dans le milieu du cinéma.

En juillet 1946, elle se présente dans le premier studio de cinéma : auprès de Ben Lyon de la 20th Century Fox.

Deux jours plus tard, elle fait ses premiers bouts d'essai. Fin août 1946, elle obtient son premier contrat de studio avec la Fox, qui lui garantit 75 dollars par semaine. Enfin, il faut un nom approprié pour la starlette, Ben Lyon trouve et propose Marilyn, et sur l'insistance de Norma Jeane pour Monroe, le nom de jeune fille de sa mère. Après un an de figuration anonyme (« Je passais la plupart du temps à poser pour les photographes publicitaires des films »), Daryl Zanuck, patron de la 20th Century Fox, ne renouvelle pas son contrat.

En mars 1948, elle conclut un contrat de six mois avec les studios de la Columbia – pour 125 dollars par semaine. Marilyn prend des cours avec le professeur d'art dramatique Natasha Lytess, mais, au début, sa carrière stagne. La chance lui sourit avec Groucho Marx : le comique légendaire est la première célébrité du cinéma avec laquelle Marilyn apparaît à l'écran. Elle joue aux côtés de Marx un rôle comique d'une ravissante créature toute en courbes dans « Love Happy » (« La pêche au trésor ») et décroche ensuite de petits rôles dans des films importants. Marilyn Monroe fait sensation avec son rôle d'Angela Phinlay, la maîtresse d'un gangster dans « Asphalt Jungle » (« Quand la ville dort ») de John Huston en 1950. Le film est considéré comme sa grande percée. Après le film à succès « All about Eve » (« Ève ») en 1950, elle fait son unique apparition sur scène lors de la remise des oscars.

En décembre 1950, Marilyn Monroe signe un contrat de sept ans avec la 20th Century Fox. Elle fait la connaissance du célèbre réalisateur Elia Kazan – et de son futur mari, Arthur Miller, le plus fameux dramaturge d'Amérique. Les dernières semaines de l'année 1952 voient le début du tournage de « Gentlemen Prefer Blondes » (« Les hommes préfèrent les blondes »). Son interprétation de Lorelei Lee et surtout sa prestation chantée de « Diamonds are a Girl's Best Friend » sont légendaires. Le film devient en 1953 un immense succès pour Marilyn Monroe qui avait déjà pu convaincre la même année dans « Niagara ». La comédie « Comment épouser un millionnaire », également l'objet de nombreux éloges, augmente encore la gloire de star de Marilyn.

En octobre de la même année, Marilyn rencontre le célèbre photographe de mode Milton H. Greene qui l'aidera par la suite à se libérer de ses obligations vis-à-vis de la 20th Century Fox, un contrat léonin avec un droit de regard minimal et un cachet proportionnellement faible pour une star.

Le 14 janvier 1954, Marilyn épouse une idole américaine, la star du baseball Joe DiMaggio. L'évènement produit dans le monde entier une publicité phénoménale et le studio cinématographique prévoit des dispositions pour rupture de contrat. Lors de son voyage de noces au Japon, Marilyn fera un crochet

par Séoul, en Corée, afin de distraire les soldats américains cantonnés là-bas. Fils d'un immigrant italien, Joe DiMaggio aurait également eu une enfance difficile révèle Marilyn dans une interview. « C'est pour cela que nous nous comprenions assez bien. C'était le fondement de notre mariage. » Pourtant, leur union s'achève déjà au bout de neuf mois. Leur amitié a cependant perduré au-delà du divorce.

Le tournage de « The Seven Year Itch » (« Sept ans de réflexion ») débute en août 1954 sous la direction de Billy Wilder. Même s'il la considère comme une « actrice hors pair », Wilder se plaindra plus tard, dans les interviews, du retard chronique et des hésitations de texte de la « Miss Monroe » qui combat régulièrement ses fréquentes peurs de ne pas être à la hauteur par des médicaments et de l'alcool. Au milieu des années cinquante, Marilyn est l'actrice qui connaît le plus grand succès aux États-Unis, mais le cliché détesté de la blonde érotique stupide lui colle à la peau.

Fin 1954, Marilyn Monroe tourne le dos à Hollywood, s'envole pour New York et fonde avec son ami Milton H. Greene les « Marilyn Monroe Productions ». Elle prend en outre des cours d'art dramatique avec Lee Strasberg à l'Actors Studio, une institution influente par laquelle sont également passés Marlon Brando, James Dean ou Paul Newman. Elle veut être plus qu'une déesse artificielle du sexe. Enfin se débarrasser de l'image de la petite blonde sexy et superficielle.

Mais tandis que Marilyn cherche à se perfectionner en tant qu'artiste, ses traitements psychiatriques s'intensifient. Elle souffre de plus en plus d'insomnies et d'angoisses, manque d'assurance et éprouve un sentiment d'insuffisance. Pendant certaines périodes, Marilyn consulte quotidiennement sa psychiatre, Dr Margaret Hohenberg, à New York.

En février 1956, elle revient à Los Angeles; la 20th Century Fox veut collaborer avec la nouvelle société de production et programme à nouveau des films avec Marilyn Monroe.

Marilyn épouse Arthur Miller civilement le 29 juin 1956 et deux jours plus tard selon le rite juif. Avant de pouvoir démontrer son sérieux talent d'actrice au-delà de tout burlesque dans « Misfits » (« Les désaxés ») sous la direction de John Huston, Marilyn se distingue encore comme Sugar la chanteuse lascive – correspondant tout à fait à son image de déesse du sexe – dans la comédie « Some Like it Hot » (« Certains l'aiment chaud ») de Billy Wilder. Le film est nominé pour six Oscars, Marilyn est célébrée comme comédienne.

Les crises personnelles se poursuivent cependant: en 1960, pendant le tournage de « Misfits » dont Arthur Miller écrivit exprès le scénario pour son épouse, Monroe et Miller décident de divorcer. Le 20 janvier 1961, le divorce est prononcé au Mexique (Ciudad Juarez). Le 7 février, Marilyn est hospitalisée à la Whitney Psychiatric Clinic du New York Hospital. Joe DiMaggio se précipite à ses côtés et se trouve être son principal soutien en ce printemps.

En mars 1962, Marilyn reçoit le prix du « World's Film Favorite » lors des Golden Globe Awards. Le tournage du film « Something's Got to Give » (« Quelque chose doit craquer ») démarre en avril. Le producteur Henry Weinstein est affolé par la condition psychique et physique déplorable de sa star. La production du film est abandonnée en août. Marilyn est renvoyée par la société cinématographique – une grande agitation s'était produite auparavant parce qu'en dépit de dates de tournage urgentes, elle avait insisté pour faire une apparition le 19 mai de cette même année lors des festivités d'anniversaire de John F. Kennedy au Madison Square Garden – et de chanter son légendaire « Happy Birthday ».

Ce sera la dernière grande apparition publique de Marilyn Monroe. Elle meurt dans la nuit du samedi 4 août au dimanche 5 août 1962, à l'âge de 36 ans, d'une overdose de Nembutal et d'hydrate de chloral dans des circonstances toujours non élucidées sans ambiguïté à ce jour. Son psychiatre, le Dr Ralph Greenson, la trouve morte sur son lit, le matin du 5 août. Elle tient dans sa main le combiné du téléphone. Marilyn sera enterrée le 8 août 1962 au Westwood Memorial Park Cemetery.

En raison d'une enquête insuffisante de la police, de témoignages contradictoires et de rumeurs selon lesquelles Marilyn Monroe entretenait une relation tant avec le président des États-Unis, John F. Kennedy, qu'avec son frère Robert, les causes réelles de son décès font encore aujourd'hui l'objet de spéculations. S'agissait-il d'un suicide, d'un meurtre – ou de l'erreur fatale et tragique d'une femme qui, des années durant, fut dépendante de médicaments – et qui avait perdu non seulement le contrôle des doses, mais sans doute également de toute sa vie.

J'AVAIS SECRÈTEMENT LE SENTIMENT DE NE PAS ÊTRE TOTALEMENT « VRAIE », D'ÊTRE EN QUELQUE SORTE UNE BONNE CONTREFAÇON.
MARILYN MONROE 1960.